Brassaï

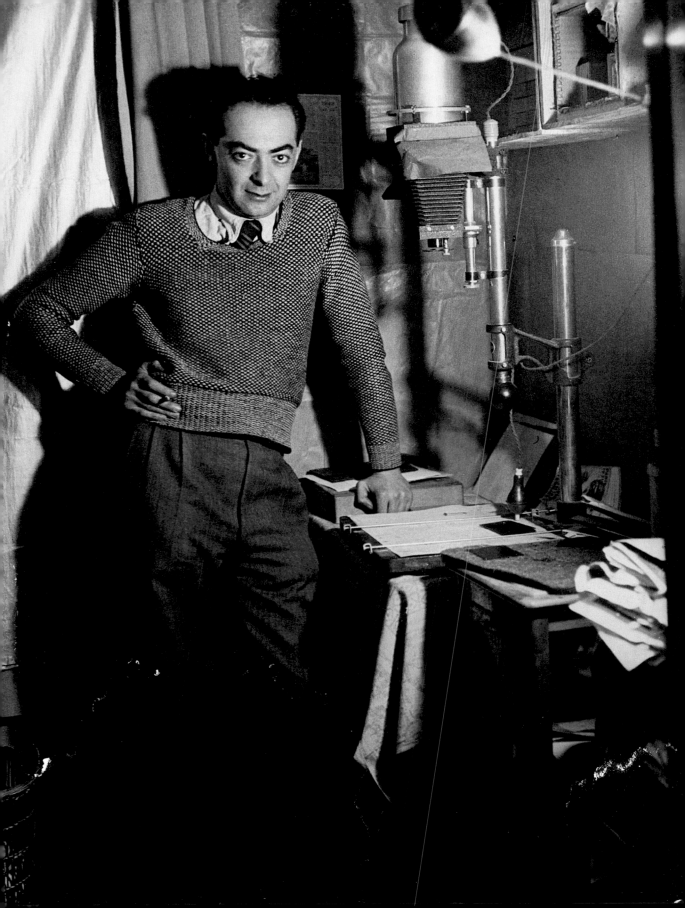

Jean-Claude Gautrand

Brassaï

1899–1984

Brassaï's Universal Art
Brassaï, der Vielseitige
Brassaï l'universel

TASCHEN

KÖLN LONDON LOS ANGELES MADRID PARIS TOKYO

Contents
Inhalt
Sommaire

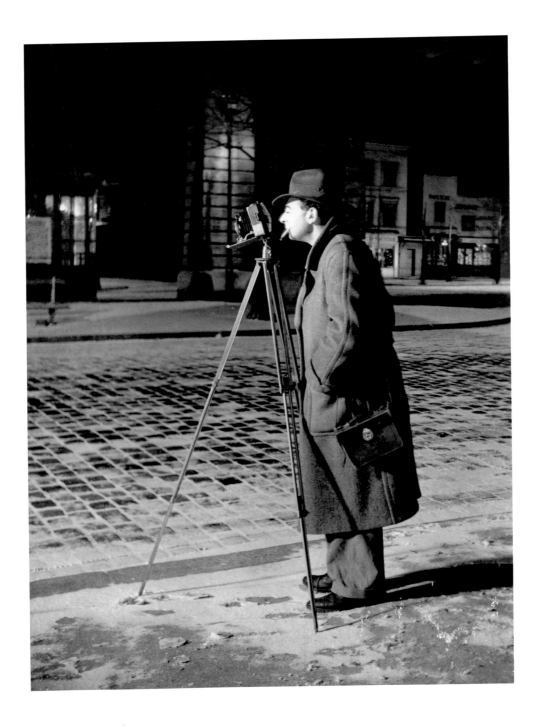

Brassaï
Boulevard Saint-Jacques, Paris 14ᵉ, c. 1931–1932

Brassaï's Universal Art
Brassaï, der Vielseitige
Brassaï l'universel

"I have always refused to specialise. I've always done many different kinds of things: photos, drawings, sculpture, films, books … In the end, it is hard to have many different talents, because each one wants to monopolise you … All you can do is try to alternate between them, following your instincts … I'm not afraid that I might be wasting my energy … I want to be free."

„Ich habe mich immer geweigert, mich zu spezialisieren. Ich habe immer viele Dinge gemacht: Fotos, Zeichnungen, Skulpturen, Filme, Bücher … Letztlich ist es ebenso schwer, viele Talente zu besitzen, denn jedes einzelne belegt einen mit Beschlag … Man kann sich nur abwechselnd mit ihnen beschäftigen, man muss dabei seinem Instinkt folgen … Ich habe keine Angst, mich dabei zu verzetteln … Ich möchte frei sein."

«J'ai toujours refusé de me spécialiser. J'ai toujours fait beaucoup de choses: photos, dessins, sculptures, films, livres … Finalement c'est aussi dur d'avoir beaucoup de talent, car chacun d'eux vous accapare … On ne peut agir que par alternance en suivant son instinct … Je n'ai pas peur de me disperser … je veux être libre.»

Brassaï

To say Brassaï was hugely talented would be an understatement. He excelled as both draughtsman and sculptor. He was a talented writer who could turn his hand to journalism. Over the years, he won the friendship of countless artists. But it is above all his work as a photographer which has won him a place in history, as the consummate observer of Paris. The night became his intimate companion, and his photographic work is inhabited by a unique kind of tenderness. His greatest gift was his capacity for responding to the slightest hint from the outside world. He acted as both receiver and reflector of the energy around him. He seems to have existed in a state of permanent availability. According to the former director of the Museum of Modern Art in New York, John Szarkowski, in the late 1930s European photography was dominated by two main figures: Cartier-Bresson, the master of classical proportion, and Brassaï, the master of the bizarre.

No one has understood and described Brassaï's work better than his fellow night owl, Henry Miller: "Brassaï is a living eye … his gaze pierces straight to the heart of truth in everything. Like a falcon, or a shark, we see him quiver, then plunge at reality."[1] For Jean Paulhan he was "this man who has more than two eyes". If Brassaï knew one thing, it was how to look. His gaze was insatiable, devouring objects and people. It was this natural facility for seeing everything, for seeing more than others, which made him a universal artist, and which he sought to express in so many different media.

Brassaï was not predestined to be a photographer. He was a fully paid-up member of 1920s Bohemian Montparnasse when he happened on the medium in which he was to express his piercingly naturalistic vision of Paris by night. It is plain from even a cursory glance at his life's work that he could have made his mark on many other disciplines had he so chosen. He certainly had a talent for drawing, to the extent of provoking Picasso's

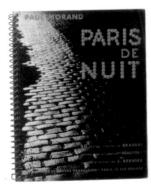

Paris de nuit, text by Paul Morand, Paris, Arts et Métiers Graphiques, 1932

Camera in Paris, London, The Focal Press, 1949

Zeichner, Bildhauer, Schriftsteller, Journalist und Freund aller Künstler, das war Brassaï, das Auge von Paris, der Fotograf der Nacht und der Zärtlichkeit, der mit allen Gaben gesegnet war, vor allem aber mit der Fähigkeit, das feinste Echo aufzuspüren und auf Schwingungen zu reagieren, immer verfügbar, immer im Einsatz. John Szarkowski, der ehemalige Direktor des Museum of Modern Art in New York, schrieb einmal, dass die europäische Fotografie um 1935 von zwei wichtigen Figuren beherrscht wurde: von Cartier-Bresson, dem Klassiker und Maßvollen, und von Brassaï, dem guten Geist des Bizarren. Keiner hat das Phänomen Brassaï besser erfasst und beschrieben als Henry Miller, sein Bruder der Nacht: „Brassaï ist

Dessinateur, sculpteur, écrivain, journaliste, ami de tous les artistes, Brassaï véritable œil de Paris, photographe de la nuit et de la tendresse a bénéficié de tous les dons et surtout de celui de vibrer au moindre écho et d'être un réflecteur d'ondes à la disponibilité permanente. John Szarkowski, ancien directeur du musée d'Art Moderne de New York, écrira que, dans le domaine de la photographie, les années 1935 ont été dominées – en Europe – par deux figures essentielles : celle de Cartier-Bresson, le classique et mesuré, et celle de Brassaï, ange du bizarre. Nul mieux que son frère de la nuit Henry Miller n'a mieux senti, observé et décrit le phénomène Brassaï : « Brassaï est un œil vivant … ses yeux ont cette véracité qui étreint tout et qui fait du faucon et du requin la sentinelle frémissante de la réalité. »[1] « Cet homme qui possède plus que deux yeux » écrivait Jean Paulhan, possédait avant tout *le regard*, un regard insatiable qui dévorait les choses et les êtres. Indéniablement, cette facilité naturelle qui lui a été donnée de tout voir, de voir plus est la source de l'universalité d'un artiste aux mille violons d'Ingres.

Brassaï n'est pas né photographe. Ce n'est qu'à un certain moment de sa vie de bohème Montparnassien, à la fin des années 20, qu'il découvre le média qui va lui permettre d'inscrire sa vision, vraie, naturaliste, des fêtes nocturnes quotidiennes qu'offrait alors Paris. Un simple survol de l'œuvre de cet homme infatigable prouve qu'il aurait pu briller dans d'autres disciplines. Dessinateur, il l'a été. Ce qui lui vaudra d'ailleurs une colère violente de Picasso lorsque feuilletant, en 1939, un de ses cartons de dessins, celui-ci s'écria soudainement « Vous êtes un dessinateur né … Pourquoi ne continuez-vous pas ? Vous avez une mine d'or et vous exploitez une mine de sel ! »[2]

Peintre il l'a été à son arrivée à Paris en 1924 ce qui l'a d'ailleurs incité à s'installer dans le haut-lieu pictural de l'époque : Montparnasse. Il y partage la vie noctambule des grands artistes et écrivains du moment : Matisse, Michaux, Dalí, Fargue, Prévert, Mac Orlan, Breton, Miller, Mann,

wrath. Leafing through one of Brassaï's notebooks in 1939, the great painter suddenly flew into a rage: "You are a born draughtsman!" he shouted. "Why don't you keep it up? You have a gold mine within you, and you insist on working in a salt pit!".[2]

He was also a gifted painter. It was painting which led him to settle in the artists' Mecca of Montparnasse on his arrival in Paris in 1924. There he frequented the same bars and cafés as the great artists and writers of the time, running shoulders with Matisse, Michaux, Dalí, Fargue, Prévert, Mac Orlan, Breton, Miller, Mann and Eluard. But this passionate and unbridled life also served to distract him from the solitary discipline of his art. He was never entirely happy to be locked away in his studio. Nevertheless, it was thanks to his reputation as a painter that he began to write occasional articles in the Hungarian press. Although badly paid, journalism did at least enable him to survive.

Sculpture was another long-standing passion. His strong sense of form and his love of his materials can be seen in the magnificent copper statuettes he produced. He also worked in stone and carved wood. His sculptural work is stylised, primitive, almost abstract. In its purity and energy, it seems to prefigure Gilioli. It was this innate sense of three-dimensional representation that later qualified Brassaï to become the first person to photograph Picasso's sculptures. He also produced tapestry cartoons. For the Lausanne Biennale in 1971 he designed a huge low warp wall-hanging in black and white wool, based on graffiti he had collected on his walks around Paris. As he himself put it, "I gave back to the wall what I had taken from it."

From time to time Brassaï also made films, and the medium-length *Tant qu'il y aura des bêtes* shot in the Vincennes zoo won a prize at the Cannes festival in 1956. But perhaps his most remarkable 'other' activity was as

ein lebendiges Auge ... sein Blick dringt direkt ins Herz der Dinge vor. Wie einen Falken oder einen Hai sehen wir ihn zittern, bevor er sich auf die Wirklichkeit stürzt."[1] – „Dieser Mann, der mehr als zwei Augen besitzt", wie Jean Paulhan schrieb, besaß vor allem *den* Blick, einen unersättlichen Blick, der die Dinge und die Menschen verschlingt. Diese natürliche Begabung, alles zu sehen, ja mehr zu sehen, ist gewiss der Urgrund seiner Vielseitigkeit, der Universalität eines Künstlers, der auf tausend Klavieren spielte.

Brassaï ist nicht als Fotograf auf die Welt gekommen. Erst in einem bestimmten Moment seines Boheme-Lebens Ende der zwanziger Jahre in Montparnasse entdeckte er das Medium für sich, das ihm die Möglichkeit gab, seine Vision von den Festen, die Paris Nacht für Nacht bereithielt, wahr und naturalistisch einzufangen. Schon ein schneller Überblick über das Gesamtwerk dieses unermüdlichen Mannes macht deutlich, dass er ebenso gut in anderen Disziplinen hätte brillieren können. Zeichner war er zunächst gewesen. Diese Tatsache brachte ihm übrigens einen heftigen Wutausbruch Picassos ein, denn als der Künstler 1939 eine von Brassaïs Zeichenmappen durchblätterte, schrie er plötzlich empört: „Sie sind ein geborener Zeichner ... Warum machen Sie nicht weiter damit? Sie besitzen eine Goldmine und beuten ein Salzbergwerk aus!"[2]

Als Maler war er 1924 nach Paris gekommen, und dieser Umstand hatte ihn dazu bewogen, sich im Malerviertel Montparnasse niederzulassen. Dort stürzte er sich ins Nachtleben, mit den großen Künstlern und Schriftstellern der Zeit: Matisse, Michaux, Dalí, Fargue, Prévert, Mac Orlan, Breton, Miller, Mann, Eluard und anderen. Ein aufregendes und zügelloses Leben, das ihn von der einzelgängerischen Disziplin seiner Kunst ablenkte. Es war eine Kunst, die ihn nicht voll befriedigte – die es ihm aber ermöglichte, Artikel für ungarische Zeitungen zu schreiben, womit er sich einen mageren Lebensunterhalt verdienen konnte. Bildhauer war er immer

Eluard ... Une vie passionnante et effrénée qui, par contrecoup, l'éloigne d'une discipline solitaire qui ne le satisfait pas complètement ... Mais qui lui permet d'écrire quelques articles pour certains journaux hongrois, trouvant ainsi les maigres ressources nécessaires à sa survie. Sculpteur, il l'a toujours été. Son sens des formes, son amour de la matière lui ont permis de réaliser de magnifiques statuettes de cuivre, de tailler la pierre et de graver le bois ... Stylisées, quasi abstraites, très primitives, ses sculptures ont une pureté et un élancement qui annoncent l'art d'un Gilioli. C'est sans doute son sens inné de la représentation de l'objet et des formes dans l'espace qui lui a permis d'être le premier à photographier l'œuvre sculpté de Picasso. Cartonnier, Brassaï l'a également été en réalisant, entre autres, une vaste fresque de laine pour la Biennale de Lausanne en 1971. Une basse lisse en noir et blanc, tissée à partir d'une composition obtenue d'après un certain nombre de graffiti. Lui faisant dire « Je rends au mur ce que je lui ai pris ».

Cinéaste, Brassaï l'a été occasionnellement : son moyen métrage tourné au zoo de Vincennes : *Tant qu'il y aura des bêtes* obtiendra un prix au festival de Cannes en 1956. Mais surtout, Brassaï s'est révélé comme un étonnant écrivain à la plume vive et alerte. De *Histoire de Marie* (1949) à *Marcel Proust sous l'emprise de la photographie* (1997) il s'affirme comme l'un des meilleurs chroniqueurs de son temps. *Conversations avec Picasso* (1964) est un véritable morceau d'anthologie qui révèle un Picasso intime et vivant mais s'avère également une chronique passionnante du monde artistique du milieu du siècle dernier. Tout comme le seront *Henry Miller, grandeur nature* (1975), *Le Paris secret des années 30* (1976) et *Les Artistes de ma vie* (1982).

Si Brassaï a pu dire « J'ai toujours eu horreur de toute spécialisation. C'est pourquoi j'ai constamment changé mon médium d'expression ... cela me donne de l'air, me rafraîchit la vision »[3], c'est évidemment, et avant tout, l'homme d'image qui s'est imposé dans l'histoire de la

a writer. His style was fluent and lively, and the results often astonishing. From *Histoire de Marie* (1949) to *Marcel Proust sous l'emprise de la photographie* (1997), he proved himself one of the best chroniclers of his age. *Conversations avec Picasso* (1964) is an absolute gem: an intimate portrayal of the painter as human being, and at the same time an absorbing account of the artistic milieu of the middle of the last century. The same qualities also distinguish *Henry Miller, grandeur nature* (1975), *Le Paris secret des années 30* (1976) and *The Artists of My Life* (1982).

Brassaï once said: "I've always hated specialisation. That's why I've constantly changed the medium in which I express myself … That way I can breathe, I can see things anew."[3] Yet despite his versatility, he has gone down in history as a visual artist, and as a photographer above all else. His work approaches the visionary realm – he reveals the true nature of the world to us, thus curing us of our blindness. His vision goes so deep into reality, it is timeless. If it sometimes appears fantastical, it is simply because it is loaded with too much truth. If his images strike us as natural, it is because they are full of tenderness. If Brassaï trapped his subjects in his "little box of night" (Michel Tournier), he did so only in order to commune with them. He was not a thief; he did not take people by force.

This tact, this sense of restraint, underlies his extraordinary self-control. He took very few pictures, but when he did release the shutter, it was because he had reached or recognised a moment of concentration, of permanence, in which the essence of a situation was immediately visible. Each image, then, is a naturally occurring visual-emotional compound, which demands to be taken as a whole. His subjects are always alive, always moving, and yet his photographs still manage to freeze and immortalise those instants in which things and people express themselves most perfectly, because involuntarily.

schon gewesen. Sein Sinn für Formen, seine Liebe zum Material gaben ihm den Antrieb, wunderschöne Kupferstatuetten herzustellen, Steine zu meißeln und Holz zu schneiden … Seine Skulpturen sind stark stilisiert, primitiv, fast abstrakt und von einer Reinheit und Energie, dass sie die Kunst eines Gilioli vorwegzunehmen scheinen. Sicherlich war es sein angeborener Sinn für die Darstellung von Gegenständen, Gestalten und Formen im Raum, der ihn befähigte, als Erster das skulpturale Werk Picassos zu fotografieren. Auch Kartons hat Brassaï entworfen, etwa zu einem großen Wandteppich für die Biennale von Lausanne 1971. Die Vorlage für diesen Wollteppich in Schwarzweiß hat er aus verschiedenen Graffiti komponiert. Damit wollte er sagen: „Ich gebe der Mauer zurück, was ich ihr weggenommen habe."

Gelegentlich war Brassaï auch als Filmemacher tätig: Sein mittellanger Film *Tant qu'il y aura des bêtes*, den er im Zoo von Vincennes gedreht hatte, erhielt beim Filmfestival in Cannes 1956 einen Preis. Vor allem aber bewies Brassaï als Schriftsteller erstaunliche Begabung, er schrieb einen flüssigen, lebendigen Stil und verstand es, Aufmerksamkeit und Neugier zu wecken. Mit *Histoire de Marie* (1949) oder *Marcel Proust sous l'emprise de la photographie* (1997) erweist er sich als einer der besten Chronisten seiner Zeit. *Conversations avec Picasso* (1964) ist wahrhaft ein Kabinettstück, das einen sehr lebendigen und intimen Picasso zeigt und zugleich eine spannende Chronik der Künstlerwelt Mitte des 20. Jahrhunderts ist. Dasselbe gilt für die Bücher *Henry Miller, grandeur nature* (1975), *Le Paris secret des années 30* (1976) und *The Artists of My Life* (1982).

„Jede Art von Spezialisierung war mir immer ein Graus. Darum habe ich ständig mein Ausdrucksmedium gewechselt … Das hat mich erfrischt, meine Sichtweise erneuert"[3] – so hat Brassaï sich einmal selbst charakterisiert, und es war gewiss und vor allem der Mann des Bildes, der sich hat durchsetzen können, um schließlich einen der ersten Plätze in der

Histoire de Marie, introduction by Henry Miller, Paris, Édition du Point du Jour, 1949

Les Sculptures de Picasso, text by Daniel-Henry Kahnweiler, Paris, Les Éditions du Chêne, 1949

photographie. Avec lui nous touchons au domaine réservé du visionnaire sans qui les choses ne seraient pas puisqu'il les révèle à nos yeux aveugles. Son œuvre, définitivement hors du temps, plonge avant tout dans la réalité pour, par excès même de vérité, atteindre au fantastique. Le naturel de ses images tient avant tout à la tendresse dont il les investit, à cette communion avec ceux qu'il piège – comme dit Michel Tournier – dans sa «petite boîte de nuit». Brassaï n'est pas un voleur, il ne brutalise personne. Ce tact, cette retenue font que Brassaï avec un self-control étonnant, ne réalise que peu de clichés, mais déclenche à un moment de concentration, à un moment de permanence où l'essentiel d'une situation est immédiatement inscrit. Son

Brassaï was born Gyula Halasz in Brasso in Transylvania (Hungary) on 9 September 1899. He studied in Budapest before serving in the Austro-Hungarian army from 1917 to 1918. After demobilisation, he enrolled in the Fine Arts Academy in Budapest. In 1921, he moved to Berlin-Charlottenburg. There he attended various drawing classes, and immersed himself in the works of Goethe, who became his true spiritual master. Yet his ultimate goal was never Berlin, but France, and in January 1924 he finally made his way to Paris. To earn a living, he wrote articles for a Hungarian sports gazette, and for several German magazines. In 1926 he made friends with another Hungarian exile, the photographer André Kertész. Brassaï would accompany Kertész when he went out with his camera, and sometimes used his friend's pictures to illustrate his articles. Through this experience, he came to realise "that only photography could provide the intensity and expressive power"[4] he needed to translate his vision of the beauty of ordinary life.

He waited until 1929, however, to take his first photographs, using a camera which a friend had lent him. Immediately he was hooked, and bought the Voigtländer Bergheil which he would continue to use for many years. In 1930, he began taking pictures of "scaled-up objects", discovering the shock potential that could be unlocked in reality when seen from an unfamiliar point of view. Together with other pictures of even more insignificant objects, such as a rolled up bus ticket, these images immediately caught the attention of the Surrealists, and were later published in the third issue of *Minotaure* (1933), an artistic review published by Skira and Tériade. It was for *Minotaure* too that Brassaï took a series of pictures of Hector Guimard's decorations for the entrances to the Paris Metro, to illustrate an article by Salvador Dalí on Art Déco.

It was no coincidence that the Surrealists were interested in his work, for they recognised in it many of

Geschichte der Fotografie einzunehmen. Mit ihm stoßen wir an das Reservat des Visionärs, ohne den die Dinge nicht da wären, denn er enthüllt sie, er offenbart sie unseren getrübten Augen. Sein zeitloses Werk taucht tief in die Realität ein, um das Fantastische zu erreichen, und sei es durch Übertreibung der Wahrheit. Das Wesen seiner Bilder zielt auf die Zärtlichkeit ab, mit der er sie erfüllt, strebt eine Vereinigung mit denjenigen an, die er in die Falle lockt, nämlich in seinen „kleinen schwarzen Kasten" (Michel Tournier). Brassaï ist kein Dieb, er geht mit niemandem brutal um. Aus diesem Taktgefühl, dieser Zurückhaltung ist zu erklären, dass er mit erstaunlicher Selbstkontrolle nur wenige Aufnahmen gemacht hat, aber immer im Augenblick höchster Konzentration auf den Auslöser gedrückt hat, in einem Augenblick, der Beständigkeit hat, dem das Wesen einer Situation unmittelbar eingeschrieben ist. Insofern ist sein Bild ein visuelles Ganzes, ein ganz natürlich wirkendes Ensemble, dessen Sujet lebendig bleibt, während der besondere Augenblick unsterblich wird.

Brassaï wurde am 9. September 1899 als Gyula Halasz in Brasso in Transsilvanien (Ungarn) geboren, erhielt seine Schulausbildung in Budapest und diente von 1917 bis 1918 in der österreichisch-ungarischen Armee. Nach seiner Demobilisierung besuchte er die Kunstakademie in Budapest und ab 1921 die Akademische Hochschule in Berlin-Charlottenburg. Während er in verschiedenen Klassen am Zeichenunterricht teilnahm, vertiefte er sich in das Werk Goethes, der ihm zum wichtigsten Lehrer des Denkens wurde. Da er schon länger den Wunsch hatte, in Frankreich zu leben, reiste er im Januar 1924 nach Paris. Um dort seinen Lebensunterhalt zu verdienen, arbeitete er für eine ungarische Sportzeitung und für mehrere deutsche Zeitschriften. 1926 lernte er den ungarischen Fotografen André Kertész kennen, den er auf Reportagen begleitete und dessen Fotografien er hin und wieder zur Illustration seiner eigenen Artikel verwendete. Dadurch kam ihm

image est donc un tout, un ensemble visuel – émotionnel essentiellement naturel qui laisse vivre le sujet tout en immortalisant l'instant privilégié où les choses et les gens s'expriment eux-mêmes.

Né à Brasso en Transylvanie (Hongrie) le 9 septembre 1899, Gyula Halasz (qui deviendra plus tard Brassaï) poursuit ses études à Budapest avant de servir dans l'armée austro-hongroise de 1917 à 1918. Démobilisé, il suit les cours de l'Académie des beaux-arts de Budapest puis, en 1921, ceux de l'Académie de Berlin-Charlottenburg. Tout en dessinant dans diverses académies, il se plonge dans l'œuvre de Goethe qui devient son maître à penser. Réalisant enfin son désir de vivre en France, il arrive à Paris en janvier 1924. Pour gagner sa vie, il collabore à un journal hongrois spécialisé dans le sport et à plusieurs magazines allemands. En 1926 il fait la connaissance d'un autre exilé hongrois, le photographe André Kertész qu'il accompagne parfois dans ses reportages et dont il utilise certaines photographies pour illustrer ses propres articles. Il prend ainsi conscience «que seule la photographie pouvait parvenir à saisir cette intensité et cette puissance d'expression»[4] nécessaire pour traduire sa vision et la beauté des choses banales.

Ce n'est qu'en 1929 qu'il réalise ses premières images grâce à un appareil que lui prête une amie. Ce qui le convainc d'acquérir un Voigtländer Bergheil auquel il restera longtemps fidèle. Dès 1930, il commence à photographier ses «objets à grande échelle», découvrant ainsi la puissance de choc de la réalité vue sous un angle nouveau. Ces images, ainsi que celles d'autres objets plus insignifiants encore – tel le billet d'autobus roulé – attirent immédiatement l'attention des surréalistes et seront publiées plus tard dans le numéro 3 du *Minotaure* (1933), la revue d'art éditée par Skira et Tériade. C'est également pour cette revue qu'il illustrera un article de Salvador Dalí consacré au Modern Style avec les images des décorations réalisées par Hector Guimard pour orner les bouches du métro parisien. Ce n'est donc pas sans

their own concerns: the appropriation and transformation of the original meaning of objects, chance encounters as a source of wonder, the city and its signs and the sheer strangeness of certain compositions, or the use of visual association of ideas to reveal unexpected meanings within reality. The realms of night and sleep in which Brassaï was so at home were also an important part of their imaginative territory.

However, it would be very misleading to call Brassaï himself a surrealist. He was never a whole-hearted member of any school, nor did he ever adopt a single language to the exclusion of all others. As he himself explained: "My ambition has always been to show the everyday city as if we were discovering it for the first time. That was the difference between me and the Surrealists."5 One person who seems to have understood what Brassaï was driving at was Pierre Mac Orlan. For him, the photographer's night images were exemplary instances of contemporary realism, with some of them coming close to the kind of social fantasy which he was then pursuing in his own work.

It was in the spring of 1930 that Brassaï began using his camera to try and capture the scenes he saw as he walked about the city streets by night. Sometimes he was accompanied on these expeditions by his friends Léon-Paul Fargue and Raymond Queneau. But usually he wandered the streets alone, pausing repeatedly to put his Voigtländer down on its tripod, as he sought to capture certain effects – light, reflections, mist. He chain-smoked Gauloises or Boyards, and would gauge the length of his exposure by the time it took for his cigarette to burn down.

Brassaï developed and printed these night scenes himself, in the little laboratory he had improvised in his room. At that time, he was staying at the Hôtel des Terrasses, where Reichel, Tihanyi and Queneau also lodged.

zum Bewusstsein, „dass nur die Fotografie dazu geeignet war, diese Intensität und Ausdruckskraft zu erfassen"4, die notwendig waren, um seine Vision und die Schönheit der banalen Dinge zu vermitteln.

Erst 1929 machte er seine ersten eigenen Bilder – mit einem Fotoapparat, dem ihm eine Freundin geliehen hatte. Diese Erfahrung brachte ihn dazu, sich selbst eine Kamera zu kaufen, eine Voigtländer Bergheil, der er lange die Treue hielt. 1930 begann er, seine „Objekte im großen Maßstab" zu fotografieren, und entdeckte, welchen Schock die Wirklichkeit auslösen kann, wenn sie aus einem neuen Blickwinkel gesehen wird. Diese Bilder wie auch Aufnahmen von Gegenständen mit geringer Bedeutung – zum Beispiel ein aufgerollter Busfahrschein –, erregten die Aufmerksamkeit der Surrealisten und wurden später im Minotaure (1933) veröffentlicht, einer von Skira und Tériade herausgegebenen Kunstzeitschrift. Für dieselbe Zeitschrift illustrierte er einen Artikel von Dalí, der sich mit dem Jugendstil befasste, mit Fotos der Pariser Metroeingänge, die Hector Guimard gestaltet hatte. Es hatte also durchaus seinen Grund, dass die Surrealisten sich einen Teil dieser Bilder aneigneten. Sie fanden darin die Verdrehung der Bedeutung eines Gegenstandes wieder, die Begegnung mit dem wunderbaren Zufall, die Vorliebe für die Stadt und ihre Zeichen, die Eigenwilligkeit mancher Bildausschnitte oder auch die Verbindung visueller Vorstellungen, die die Wirklichkeit auf einen neuen Sinn hin öffnen. Auch die Nacht und der Schlaf sind bevorzugte Themen der Surrealisten, und hier bewegte sich Brassaï als echter Nachtschwärmer mit besonderer Leichtigkeit.

Es wäre aber völlig unzutreffend, Brassaï einen Surrealisten zu nennen, denn er hat sich niemals einer bestimmten Schule zugehörig gefühlt oder sich auf eine spezielle Sprache festlegen lassen: „Mein Ehrgeiz hat immer darin bestanden, einen Aspekt der Stadt, wie sie uns täglich begegnet, so sichtbar zu machen, als entdeckten wir sie gerade zum ersten

raison que les surréalistes s'approprient une partie de ces images. Ils y retrouvent ce détournement du sens de l'objet, la rencontre du hasard merveilleux, l'attirance pour la ville et ses signes, l'étrangeté de certains cadrages ou encore les associations d'idées visuelles ouvrant sur une autre signification de la réalité. La nuit et le sommeil sont également des territoires surréalistes privilégiés dans lesquels Brassaï s'ébat à l'aise en bon noctambule qu'il est.

Il serait cependant totalement inexact d'appliquer à Brassaï le terme de surréaliste car il a su ne jamais appartenir totalement à une école où à un quelconque langage particulier. Il s'en est expliqué : « Mon ambition fut toujours de faire voir un aspect de la ville quotidienne comme si nous la découvrions pour la première fois. Voilà ce qui me séparait des surréalistes. »5 C'est sans doute ce qu'a compris – entre autres – Pierre Mac Orlan pour qui ces images de nuit s'inscrivent parfaitement dans le courant réaliste, voire même dans celui du fantastique social dont il s'est fait le héraut. Dès le printemps 1930, Brassaï commence à photographier pour tenter de capter et de conserver quelques-uns des aspects qu'il découvre lors de ses déambulations nocturnes dans les rues de la capitale. Parfois accompagné de ses amis Léon-Paul Fargue ou Raymond Queneau, mais le plus souvent seul, il multiplie les prises de vue nocturnes, posant son Voigtländer sur son trépied pour saisir lumières, reflets ou brouillards ; fumant gauloises (ou boyards) sur gauloises, déterminant ainsi, en fonction du temps mis par sa cigarette pour se consumer, le temps de pose nécessaire.

Brassaï accumule ainsi les photos de nuit qu'il développe et tire lui-même dans le petit labo de fortune qu'il installe dans sa chambre de l'hôtel des Terrasses où logent également Reichel, Tihanyi, Queneau et où Henry Miller lui rend de fréquentes visites. C'est à cette époque que Gyula Halasz va abandonner son nom pour le pseudonyme de Brassaï du nom de Brasso, village de Transylvanie d'où il est originaire. « Un jour, (de 1932) un

Henry Miller, who had just arrived in Paris, would often visit him there. It was during this period that he stopped using the name Gyula Halasz in favour of the simpler pseudonym Brassaï, adapted from the name of his home village in Transylvania, Brasso. "One day (in 1932) a journalist friend of mine, Carlo Rim, told me that he knew a publisher who wanted to do a book of night views of Paris, but the man hadn't found a photographer who was up to the task. When he saw my pictures, this publisher – Charles Peignot of Arts et Métiers Graphiques – immediately made an appointment to meet me. That was how my first book was born: *Paris de nuit*."[6]

The volume appeared on 2 December 1932 with a preface by Paul Morand. Its publication was a major event. For the first time, Brassaï's astonishing nocturnal visions were revealed to the world, and the world was amazed. The newspaper *Le Temps* published an enthusiastic article by Emile Henriot, in which the critic described how these images "seem new to us, seem to invent a totally new style, and in doing so trigger that emotion which we feel when we see the most unexpected aspects of nature recreated by man".[7] Night was Brassaï's willing partner, as he juggled with light, volume and form, using its deep blacks to emphasise and define contours. The result was a series of cityscapes of timeless simplicity, which continue to exert a tremendous fascination over us today.

However, Brassaï was not simply an observer of empty streets and parks. "Thanks to my endless walks through Paris, I was able to go on and do a kind of social study of the creatures who peopled the city at night. I was familiar with all the low life, and even with the criminals of that time." [8] Yet it would be a long time before these images were published. They only appeared in book form in *Le Paris secret des années 30* in 1976. Not only is this book full of quite astonishing pictures, it is also a rich anthology of racy stories and anecdotes, related by a

Mal. Und das ist es, was mich von den Surrealisten trennt."[5] Genau das hat Pierre Mac Orlan, neben anderen, sehr wohl verstanden, denn für ihn fügen sich die Nachtbilder perfekt in den gewöhnlichen Realismus, ja sogar in das soziale Fantastische ein, zu dessen Herold er selbst sich gemacht hatte. Im Frühjahr 1930 begann Brassaï zu fotografieren, weil er einige Aspekte, die er während seiner nächtlichen Spaziergänge in den Straßen der Hauptstadt entdeckt hatte, einfangen und bewahren wollte. Manchmal war er in Begleitung seiner Freunde Léon-Paul Fargue oder Raymond Queneau unterwegs, meistens aber allein. Für die vielfachen Aufnahmen nächtlicher Ansichten stellte er seine Voigtländer auf ein Stativ, um Lichter, Reflexe oder Nebelschwaden besser einfangen zu können; dabei rauchte er eine Gauloise (oder Boyard) nach der anderen und bestimmte so nach der Zeit, die seine Zigarette brauchte, um herunterzubrennen, die notwendige Belichtungszeit.

So sammelten sich die Nachtaufnahmen, die Brassaï in einem kleinen, in seinem Hotelzimmer eingerichteten provisorischen Labor entwickelte, um dann selbst Abzüge herzustellen. Er logierte im Hôtel des Terrasses, in dem auch Reichel, Tihanyi und Queneau abgestiegen waren und wo Henry Miller, der gerade in Paris eingetroffen war, ihm häufig Besuche abstattete. Um diese Zeit trennte sich Gyula Halasz von seinem Geburtsnamen und legte sich nach seinem Geburtsort Brasso in Transsylvanien das einfachere Pseudonym Brassaï zu. „Eines Tages im Jahr 1932 sagte mir ein Redakteur, den ich gut kannte, namens Carlo Rim, dass er einen Verleger kenne, der gern ein Buch über Paris bei Nacht machen wolle, aber noch keinen Fotografen gefunden habe, der dazu in der Lage sei. Als dieser Verleger meine Fotografien sah – es war Charles Peignot von Arts et Métiers Graphiques –, lud er mich zu sich ein. Es wurde mein erstes Buch, *Paris de Nuit*."[6] Dieser Bildband, der am 2. Dezember 1932 mit einem Vorwort von Paul Morand herauskam, machte erheblich Furore, denn er bot einer

rédacteur que je connaissais bien, Carlo Rim, m'a dit qu'il connaissait un éditeur désireux de faire un livre sur Paris la nuit mais qu'il n'avait pas trouvé le photographe capable de faire cela. Quand il a vu mes photographies, cet éditeur – c'était Charles Peignot d'*Arts et Métiers Graphiques* – m'a donné rendez-vous. Ce fut mon premier livre *Paris de Nuit*."[6] Publié le 2 décembre 1932 avec une préface de Paul Morand, ce livre illuminé, s'avère un événement considérable qui offre pour la première fois au public ébahi, des visions nocturnes étonnantes. Ce qui lui vaudra dans le quotidien *Le Temps* un article élogieux d'Émile Henriot soulignant combien ces images …« nous donnent l'impression de la nouveauté, d'un total renouvellement par le style et par là provoquent l'émotion qui naît des spectacles inattendus de la nature recréée par l'homme … ».[7] La nuit s'avère une complice soumise au photographe qui jongle avec les lumières, avec les masses et les formes, avec les graphismes les plus aboutis que soulignent souvent des noirs profonds. C'est de la simplicité même de ces images quasi-intemporelles que surgit la fascination qu'elles exercent encore sur nous.

Brassaï n'en restera cependant pas à la contemplation du paysage parisien. «Mes promenades continuelles dans Paris m'ont ensuite permis de réaliser une espèce d'étude de mœurs de la faune parisienne nocturne. J'ai fréquenté le milieu et même les voyous de l'époque. Les filles, les souteneurs les bordels … »[8] Ces images resteront longtemps inédites avant d'être publiées dans *Le Paris secret des années 30* en 1976. Un ouvrage qui fourmille d'images plus surprenantes les unes que les autres et surtout d'histoires et d'anecdotes savoureuses. Du monde des travailleurs (polisseurs de rails, vidangeurs, forts des Halles) au milieu interlope interdit aux non-initiés, cette véritable chronique de mœurs, est un voyage initiatique au bout de la nuit, qui conserve encore aujourd'hui un parfum d'aventure savoureux.

Ces pérégrinations permanentes dans les milieux les plus divers

talented story teller. Brassaï knew the workers – the rail polishers, the night soil collectors, the barrow boys – but he also had his entrées into the underworld which few people frequented. The result is both a portrait of a part of society, and an initiatory journey through the night which can still set our pulses racing today.

His constant wandering brought Brassaï into contact with the most diverse milieus, including the Parisian artistic and intellectual elite. In this way, he came to know the Prévert brothers, Léger and Le Corbusier. But the most important of these encounters was certainly with Picasso, whom he met in 1932. Picasso was so impressed by his night views, he asked Brassaï to photograph a group of sculptures which he had not yet shown, which he was working on at his château at Boisgeloup and in his studio in the rue de La Boétie. These pictures were published in the *Minotaure*.

Out of this encounter grew an enduring friendship between the two men, as the stories collected in Brassaï's *Conversations avec Picasso* (1964) bear witness. Through his work for the *Minotaure* review, Brassaï also came to meet the Surrealist writers and poets, including Breton, Eluard and Desnos, as well as making a series of photographs of artists' studios (Laurens, Maillol and Giacometti, among others). After 1937 he went on to photograph artists at work for *Harper's Bazaar,* with whom he continued to work right up until the 1960s. Taken together, these portraits form an invaluable document of the art world of the period. Brassaï later assembled them in book form in *The Artists of My Life* (1982).

As he walked around Paris, he also began taking photographs of graffiti that caught his eye. He started collecting these images in 1932, and later assembled them in a volume published in 1960. Some of the earliest images appeared in *Minotaure* accompanying an article written by Brassaï himself which he entitled: "From cave

erstaunten Öffentlichkeit zum ersten Mal Ansichten von einem nächtlichen Paris, wie man es noch nie gesehen hatte. Das brachte ihm in der Zeitung *Le Temps* einen lobenden Artikel von Emile Henriot ein, der darauf hinwies, wie sehr uns diese Bilder „den Eindruck von Neuheit vermitteln, von einer totalen Erneuerung durch den Stil, wodurch das Gefühl hervorgerufen wird, das aus dem unerwarteten, vom Menschen zu neuem Leben erweckten Anblick der Natur entspringt …"[7] Die Nacht erweist sich als Komplizin des Fotografen, der mit den Lichtern jongliert, mit den Volumen und den Formen, mit einer klaren Grafik, die häufig dem schwärzesten Dunkel Kontur verleiht. Aus der äußersten Einfachheit dieser gleichsam zeitlosen Bilder erwächst die Faszination, die sie noch heute auf uns ausüben.

Brassaï begnügte sich jedoch nicht mit der Betrachtung der Pariser Stadtlandschaft. „Meine unablässigen Wanderungen durch Paris haben mich dann auch dazu gebracht, den Lebenswandel der Geschöpfe der Nacht in Paris genauer unter die Lupe zu nehmen. Ich bin im Milieu ein und aus gegangen, sogar bei den Gaunern und Ganoven …"[8] Diese Bilder blieben lange Zeit unveröffentlicht, bis sie 1976 in *Le Paris secret des années 30* herauskamen. Ein Band mit einer Fülle erstaunlicher Bilder und dazu genüsslich erzählte Anekdoten, in denen sich das große Talent des Schriftstellers Brassaï erweist. Von der Welt der Arbeiter (Schienenputzer, Latrinenreiniger, Lastenträger aus Les Halles) bis zur Unterwelt, die den Nicht-Eingeweihten verschlossen bleibt, reicht diese Sittenchronik. Noch heute haftet dieser Reise ans Ende der Nacht der Ruch des Abenteuerlichen an.

Das ständige Umherwandern in den unterschiedlichsten Milieus gab Brassaï die Möglichkeit, das ganze künstlerische und literarische Paris zu treffen. So lernte er die Brüder Prévert, Léger, Le Corbusier und vor allem im Jahr 1932 Picasso kennen, der von Brassaïs Nachtaufnahmen so beeindruckt war, dass er ihn bat, seine eigenen, damals noch unbekannten Skulpturen zu

Brassaï, texts by Henry Miller and Brassaï, Paris, Éditions Neuf, 1952

Graffiti, text by Brassaï, Stuttgart, Belser Verlag, 1960

vont permettre à Brassaï de rencontrer le Tout-Paris artistique et littéraire. Il fait la connaissance des frères Prévert, de Léger, de Le Corbusier et surtout en 1932 de Picasso qui, impressionné par ses photos de nuit, va lui demander de photographier ses sculptures, alors inconnues, dans son château de Boisgeloup et dans son atelier de la rue de La Boétie. Photographies qui seront publiées dans le *Minotaure*. Une amitié va naître, qui liera longtemps les deux hommes comme on peut en juger dans le recueil de souvenirs *Conversations avec Picasso* (1964). La collaboration de Brassaï avec la revue le *Minotaure* déjà évoquée lui permet de rencontrer les écrivains et poètes surréalistes (Breton, Eluard, Desnos) de réaliser une série de photographies d'ateliers d'artistes (Laurens, Maillol, Giacometti). Série qu'il poursuivra à

wall to factory wall." Brassaï spent almost twenty years collecting these images, carefully noting where each one had been taken, so that he could track the way in which they changed over time. The subject was a new one, and though it might appear entirely abstract, it was also a very human theme. Graffiti was a primitive art form which projected its own truth onto the screen provided by the walls of the city. Brassaï became its advocate. The whole of modern art drew inspiration from this archaic language and from Brassaï's attempts to decipher it – Miró, Klee, Dubuffet and Tàpies, to name but a few. And it was Picasso who wrote: "It was a brilliant idea to collect these images ... These walls are as rich as the facade of any cathedral! Your book connects our art with the art of primitive peoples ...".9 But collecting these images was not enough to satisfy Brassaï.

Inspired by the graffiti he had seen, in 1934/35 he began engraving on exposed photographic plates. The result was a series of works to which he later gave the title "Transmutations". "I went at these plates mechanically, like a sculptor. It was strange to see how the nudes would change under the influence of this tool which wore away at their substance. A weird obsession took hold of me: I wanted to change these forms into those of a musical instrument: first woman, then guitar, then mandolin-woman. I was subject to a series of almost unconscious reactions, which smashed the photograph to smithereens ..."10

During the Second World War, the Germans courted Brassaï, but he refused to apply for a permit, and so was obliged to stop working as a photographer. Instead, he returned to drawing, frequenting the Académie de la Grande Chaumière. He also took up writing again. In 1943, Picasso asked him to photograph the sculptures in his studio in the rue des Grands-Augustins. This work kept him busy until 1946. It also gave him the opportunity to note down his conversations with Picasso and his friends – artists, writers and other prominent figures. Imme-

fotografieren. Diese Aufnahmen, entstanden in Picassos Schloss Boisgeloup und in seinem Atelier in der Rue de La Boétie, wurden im *Minotaure* veröffentlicht. Von da an entwickelte sich eine Freundschaft, die die beiden Männer lange Jahre verband, wie man aus dem Erinnerungsband *Conversations avec Picasso* (1964) ersehen kann. Die Zusammenarbeit mit dem *Minotaure* ermöglichte es Brassaï, surrealistische Schriftsteller (Breton, Eluard, Desnos) kennen zu lernen und Künstler (Laurens, Maillol, Giacometti) in ihren Ateliers zu fotografieren. Diese Serie führte er ab 1937 fort, nun aber für *Harper's Bazaar*, einer Zeitschrift, für die er bis in die sechziger Jahre arbeitete. Die Porträts aus dieser Zeit sind eine Bestandsaufnahme der Gegenwartskunst jener Zeit, und sie bildeten den Ausgangspunkt für ein weiteres bedeutendes Werk, *The Artists of My Life* (1982).

Und schließlich jagte Brassaï bei seinen Wanderungen durch Paris ab 1932 auch den Kritzeleien auf den Wänden nach; sämtliche Fotos mit den Graffiti von Pariser Hauswänden und Mauern veröffentlichte er 1960. Der *Minotaure* publizierte einige seiner ersten Bilder als Illustration zu einem von ihm selbst geschriebenen Artikel mit dem Titel „Du mur des cavernes au mur d'usine" (Von der Höhlenwand zur Fabrikmauer). Fast zwanzig Jahre lang fotografierte Brassaï diese Graffiti und notierte ihren Standort sorgsam in ein Heft, um weiterverfolgen zu können, wie sie sich veränderten. Ein neues Thema also, das etwas Abstraktes zu haben schien, in Wahrheit aber zutiefst menschlich war. Art brut, die naive Kunst, die Wandzeichnung – Projektionsfläche der Wahrheit für den Mann von der Straße – haben in ihm einen Verfechter gefunden. Diese Entzifferung einer Sprache, die bis in die Urzeiten der Menschheitsgeschichte zurückgeht, hat unbestreitbar die gesamte moderne Kunst beeinflusst. Miró, Klee, Dubuffet, Tàpies und viele andere gehören dazu, auch Picasso begeisterte sich dafür: „Welch glückliche Idee von Ihnen, diese Sammlung zusammenzustel-

partir de 1937, pour le compte du *Harper's Bazaar* avec qui il collaborera jusque dans les années 60. L'ensemble de ces portraits constitue un témoignage essentiel sur l'art contemporain de l'époque et donnera naissance à un autre ouvrage précieux, *Les Artistes de ma vie*, publié en 1982.

C'est enfin à l'occasion de ses pérégrinations parisiennes que Brassaï, dès 1932, commence à traquer sur les murs de Paris les graffiti dont il publiera la somme en 1960. Le *Minotaure* publiera quelques-unes de ses premières images en illustration d'un article écrit par Brassaï lui-même et intitulé : « Du mur des cavernes au mur d'usine. » Pendant près de vingt années, Brassaï va ainsi photographier ces graffiti notant soigneusement sur un carnet leur localisation pour en suivre et noter les modifications successives. Un sujet nouveau, abstrait en apparence, mais ô combien humain. Art naïf, art brut, l'art du mur – l'écran de vérité pour l'homme de la rue – a trouvé en lui un véritable héraut. Ce décryptage d'un langage qui remonte à la nuit des temps inspire incontestablement tout l'art moderne. Miró, Klee, Dubuffet, Tàpies, s'y retrouvent, Picasso s'enthousiasme « Vous avez eu une idée heureuse de constituer cette collection ... [Le Mur] c'est aussi riche que la façade d'une cathédrale ! Votre livre relie l'art avec les arts primitifs ... ».9 Mais la boulimie créatrice de Brassaï, ne s'arrête pas là. Sans doute inspiré par ces graphismes muraux, il va lui-même, dans les années 1934/35, graver des plaques impressionnées qu'il va rassembler sous le titre « Transmutations ». « Comme un sculpteur j'ai attaqué ces plaques presque mécaniquement. Étrangement, ces nus se modifiaient sous une pointe qui en détruisait la matière. Il est apparu là une étrange obsession de transformer la forme en instrument de musique : femme, guitare, femme-mandoline. Il s'agissait là de réactions presque inconscientes qui ont fait voler en éclat la photographie. »10

Pendant la Seconde Guerre mondiale, Brassaï, sollicité par les Allemands, refuse de demander une autorisation de photographier et, de ce

diately after the Liberation, Brassaï held an exhibition of his drawings in Paris. At the same time, he started designing sets based on his photographs for ballets and plays.

In 1948, he married Gilberte-Mercédès Boyer, and the couple moved to the South of France, living there for part of every year. On his regular walking trips in the Pyrenees, he discovered the perfect material for his sculptures in the pebbles he gathered from the mountain streams. His new environment gave him all the time he wanted to meditate and to write. Yet it did not put an end to his photographic work, though his reportages of these years are not well known. Between 1949 and 1960, he travelled extensively for *Harper's Bazaar*. He visited Greece, Turkey, Sweden and Morocco. In Italy, he photographed the Bomarzo park before it was restored. In Spain, he produced a book on Holy Week in Seville, while in the United States he visited Louisiana and documented the skyscrapers of New York.

By this time, Brassaï's reputation as a photographer was at its peak across most of the planet. Many exhibitions were held devoted to his work, and a retrospective organised at the Museum of Modern Art in New York in 1968 went on to tour until 1974. In France, however, Brassaï was best known for his drawings, sculptures, engravings and tapestries. It was his triumphant show at the Arles International Photography Festival in 1974, alongside his friend Ansel Adams, which triggered the rediscovery of his photographic work by a younger generation. In 1978 he was awarded the Grand Prix National de la Photographie, but it was not until 1988 that a major Brassaï exhibition was held in Paris, at the Musée Carnavalet. This was followed in 1993 by the exhibition "From Surrealism to lyrical abstraction" which was hosted at the National Photographic Centre in Paris after originally showing at the Tàpies Foundation in Barcelona.

len …[Die Wand] ist genauso prächtig wie die Fassade einer Kathedrale! Ihr Buch stellt eine Verbindung zwischen der Kunst und den primitiven Künsten her …"⁹ Aber der kreative Heißhunger Brassaïs war damit noch nicht gestillt. Inspiriert durch diese Wandkritzeleien ging er selbst in den Jahren 1934/35 daran, in die belichteten fotografischen Platten hineinzuritzen, und die Ergebnisse versammelte er unter dem Titel „Transmutations" (Verwandlungen). Dazu erklärte er: „Wie ein Bildhauer habe ich diese Platten fast mechanisch attackiert. Seltsamerweise verwandelten sich diese Aktaufnahmen unter einer Nadelspitze, die das Material zerstörte. Dabei trat eine seltsame Obsession zutage, die Körperform in ein Musikinstrument zu verwandeln: Frau, Gitarre, Mandolinenfrau. Es handelte sich dabei um fast unbewusste Reaktionen, die die Fotografie in Stücke sprengten."¹⁰

Während des Zweiten Weltkriegs wurde Brassaï von den Deutschen ausdrücklich aufgefordert, eine Erlaubnis zum Fotografieren einzuholen, und da er dies verweigerte, musste er seine Tätigkeit bis auf weiteres unterbrechen. Er wandte sich wieder dem Zeichnen zu und ging dafür an die Académie de la Grande Chaumière; außerdem schrieb er wieder mehr. 1943 fotografierte er auf Picassos Bitte die Skulpturen des Künstlers in dessen Atelier in der Rue des Grands-Augustins. Diese Arbeit beschäftigte ihn bis 1946 und gab ihm die Möglichkeit, alle Gespräche des Malers mit Freunden, Künstlern, Schriftstellern und anderen Persönlichkeiten, die im Atelier ein und aus gingen, in seinem Notizbuch festzuhalten. Nach der Befreiung stellte Brassaï seine Zeichnungen in Paris aus und schuf mehrere fotografische Bühnenbilder für Ballett- oder Theateraufführungen. Im Jahr 1948 heiratete er Gilberte-Mercédès Boyer. Bei Wanderungen in den Pyrenäen entdeckte er ein ideales Material, um daraus Skulpturen zu fertigen, die Bachkiesel aus den Gaves. Von nun an verbrachte er einen Teil des Jahres in Südfrankreich, wo er nachdenken und schreiben konnte. Seine foto-

fait, doit interrompre son activité. Il se remet au dessin à l'Académie de la Grande Chaumière et à l'écriture. En 1943, à la demande de Picasso, il photographie les sculptures de l'artiste dans l'atelier de la rue des Grands-Augustins. Un travail qui l'occupera jusqu'en 1946 mais qui lui permet, par ailleurs, de noter tous les propos du peintre avec ses amis, artistes, écrivains et autres personnalités qui fragmentent l'atelier. Dès la Libération, Brassaï expose ses dessins à Paris et réalise quelques décors photographiques pour des spectacles de ballet ou de théâtre. En 1948, il épouse Gilberte-Mercédès Boyer et, à l'occasion de randonnées dans les Pyrénées, il découvre avec les galets des gaves un matériel idéal pour réaliser ses sculptures. Il vit désormais en partie dans le Midi de la France où il peut à loisir méditer et écrire. Il n'en interrompt pas pour autant son activité photographique puisque de 1949 à 1960, il va beaucoup voyager pour le *Harper's Bazaar* et réaliser des reportages, moins connus, en Grèce, Turquie, Suède, Maroc, Italie où il photographie le parc de Bomarzo encore à l'état sauvage. En Espagne, il compose un album sur la Semaine Sainte de Séville, alors qu'aux États-Unis il photographie la Louisiane ainsi que les gratte-ciel de New-York.

Mais bizarrement, alors qu'il est fêté et admiré partout dans le monde où ses expositions de photographies se multiplient comme sa rétrospective présentée au Musée d'Art Moderne de New York en 1968 qui fera ensuite le tour du monde jusqu'en 1974, ce sont surtout ses dessins, ses sculptures, ses gravures, ses tapisseries qui sont alors exposés en France. Invité d'honneur en compagnie de son ami Ansel Adams aux Rencontres Internationales de la Photographie à Arles, cette même année, il remporte un véritable triomphe de la part d'un jeune public. Si le Grand Prix National de la Photographie lui est décerné en 1978, ce n'est que dix années plus tard qu'une importante exposition Brassaï sera présentée au Musée Carnavalet à Paris. Suivie en 1993 de l'exposition « Du surréalisme à l'art informel », orga-

In April 2000, a complete retrospective was finally organised at the Centre Pompidou in Paris, bringing together almost every aspect of this eclectic and unique body of work which showed Brassaï as both a privileged witness of the art of his time, and a major creative force in his own right. Sadly, he died on 7 July 1984 at Beaulieu-sur-Mer without living to enjoy this final consecration of his talents. He was buried, in accordance with his wishes, in the Montparnasse Cemetery, at the heart of the quartier which had been his great photographic hunting ground. He had turned his hand to many trades over the years, but his gift for recording the life around him, in writing or in images, wherever he found it – on the walls of the city, in people's faces, in the paving stones themselves – was universal. His vision penetrated to the simplest yet deepest truths about people and things. He was also remarkably clear-sighted in his appreciation of his own career, as he demonstrated in the preface to *Camera in Paris* (1949).

There, Brassaï discussed the great painters of the past who had also served as chroniclers of their times: Rembrandt, Toulouse-Lautrec, Goya, Daumier and above all Constantin Guys, "the painter of modern life". It was the portrait of Guys by Baudelaire in which he recognised himself most clearly. For Baudelaire, Guys did not like people referring to him as an artist, for "he was interested in everything in the world", and wanted "to know, understand and appreciate everything which happened on the surface of this sphere which we inhabit". Above all, Guys refused to be defined as a specialist. Likewise Brassaï, who would photograph anything which intrigued or moved him, and who knew equally well how to listen to others and record their words for posterity in his little notebooks.

And, indeed, Brassaï always defended his freedom fiercely. He would refuse commissions which did not

grafischen Aktivitäten gab er jedoch keinesfalls auf, denn zwischen 1949 und 1960 machte er für *Harper's Bazaar* viele weniger bekannte Reisereportagen aus Griechenland, der Türkei, Schweden oder Marokko und fotografierte in Italien den damals noch wilden Park von Bomarzo. Ein Bildband über die Semana Santa in Sevilla war das Ergebnis einer Spanien-Reise; in den USA fotografierte er Louisiana und die Wolkenkratzer von New York.

Eines ist jedoch seltsam: Während er überall in der Welt bewundert und gefeiert wurde, während seine Fotoausstellungen immer zahlreicher wurden, darunter die Retrospektive von 1968 im Museum of Modern Art in New York, die anschließend bis 1974 um die Welt reiste, wurden in Frankreich vor allem Brassaïs Zeichnungen, Skulpturen, Radierungen und Tapisserien ausgestellt. Als er im selben Jahr als Ehrengast mit seinem Freund Ansel Adams zu den Rencontres Internationales de la Photographie in Arles eingeladen wurde, feierte er wahre Triumphe bei einem jungen Publikum. Während ihm der Grand Prix National de la Photographie bereits 1978 zuerkannt wurde, mussten noch zehn Jahre verstreichen, bis eine umfangreiche Brassaï-Ausstellung im Musée Carnavalet in Paris gezeigt wurde. Erst 1993 folgte die Ausstellung „Du surréalisme à l'art informel", die zunächst von der Fondation Tàpies in Barcelona ausgerichtet und dann im Centre National de la Photographie in Paris gezeigt wurde. Im April 2000 fand endlich eine große Retrospektive im Pariser Centre Pompidou statt, die das so vielgestaltige, einzigartige und eklektische Werk des Künstlers fast vollständig vor Augen führte; das Werk eines Künstlers, der als Akteur wie als Zeuge im Kunstschaffen seiner Zeit einer herausragende Stellung hatte.

Brassaï starb am 7. Juli 1984 in Beaulieu-sur-Mer und wurde seinem Wunsch entsprechend auf dem Friedhof Montparnasse bestattet, im Herzen des Stadtviertels, das er so unermüdlich durchwandert hatte. Er hat leider nicht mehr erleben können, welch großartige Anerkennung ihm

nisée au préalable par la Fondation Tàpies de Barcelone et présentée au Centre National de la Photographie à Paris. En avril 2000, une grande rétrospective est enfin organisée au Centre Pompidou à Paris qui restitue dans sa presque globalité l'œuvre plurielle, singulière et éclectique d'un artiste acteur et témoin privilégié de la création artistique de son temps.

Décédé le 7 juillet 1984 à Beaulieu-sur-Mer et enterré, selon son vœu, au cimetière du Montparnasse, au cœur d'un quartier qu'il n'a cessé de sillonner, Brassaï n'aura malheureusement pas assisté à ces grandes manifestations de reconnaissance qui mettent à l'honneur le talent universel d'un chroniqueur touche-à-tout. Analysant avec perspicacité son parcours, Brassaï s'est longtemps interrogé sur lui-même. Sa préface de *Camera in Paris* (1949) apparaît sur ce point comme un texte fondamental. Il s'y réfère aux grands chroniqueurs du passé : Rembrandt, Toulouse-Lautrec, Goya, Daumier et surtout Constantin Guys « le peintre de la vie moderne » dont le portrait, dressé par Baudelaire, lui paraît refléter au mieux sa propre personnalité. Il y découvre un homme qui n'aime pas être appelé artiste, qui « s'intéresse au monde entier », qui « veut savoir, comprendre, apprécier tout ce qui se passe à la surface de notre sphéroïde ». Il y découvre surtout un homme qui refuse d'être catalogué comme spécialiste. Ce qui correspond parfaitement à l'état d'esprit de Brassaï qui photographie tout ce qui l'intrigue, ou l'émeut, qui sait écouter et capter les paroles lancées au vent pour en emplir ses petits carnets.

Brassaï a effectivement toujours défendu avec acharnement sa liberté, se gardant bien d'adhérer à tel clan ou à telle école. Cette exigence d'indépendance n'a d'égale que son exigence de la forme. « Je suis un reporter qui n'aime pas les photos négligées ... Il y a deux dons qui font l'homme d'image, le créateur : une certaine sensibilité pour la vie, pour la chose vivante et, d'autre part, un art de saisir celle-ci d'une certaine façon. Il ne s'agit pas d'esthétisme pur ... une photo confuse ne peut pas pénétrer dans

interest him; he never belonged to a school or a group. His insistence on independence was matched by his passion for form: "As a reporter, I hate slipshod photographs … There are two gifts which every man of images needs to be a true creator: a certain sensitivity to life, to living things, and at the same time, the art which will enable him to capture that life in a certain specific way. I'm not talking about a pure aesthetics: a confused photo just isn't capable of penetrating the viewer's memory. I've always felt that the formal structure of a photo, its composition, was just as important as the subject itself … You have to eliminate every superfluous element, you have to guide your own gaze with an iron will. You have to take the viewer's gaze, and lead it to what is interesting."[11]

These few sentences encapsulate the simplicity of Brassaï's art, and its strength. Brassaï was not a visual thief, stealing bits of reality that happened to come his way, but an artist with a consciously structured vision of the world to communicate. He knew how to project his sense of form with an energy which keeps it alive today – just as alive as it ever was, and just as relevant. Doubtless, he was able to do this because he knew how to forget himself as he focused on what he saw through his viewfinder. "If you take your inspiration from nature, you don't invent anything, because what you want to do is to interpret something. But still, everything passes through your imagination. What you produce at the end is very different from the reality you started with. The author and the subject change places. It was Proust who spoke about this most eloquently: every great artist creates a new universe." [12]

There is nothing accidental about this reference to Proust. Brassaï was profoundly influenced by Proust, and even wrote a book about him, published posthumously in 1997 under the title *Marcel Proust sous l'emprise de*

durch die Ausstellungen zuteil wurde. Sie ehrten das Universaltalent eines Chronisten, der mittels seiner Feder oder seines Objektives auf den Häuserwänden und Mauern, in den Gesichtern und im Straßenpflaster die einfache und tiefe Wahrheit der Dinge und der Menschen gefunden hatte. Sein Vorwort zu *Camera in Paris* (1949) erweist sich in dieser Hinsicht als grundlegend. Brassaï bezieht sich darin auf die großen Chronisten der Vergangenheit: Rembrandt, Toulouse-Lautrec, Goya, Daumier und vor allem Constantin Guys. In dem Porträt, das Baudelaire über diesen „Maler des modernen Lebens" entworfen hatte, scheint ihm die eigene Persönlichkeit am besten wiedergegeben. Er erkennt darin einen Mann, dem es nicht gefällt, Künstler genannt zu werden, der „sich für die ganze Welt interessiert", der „alles wissen, verstehen, einschätzen will, was sich auf der Oberfläche unseres Globus abspielt". Er entdeckt in Guys vor allem einen Mann, der es ablehnt, als Spezialist eingeordnet zu werden. Und das entspricht genau der Geisteshaltung Brassaïs, der alles fotografiert, was ihn in den Bann zieht, der zuhören kann und die Worte aufschnappt, die in den Wind gesprochen sind, um seine Notizhefte damit zu füllen.

Brassaï hat seine Freiheit immer vehement verteidigt und Auftragsarbeiten, die ihm nicht gefielen, abgelehnt, und er hat sich auch davor gehütet, irgendeinem Clan oder einer Schule anzuhängen. Wenn es um seine Unabhängigkeit ging, hatte er eine ähnlich hohe Ansprüche wie hinsichtlich der Form. „Ich bin ein Reporter, der nachlässig gemachte Fotos nicht mag … Es gibt zwei Fähigkeiten, die den Mann des Bildes, den Bildermacher auszeichnen: eine gewisse Sensibilität gegenüber dem Leben, gegenüber den belebten Dingen, und andererseits die Begabung, diese Dinge auf eine bestimmte Weise zu erfassen. Das ist keine Frage der reinen Ästhetik … Ein wirres Foto kann sich nicht im Gedächtnis festsetzen. Ich habe immer die formale Struktur eines Fotos, seine Komposition, für ebenso wichtig gehalten wie das

Picasso and Company, London, Thames and Hudson, 1967

Henry Miller, grandeur nature, text by Brassaï, Paris, Gallimard, 1975

la mémoire. J'ai toujours tenu la structure formelle d'une photo, sa composition, pour aussi importante que le sujet lui-même … Il faut éliminer tout ce qui est superflu, il faut diriger l'œil en dictateur. Et il faut prendre celui du spectateur et le conduire à ce qu'il est intéressant de voir. »[11] Tout est dit en quelques phrases de la simplicité des images de Brassaï et par là même, sans doute, de leur force. Brassaï n'est pas un «pickpocket du réel» mais un artiste qui a construit et mis en scène sa propre vision du monde. À son sens de l'harmonie des formes, il a su adjoindre une vitalité qui permet à son œuvre de vivre toujours aussi intensément et d'être toujours aussi actuelle. Sans doute parce qu'il a su s'effacer derrière ce qu'il voyait dans son viseur : «Quelqu'un qui s'inspire de la nature n'invente rien puisqu'il

la photographie. For Brassaï, Proust was a mental photographer. His mind acted like a photosensitive plate, capturing and storing thousands of perceptions which he then proceeded to develop over the years, "thus making the latent image of his whole life visible, in one single gigantic photograph called *À la recherche du temps perdu*".[13]

Over the years, Brassaï was able to translate his sensibility into a number of different media. But all his work was driven by the same basic goal: he wanted to create a sort of encyclopaedia of human life. And he never played tricks with the truth. Some of his images may have been staged, just as some of Robert Doisneau's were; but if they are, this only served to make them more true, more authentic. For Henry Miller, Brassaï was "a cosmogonic eye which sees only that which exists ... The wealth of life itself seems to satisfy him ... For him, seeing is an end in itself. For Brassaï is an eye – a living eye."[14]

This living eye had the imagination to see things in reality which the rest of us cannot see. He was as demanding in the laboratory as he was on the streets of Paris, constantly reframing his images and altering the play of light and dark to endow them with an expressive power that went far beyond any simple transcription of what was there. Brassaï took photographs as if he was a poet, using them to express his universal vision.

The result was one of the greatest bodies of work yet created in the art form. When he died, his wife devoted herself to sorting and cataloguing his work. To prevent this corpus from being broken up and sold off, on 2 December 2000 she made a major donation to the Centre Pompidou. Thanks to her tireless work and generosity, the museum is now the owner of more than 35,000 negatives, together with the contact sheets printed from them.

Motiv selbst. ... Alles Überflüssige muss entfernt werden, man muss das Auge wie ein Diktator lenken. Und man muss das Auge des Betrachters zu dem führen, was interessant zu sehen ist."[11] Mit diesen wenigen Sätzen ist alles gesagt über die Einfachheit der Bilder Brassaïs und gewiss ebenso über ihre Kraft. Brassaï ist kein „Dieb der Realität", sondern ein Künstler, der seine eigene Sicht der Welt konstruiert hat. Seinen Sinn für die Harmonie der Formen hat er mit einer Vitalität zu verbinden gewusst, durch die sein Werk immer lebendig und aktuell bleiben, niemals an Intensität verlieren wird. Und das liegt wohl daran, dass er sich hinter dem, was er durchs Objektiv sah, zum Verschwinden gebracht hat. „Wer sich von der Natur anregen lässt, erfindet nichts, denn er will etwas interpretieren. Aber alles läuft durch seine Imagination hindurch, und das, was er am Ende schafft, unterscheidet sich sehr von der Realität. Es findet eine Übertragung zwischen Autor und Motiv statt. Vor allem Proust hat sich mit diesem Thema befasst, er hat dargelegt, dass jeder große Künstler ein Universum erschafft."[12]

Nicht von ungefähr verweist Brassaï auf Proust. Der Romancier hat den Fotografen tief geprägt, wie der 1997 posthum veröffentlichte Band *Marcel Proust sous l'emprise de la photographie* belegt. Brassaï spricht von dem Schriftsteller als einem Fotografen im Geiste, der Tausende von Eindrücken aufnehmen und speichern konnte – wie eine empfindliche fotografische Platte –, die er im Laufe seines Lebens nach und nach entwickelte, „und so machte er das latente Bild seines ganzen Lebens in dieser gigantischen Fotografie sichtbar, als die man *À la recherche du temps perdu* bezeichnen kann".[13] Brassaï macht sich im Laufe der Zeit dadurch sichtbar, dass er mithilfe verschiedener Medien, die aber alle in dieselbe Richtung weisen, diese Dinge auf seine Weise übersetzt: indem er eine Art Enzyklopädie des Menschen erstellt. Denn Brassaï betreibt kein Falschspiel mit der Wahrheit. Selbst wenn manche seiner Bilder – Gleiches gilt für Robert Doisneau –

veut interpréter quelque chose. Mais tout passe par son imagination et ce qu'il a réalisé a, finalement, une grande différence avec la réalité. Il y a transposition entre l'auteur et le sujet. C'est surtout Proust qui a développé ce thème que chaque grand artiste apporte un univers».[12]

Lui consacrant un ouvrage, publié à titre posthume en 1997, *Marcel Proust sous l'emprise de la photographie*. Brassaï en parle comme d'un photographe mental, qui sut capter et emmagasiner – comme une plaque sensible – des milliers d'impressions qu'il développe tout au long de son existence «rendant ainsi visible l'image latente de toute sa vie, dans cette photographie gigantesque que constitue *À la recherche du temps perdu*».[13] Brassaï lui-même s'affirme, au fil du temps, doué d'une hyper sensibilité et d'une hyper réceptivité aux choses du monde qu'il a traduit à l'aide de divers médiums mais qui vont tous dans le même sens : celui de réaliser une sorte d'encyclopédie de l'homme. Car Brassaï ne triche pas avec la vérité. Quand bien même, certaines de ses images peuvent être mises en scène – comme l'a fait également Robert Doisneau – elles n'en deviennent pas plus véridiques, plus authentiques. Cet « œil cosmologique », écrira Henry Miller, « ne voyant que ce qui est ... paraît comblé par la richesse de la vie ... Voir pour lui, devient une fin en soi. Car Brassaï est un œil, un œil vivant ».[14]

Un œil vivant et imaginatif capable de débusquer dans la réalité ce qui n'apparaît pas toujours à un simple regard. Poussant même cette exigence jusqu'à poursuivre sa réflexion dans le silence de son laboratoire où il n'hésite pas à recadrer son image ou modifier certaines lumières pour atteindre à une expressivité maximum bien éloignée de la simple transcription. Brassaï agit ainsi en poète porteur d'une vision ayant valeur universelle. Son œuvre est immense. Grâce à l'action déterminante de son épouse qui a entrepris au décès de son mari un énorme travail de classement et d'inventaire, et à la généreuse donation qu'elle a faite au Centre Pompidou le 2

Brassaï was fascinated by the invisible and the unconscious. But he was also captivated by random scenes which he happened on in the course of his walks and encounters. He always preferred reality to dreams. Whether by night or in daylight, "his insatiable eye" never stopped capturing the images offered him by streets, sidewalks, faces, everyday events. "Basically, my work has been one long reportage on human life." Brassaï was at once a sociologist, and the creator of a visionary body of work which took on a multiplicity of forms. The curiosity of his poet's eye was never sated. Today, he is recognised as the most complete witness of his time, as well as one of that age's most accomplished artists. He is a seer, a voyeur, and yet he is also our brother in humanity. Through this double mission, he challenges us to open our eyes and discover the world as it really is.

inszeniert sein mögen, werden sie doch nur umso wahrhaftiger. Henry Miller sprach von einem „kosmologischen Auge, das nur sieht, was wirklich ist …" Brassaï erscheint ihm „erfüllt vom Reichtum des Lebens … Sehen wird für ihn zum Selbstzweck. Denn Brassaï ist ein Auge, ein lebendiges Auge."[14]

Ein lebendiges und imaginatives Auge, das fähig ist, in der Realität das aufzustöbern, was beim einfachen Hinsehen nicht immer offenbar wird. In diesem Anspruch geht Brassaï sogar so weit, dass er ihn in der Stille seines Labors weiterverfolgt; er scheut sich nicht, Ausschnitte seiner Bilder herzustellen oder manche Lichter zu verändern, um jenen höchsten Ausdruck zu erreichen, der über eine bloße Wiedergabe weit hinausreicht. Brassaï agiert hier eher wie ein Dichter, der Träger einer künstlerischen Vision, die eine universelle Bedeutung in sich birgt. Brassaïs Werk ist riesig. Dank seiner Witwe, die eine gewaltige Arbeit des Ordnens, Klassifizierens und Inventarisierens geleistet und am 2. Dezember 2002 eine großzügige Schenkung an das Centre Pompidou gemacht hat, sind mehr als 35 000 Negative mitsamt den Kontaktabzügen in den Bestand des Museums eingegangen, wodurch sie vor einer möglichen Zerstreuung in alle Welt bewahrt wurden. Brassaï war fasziniert vom Unsichtbaren und Unbewussten, bei manchen Begegnungen erhaschte er anrührende Szenen, aber letztlich hat er immer die Realität den Träumen vorgezogen. Bei Tag und bei Nacht hat „sein unersättliches Auge" unablässig Bilder von Straßen und ihrem Pflaster, von Gesichtern und Szenen des Alltags aufgelesen: „Im Grunde habe ich eine große Reportage über das menschliche Leben gemacht." Als Berichterstatter des sozialen Lebens, als Schöpfer eines vielgestaltigen Werkes wirkt Brassaï eher wie ein visionärer Dichter mit einer unersättlichen Neugier. Er erweist sich im umfassendsten Sinne als Künstler und Zeuge seiner Zeit. Er ist für uns so etwas wie ein „sehender Bruder", der uns auffordert, die Augen zu öffnen und zu sehen, um zu erkennen.

Le Paris secret des années 30, text by Brassaï, Paris, Gallimard, 1976

The Artists of My Life, London, Thames and Hudson, 1982

décembre 2002, plus de 35 000 négatifs ainsi que leurs planches de contacts sont entrés dans les fonds du musée, les sauvant d'une dispersion éventuelle.

Fasciné par l'invisible et l'inconscient tout en sachant également s'attendrir sur quelques scènes glanées au fil des rencontres, Brassaï a toujours préféré la réalité aux rêves. De jour comme de nuit, «son œil insatiable» n'a cessé de glaner des images de rues, de pavés, de visages, de scènes de rue : «Au fond, j'ai fait un grand reportage sur la vie humaine.» Reporter sociologue, créateur d'une œuvre multiforme, Brassaï apparaît un poète visionnaire d'une insatiable curiosité. Il s'affirme comme l'artiste et le témoin le plus complet de son temps. En se révélant comme un véritable «frère voyant», il nous incite à ouvrir les yeux et à voir pour savoir.

"My images were surreal simply in the sense that my vision
brought out the fantastic dimension of reality. My only aim
was to express reality, for there is nothing more surreal than
reality itself. If reality fails to fill us with wonder, it is because
we have fallen into the habit of seeing it as ordinary."

„Der Surrealismus meiner Bilder war nichts anderes als die durch die
spezielle Sichtweise ins Fantastische gewendete Realität. Es ging mir
nur darum, die Realität auszudrücken, denn nichts ist surrealer. Wenn
sie uns nicht mehr in Erstaunen versetzt, dann nur darum, weil die
Gewohnheit sie für uns banal gemacht hat."

« Le surréalisme de mes images ne fut autre que le réel rendu fantastique
par la vision. Je ne cherchais qu'à exprimer la réalité, car rien n'est plus
surréel. Si elle ne nous émerveille plus, c'est que l'habitude nous l'a
rendue banale. » 4

Brassaï

Minotaure magazine
Die Zeitschrift *Minotaure*
Du côté du *Minotaure*

Large-scale Objects: Matches
Objekte im großen Maßstab: Streichhölzer
Allumettes – Objets à grande échelle
c. 1930

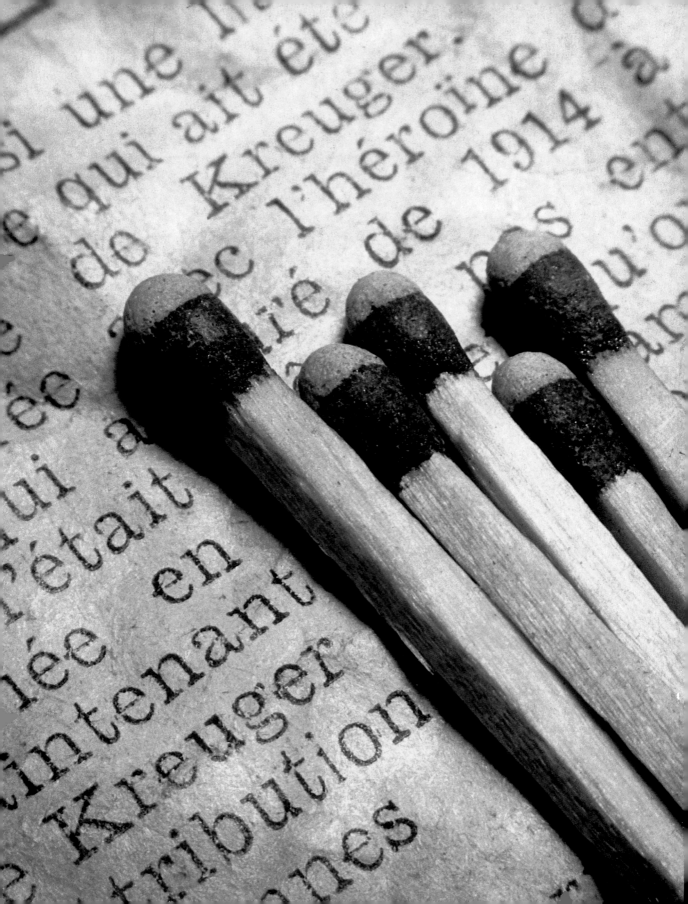

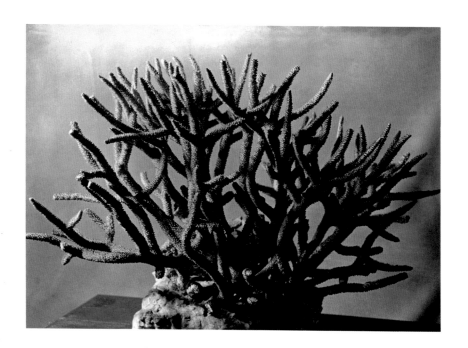

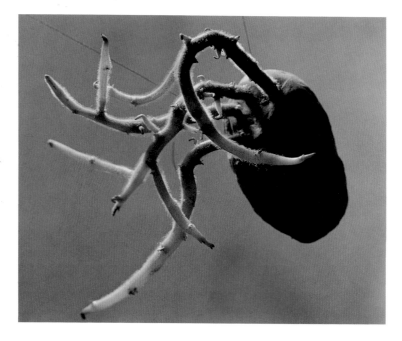

Madrepore
Schwammkoralle
Madrépore
c. 1930

Circumstantial Magic
Gelegenheitsmagie
Magique circonstancielle
1931

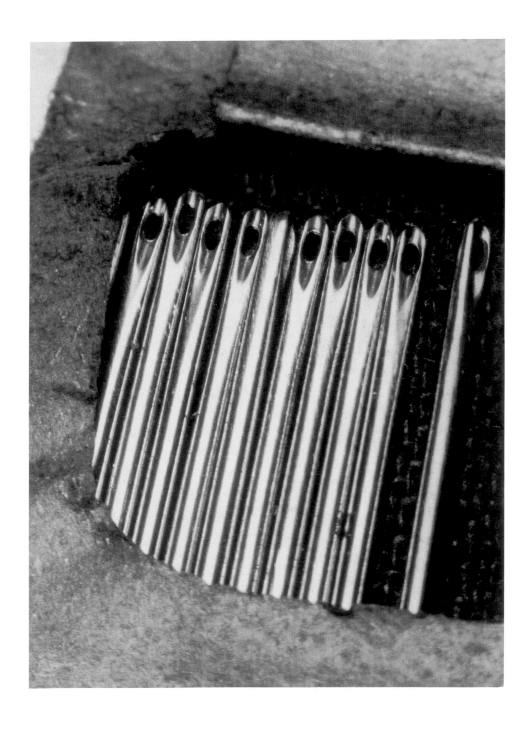

Scaled up, the little needles look like an organ
Vergrößert sehen die Nadeln im Etui wie Orgelpfeifen aus
Les petites aiguilles comme un orgue
c. 1930

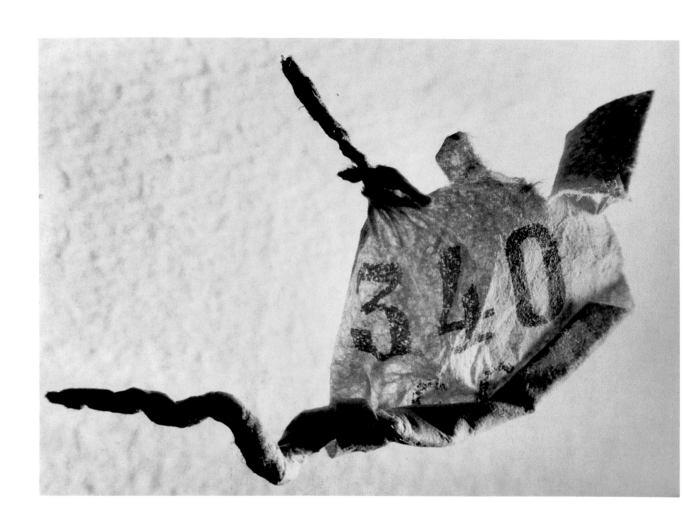

"I believe photography should suggest things, rather than insist or explain."
„Für mich muss die Fotografie etwas suggerieren, nicht aber insistieren oder erklären."
« Pour moi, la photographie doit suggérer plutôt qu'insister ou expliquer. » [3]

Brassaï

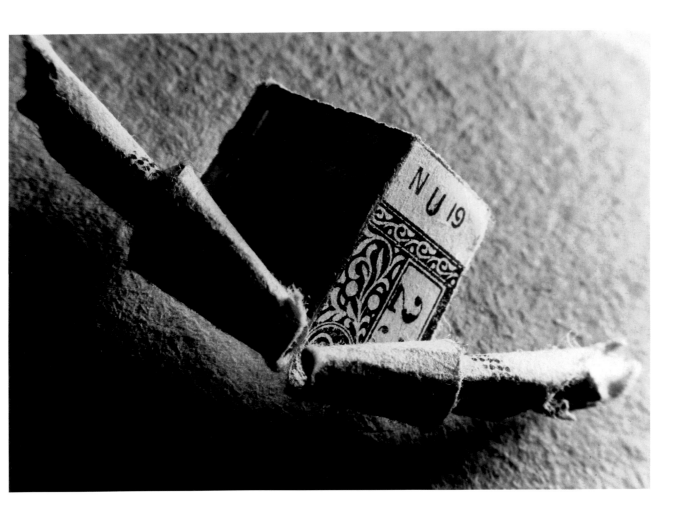

Involuntary Sculptures – Jacket Pocket Ticket
Zufällige Skulpturen: Ticket aus einer Westentasche
Billet poche de veston – Sculptures involontaires
c. 1932–1933

Involuntary Sculptures – Crumpled Bus Ticket
Zufällige Skulpturen: aufgerollter Busfahrschein
Billet d'autobus roulé – Sculptures involontaires
1932

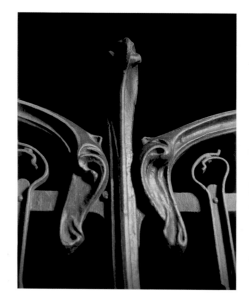
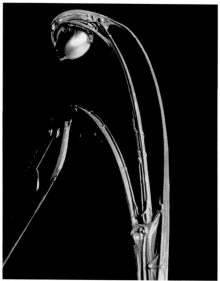
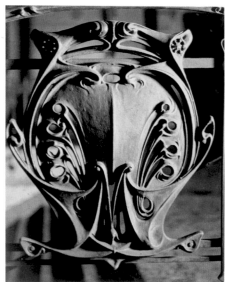
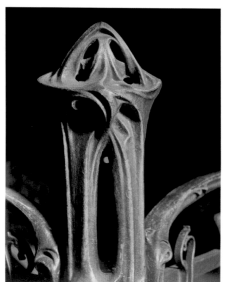

Materialist Psychic Symbolic Operations
Against Idealist Functionalism
Gegen den idealistischen Funktionalismus das sym-
bolisch-psychisch-materialistische Funktionieren
Contre le fonctionnalisme idéaliste le fonctionnement
symbolique psychique matérialiste
1934

Le métro « Guimard »
1933

This is one more metallic avatar of Millet's "Angelus"
Es handelt sich außerdem um einen metallischen
Atavismus von Millets „Angelusläuten"
Il s'agit encore d'un atavisme métallique
de l'« Angélus » de Millet
1933

Me Too
Mich auch
Moi aussi
1933

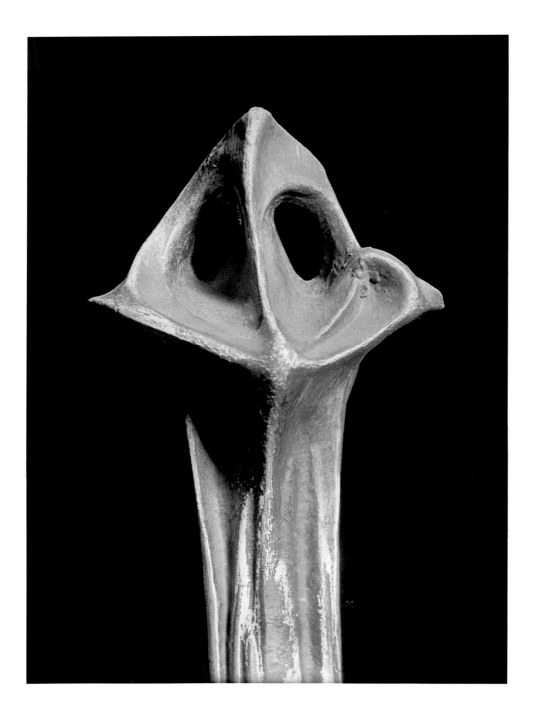

Eat Me! – Art Déco Metro
Friss mich! Jugendstil-Metro
Mange-moi, Métro Modern Style
1933

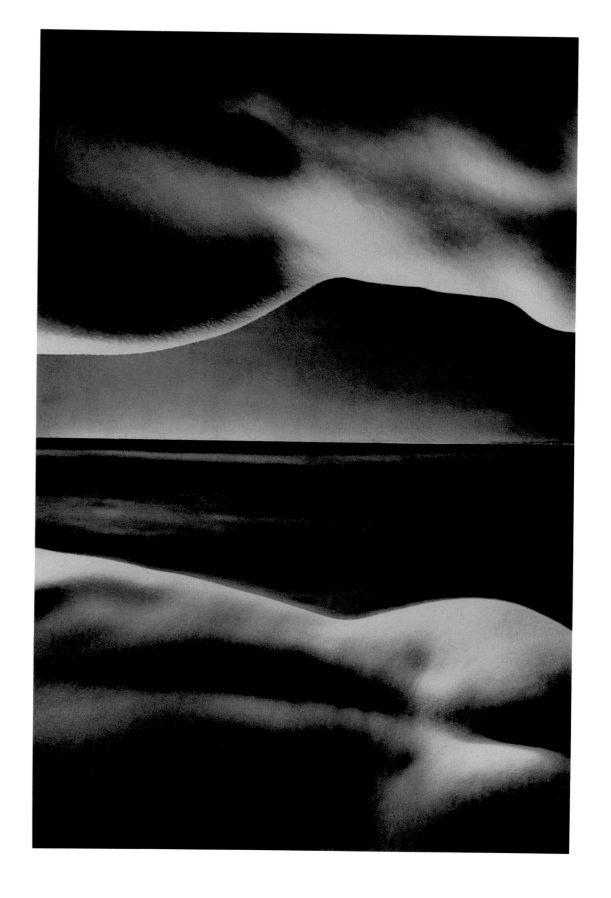

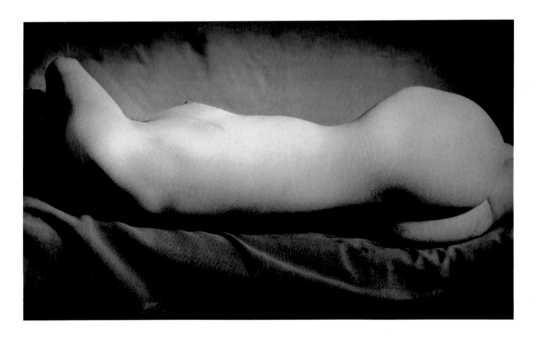

Nude
Akt
Nu
1934

Nude
Akt
Nu
c. 1934

Fake Sky
Himmelsattrappe
Ciel postiche
1934–1935

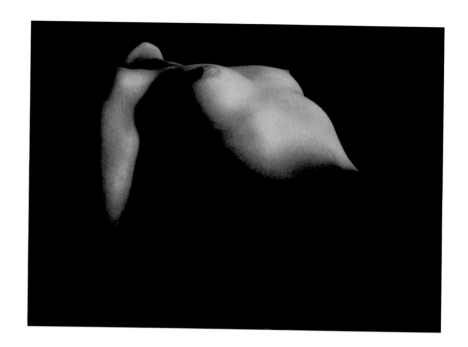

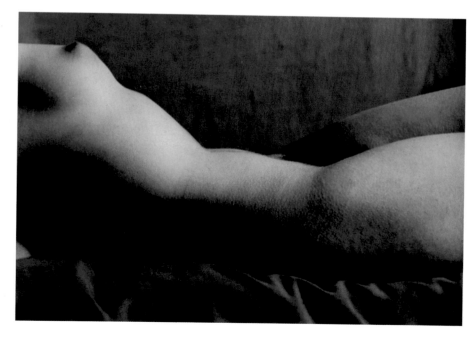

Nude
Akt
Nu
1931–1932

Nude
Akt
Nu
1931–1933

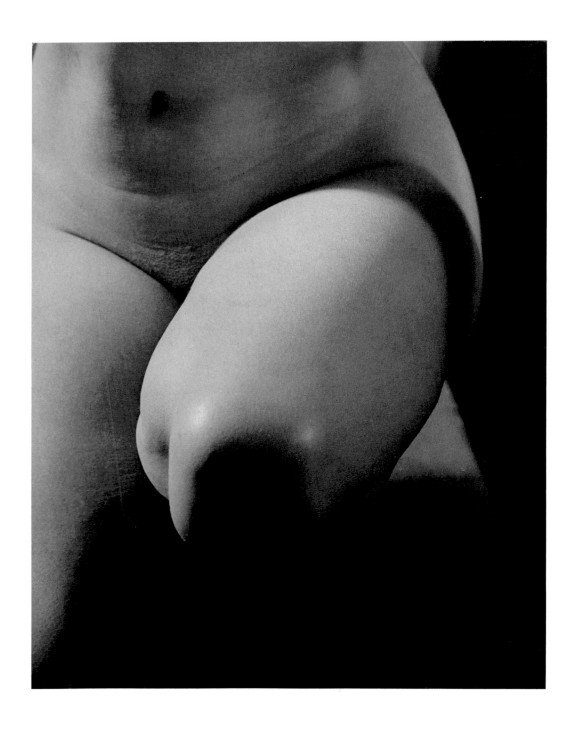

Nude
Akt
Nu
1934

Paris by Night
Paris bei Nacht
Paris la nuit

"Night does not show things, it suggests them. It disturbs and surprises us with its strangeness. It liberates forces within us which are dominated by our reason during the daytime."

„Die Nacht lässt ahnen, sie offenbart nicht. Die Nacht verwirrt uns und überrascht uns durch ihre Fremdheit, sie setzt Kräfte in uns frei, die bei Tage vom Verstand beherrscht werden."

« La nuit suggère, elle ne montre pas. La nuit nous trouble et nous surprend par son étrangeté, elle libère les forces en vous qui, le jour, sont dominées par la raison. »[5]

Brassaï

The Saint-Jacques Tower staggering under its veil of scaffolding
Der Turm Saint-Jacques, hinter seiner Einrüstung schwankend
La Tour Saint-Jacques chancelante sous son voile d'échaffaudage
Paris 4e, c. 1931–1933

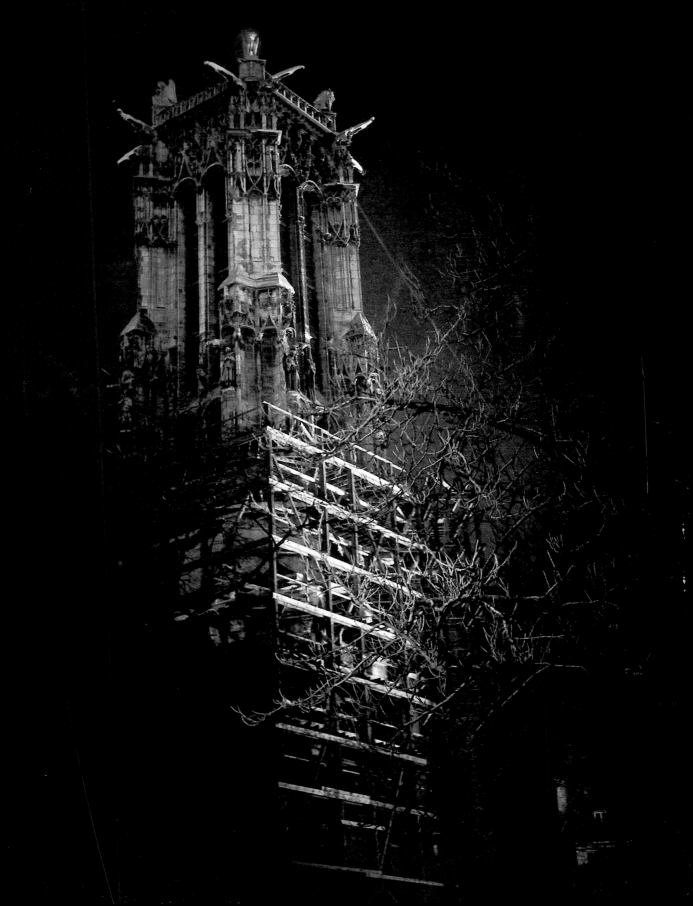

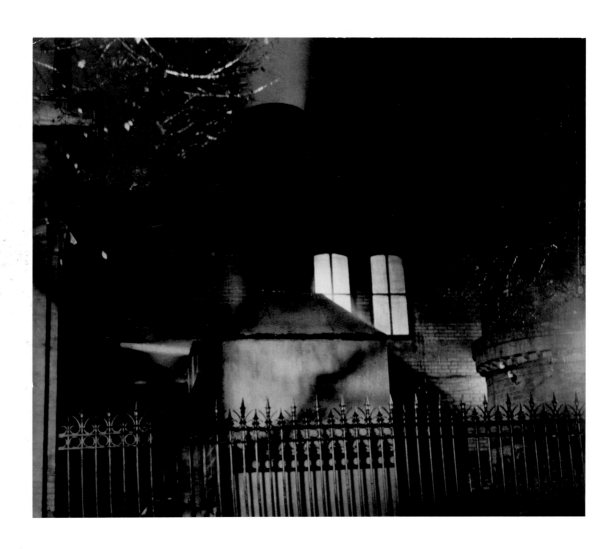

Factory
Fabrik
Usine
Boulevard Saint-Jacques, Paris 14ᵉ, 1932

Pont de Crimée
Paris 19ᵉ, c. 1932–1934

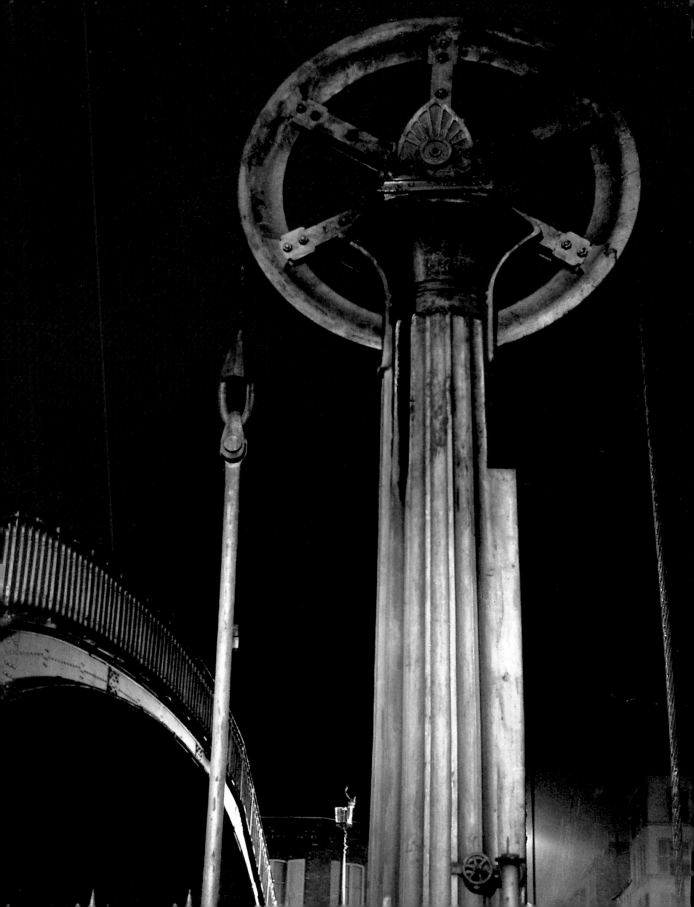

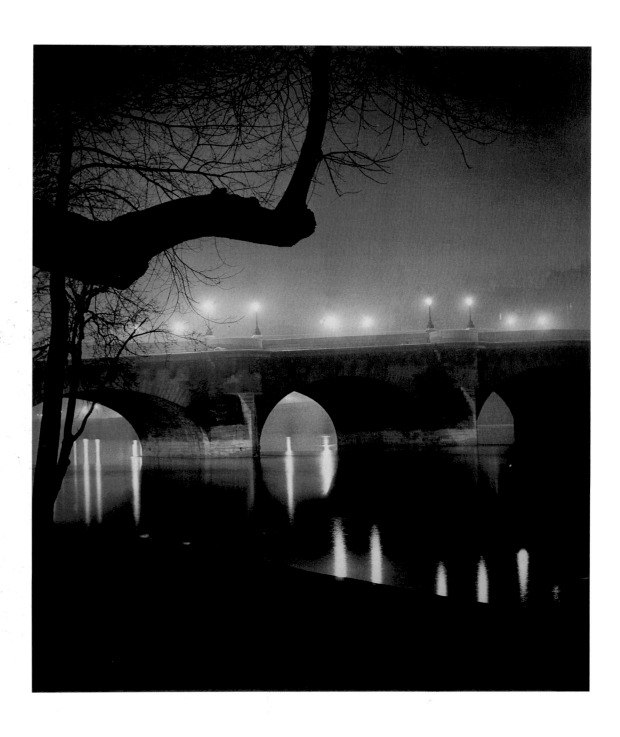

Le Pont-Neuf
Paris 1ᵉʳ, 1936

Notre-Dame de Paris
Paris 4ᵉ, c. 1932

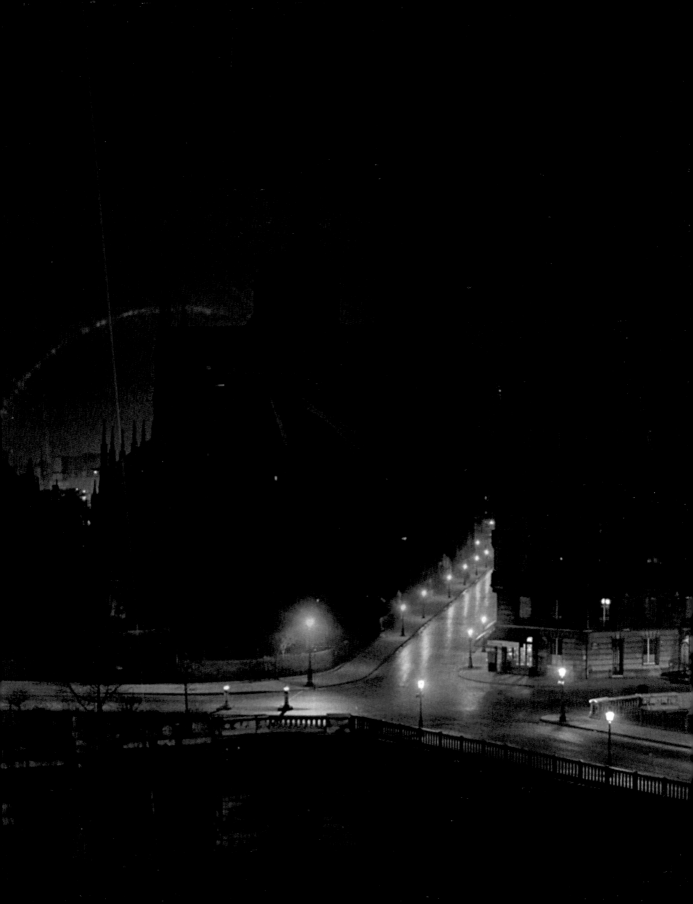

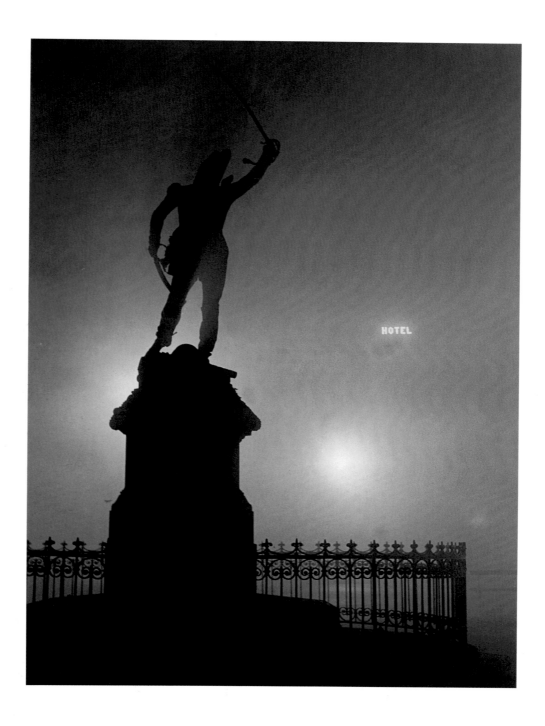

Statue of Marshall Ney in the Fog
Das Denkmal von Marschall Ney im Nebel
Statue du Maréchal Ney dans le brouillard
Paris, 1932

Morris Column
Der Morris-Turm
Colonne Morris
Avenue de l'Observatoire, Paris, 1933

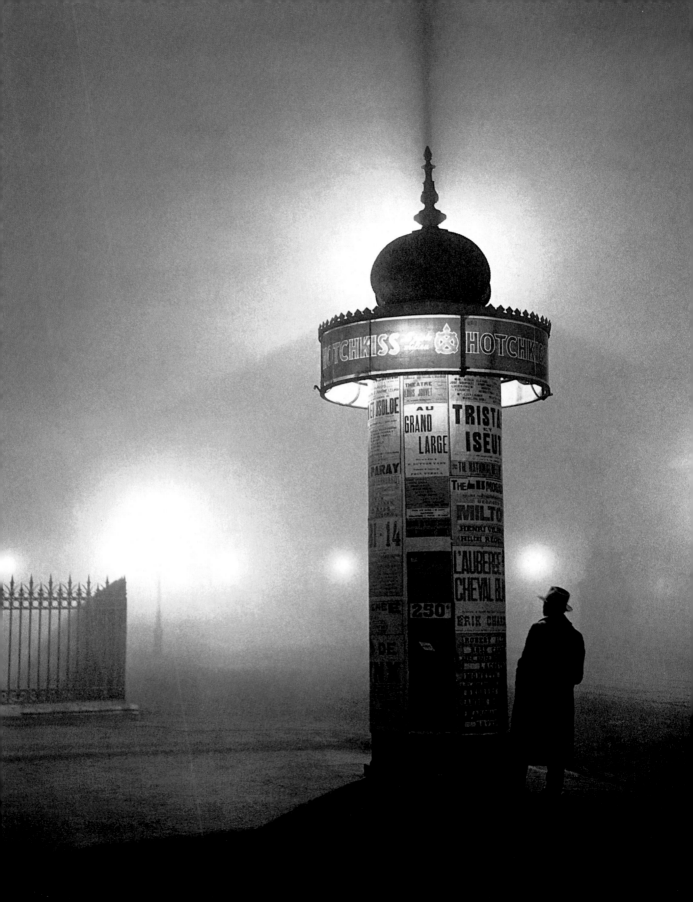

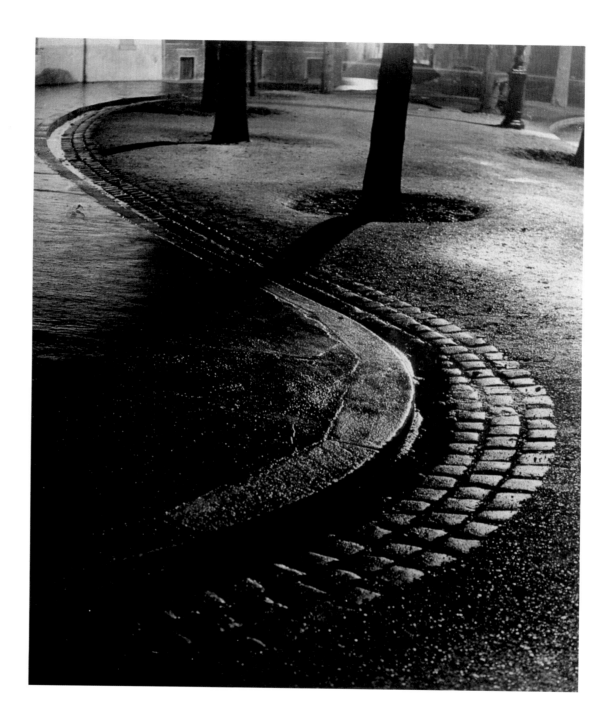

Winding Stream
Sich schlängelder Rinnstein
Le ruisseau serpente
Paris, 1932

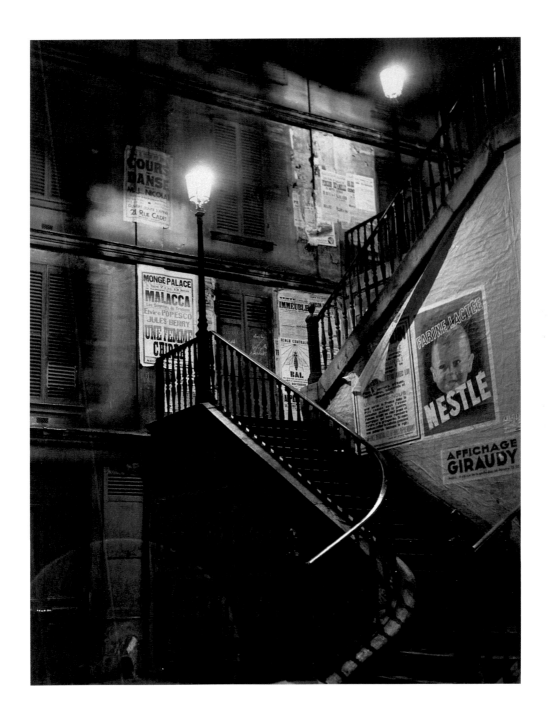

Staircase in the rue Rollin (Nestlé poster)
Treppe in der Rue Rollin (mit Nestlé-Plakat)
Escalier rue Rollin (affiche Nestlé)
Paris 5ᵉ, 1934–1935

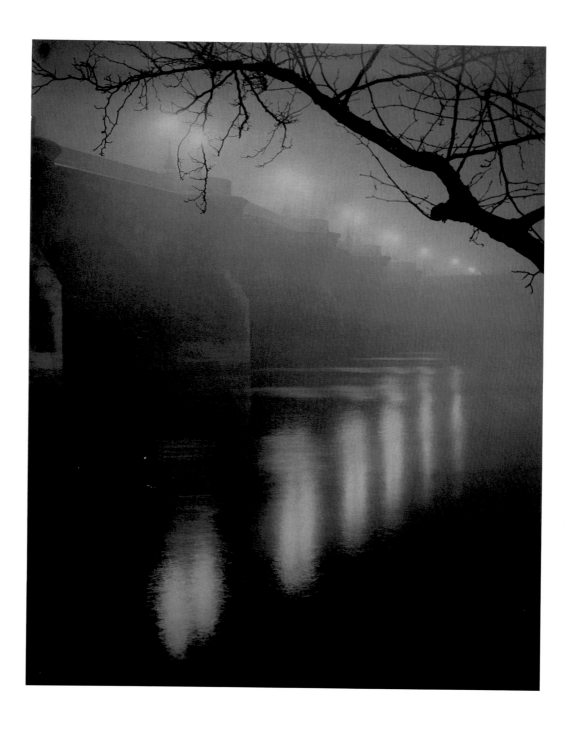

Pont-Neuf in the Fog
Pont-Neuf im Nebel
Pont-Neuf dans le brouillard
Paris 1er, 1934–1935

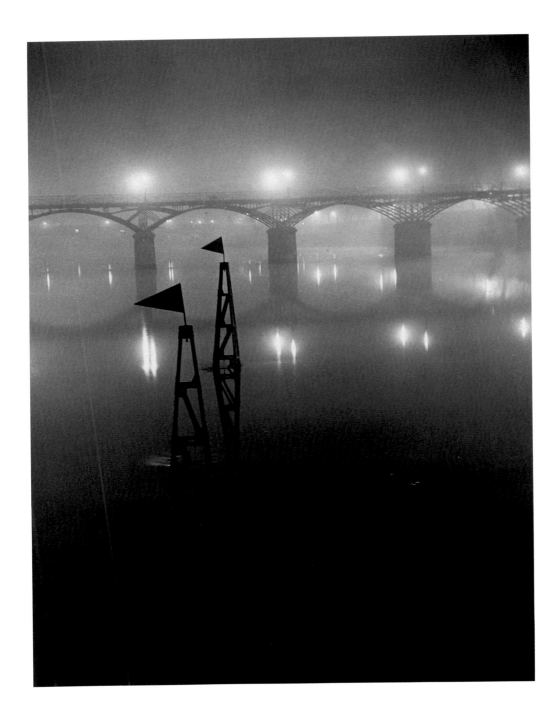

The Pont des Arts in the Fog
Der Pont des Arts im Nebel
Le Pont des Arts dans le brouillard
Paris 1er, 1934

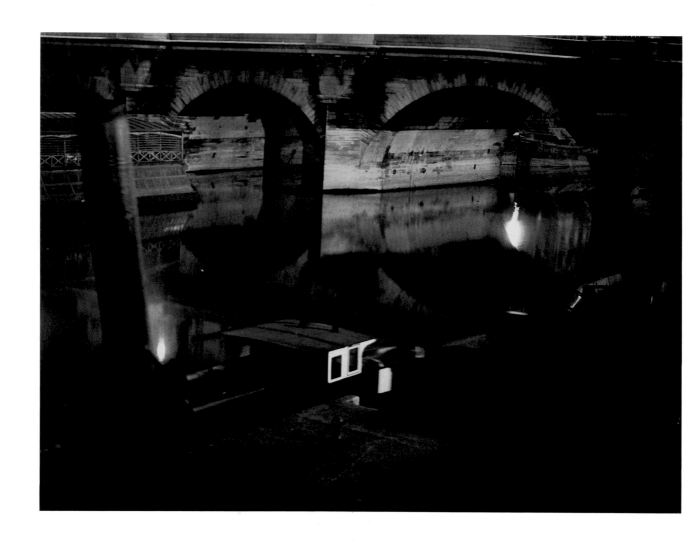

Tugs and Barges near the Pont-Neuf
Schlepper und Schleppkähne am Pont-Neuf
Remorqueurs et péniches près du Pont-Neuf
Paris 1er, 1930–1932

Tramps on the Quai des Orfèvres
Clochards am Quai des Orfèvres
Clochards quai des Orfèvres
Paris 1er, c. 1930–1932

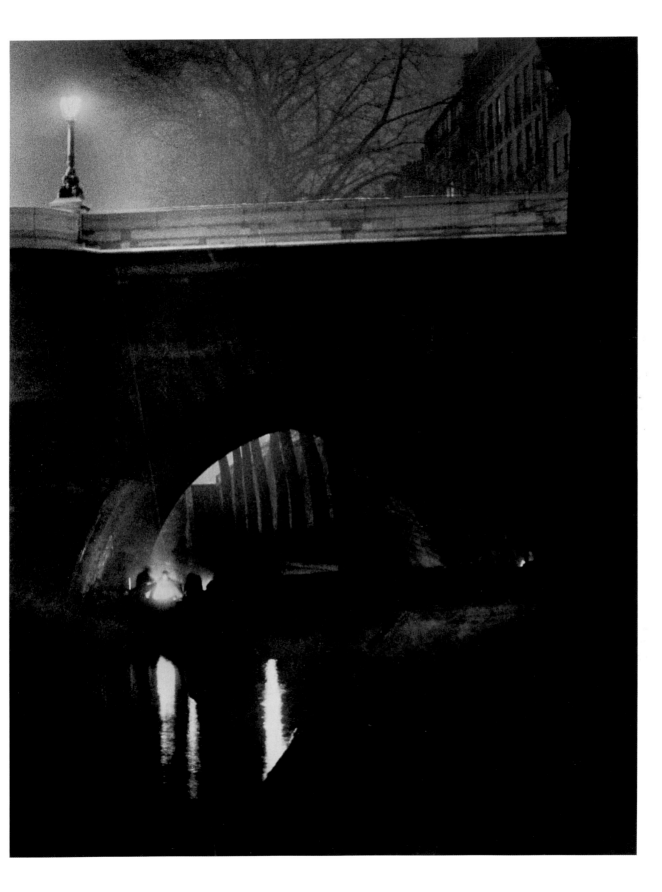

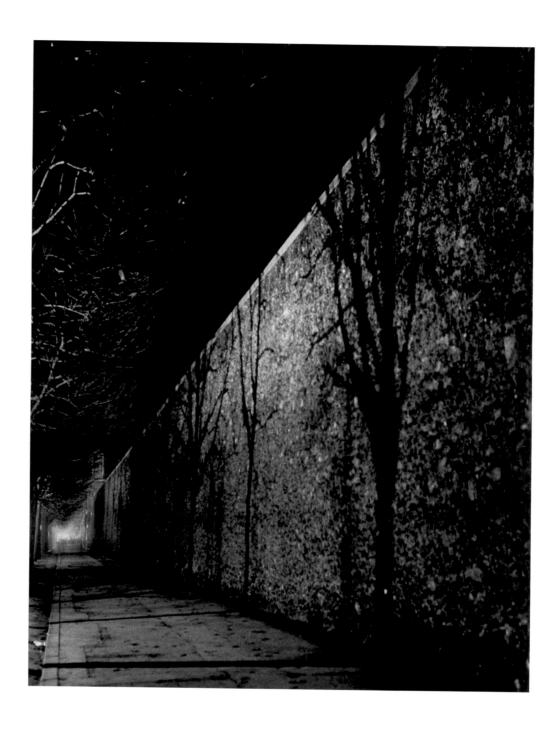

Wall of the Santé Prison
Gefängnismauer von „La Santé"
Mur de la prison de la Santé
Boulevard Arago, Paris 14ᵉ, c. 1932

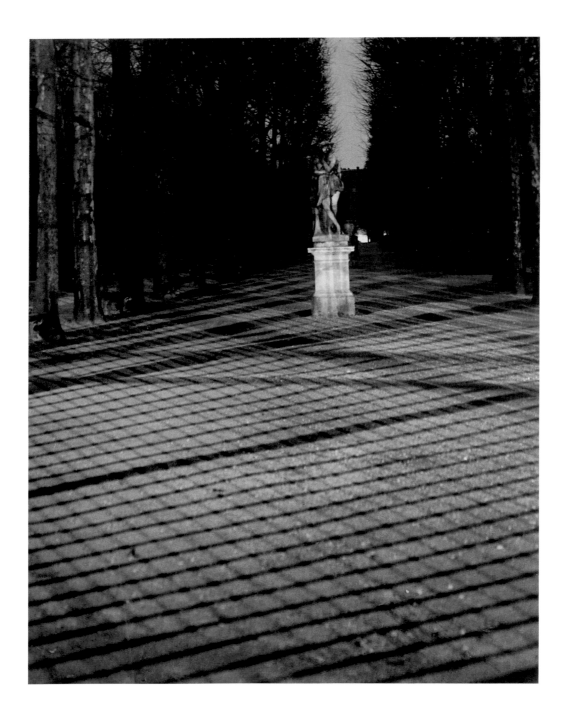

Shadows of Railings in the Luxemburg Gardens
Schatten der Gitter im Jardin du Luxembourg
Ombres des grilles du Jardin du Luxembourg
Paris, 1932–1933

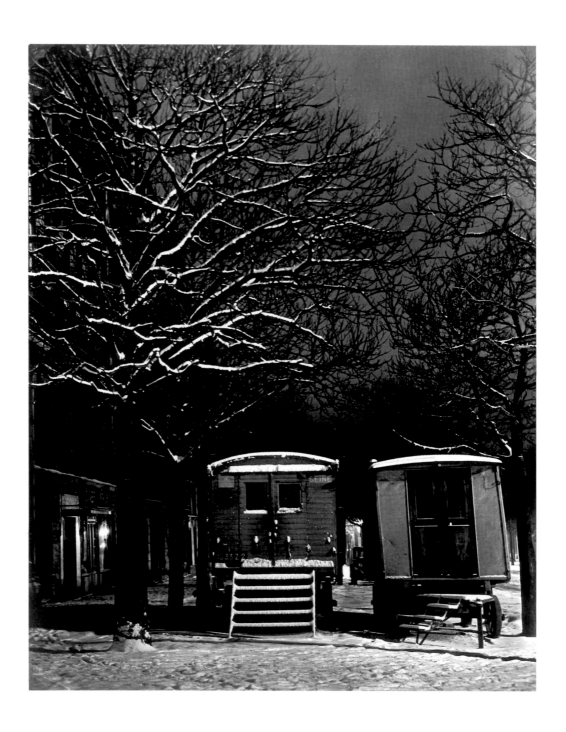

Caravans
Die Wohnwagen
Les roulottes
Boulevard Arago, Paris 14ᵉ, c. 1935–1938

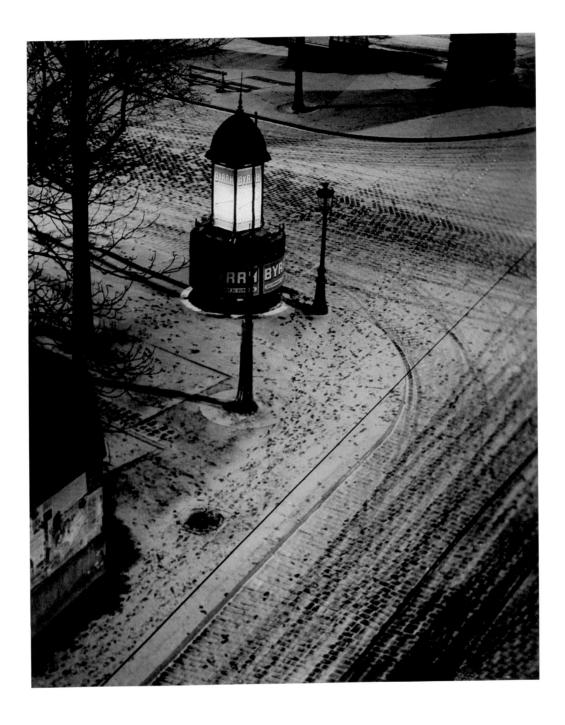

Public Urinal
Pissoir
Vespasienne
Boulevard Auguste Blanqui, Paris 14ᵉ, c. 1933–1935

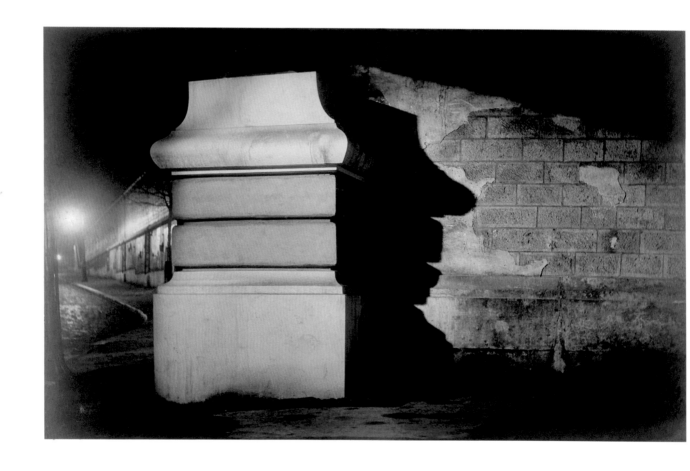

Metro Pillar
Stützpfeiler der Metro
Pilier de métro
Paris, 1934

Avenue de l'Observatoire
Paris 14ᵉ, 1934

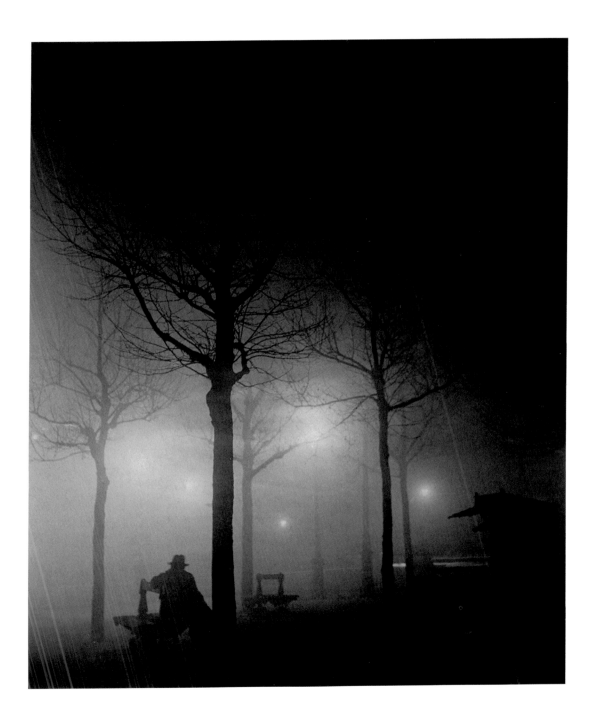

Avenue de l'Observatoire
Paris 14ᵉ, c. 1932–1934

"There are two gifts which every man of images needs to be a true creator:
a certain sensitivity to life, to living things, and at the same time, the art
which will enable him to capture that life in a certain specific way. I'm not
talking about a pure aesthetics …"

„Es gibt zwei Fähigkeiten, die den Mann des Bildes, den Bildermacher auszeichnen:
eine gewisse Sensibilität gegenüber dem Leben, gegenüber den belebten Dingen, und
andererseits die Begabung, diese Dinge auf eine bestimmte Weise zu erfassen. Das ist
keine Frage der reinen Ästhetik …"

« Il y a deux dons qui font l'homme d'image, le créateur : une certaine sensibilité pour
la vie, pour la chose vivante et, d'autre part, un art de saisir celle-ci d'une certaine façon.
Il ne s'agit pas d'esthétisme pur … »[3]

Brassaï

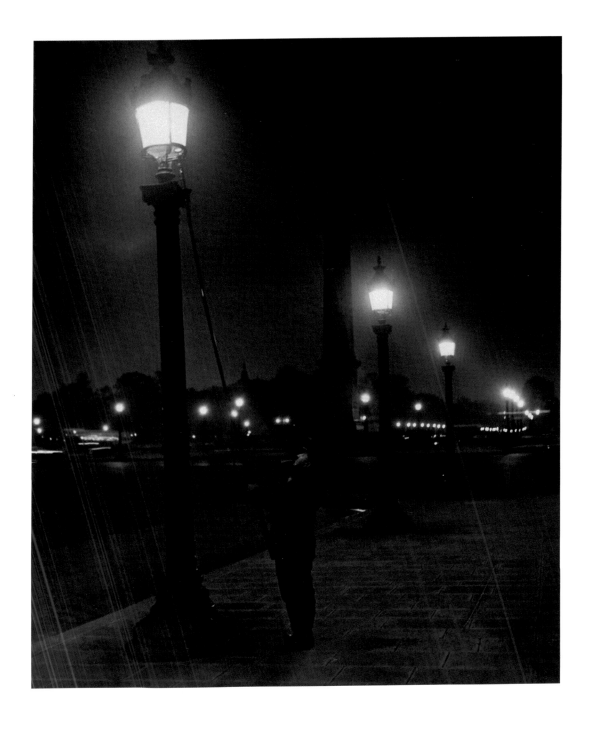

Lighting the Lamps
Laternenanzünder
Allumeur de réverbères
Place de la Concorde, Paris 8e, c. 1932–1933

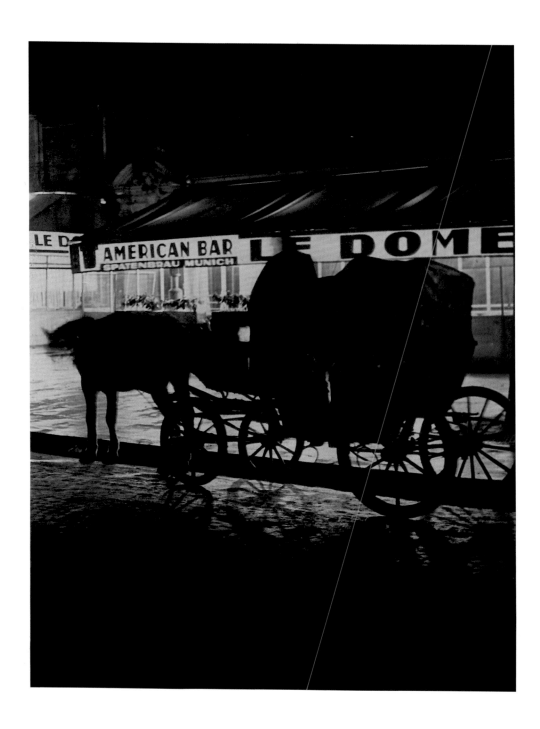

Horse-drawn Carriage outside Le Dôme
Kutsche vor dem Dôme
Le fiacre devant le Dôme
Boulevard du Montparnasse, Paris 14ᵉ, 1932

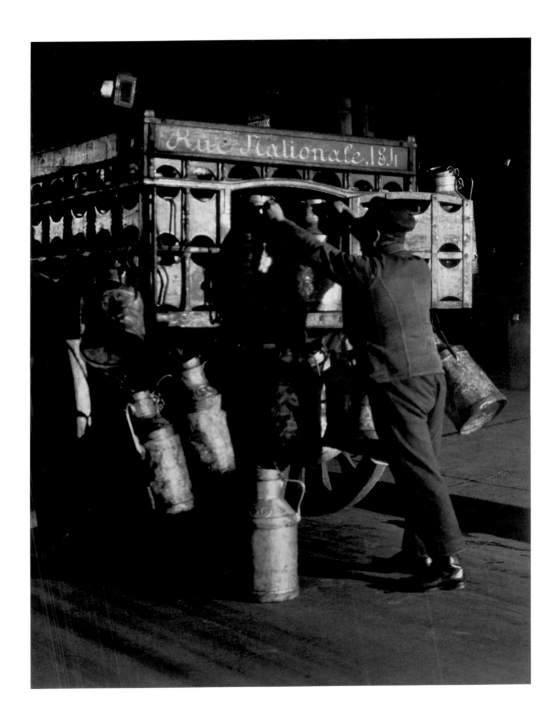

Milkman in the Rue Nationale
Der Milchmann in der Rue Nationale
Le laitier de la rue Nationale
Paris 14ᵉ, 1932

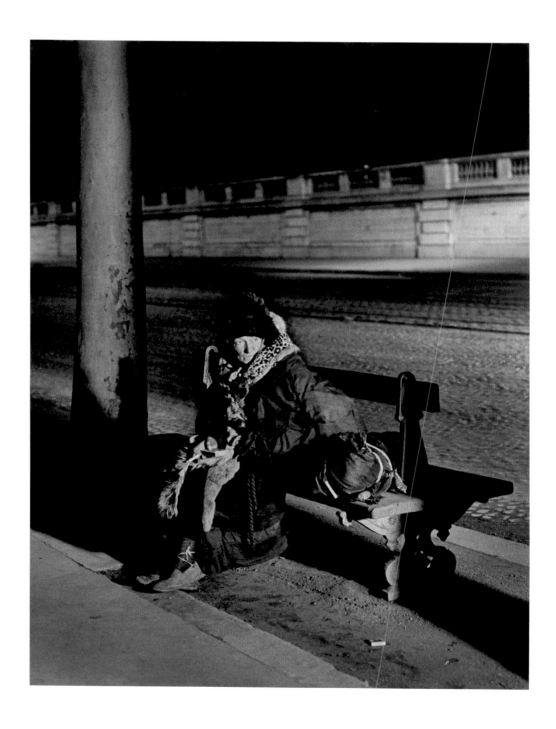

Woman Tramp on the Quai des Tuileries
Weiblicher Clochard am Quai des Tuileries
Clocharde, quai des Tuileries
Paris 1^{er}, 1930–1932

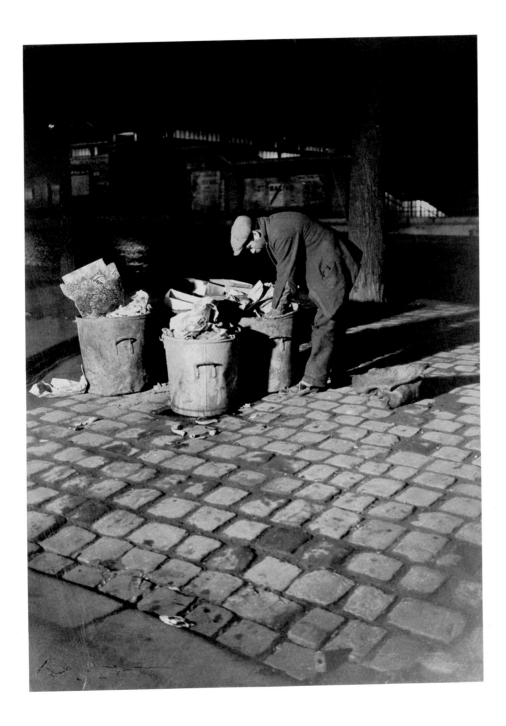

Rag Picker
Der Lumpensammler
Le chiffonnier
Paris, c. 1931–1932

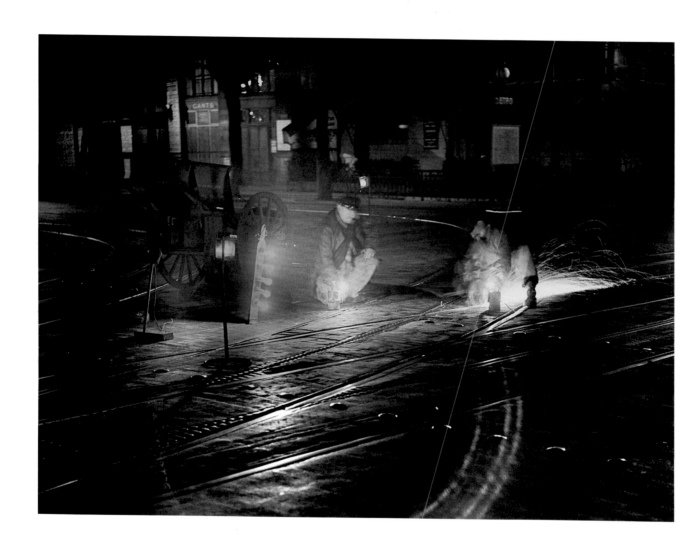

"Only photography could provide the intensity and expressive power …"

„Nur die Fotografie ist dazu geeignet, diese Intensität und Ausdruckskraft zu erfassen …"

« Seule la photographie pouvait parvenir à saisir cette intensité et cette puissance d'expression … »[3]

Brassaï

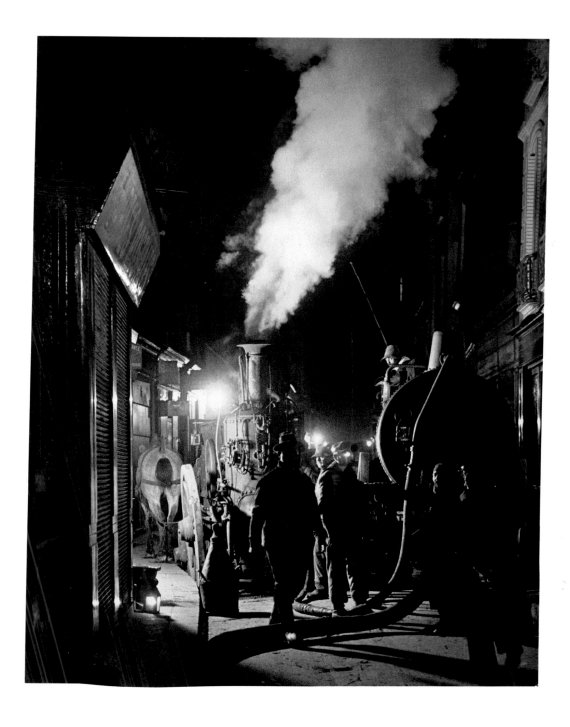

<div style="display:flex; justify-content:space-between;">

Rail Polishers
Schienenputzer
Polisseurs de rails
Paris, 1930–1932

Cesspool Cleaners with their Cart
Die Latrinenreiniger an der Pumpe
Les vidangeurs et leur pompe
Rue Rambuteau, Paris 1er, c. 1931

</div>

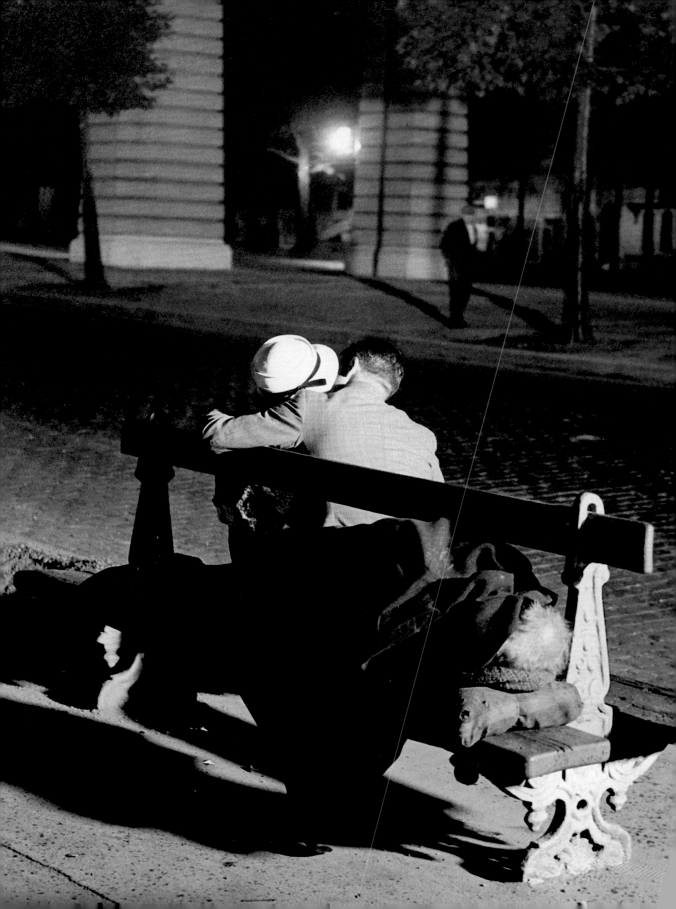

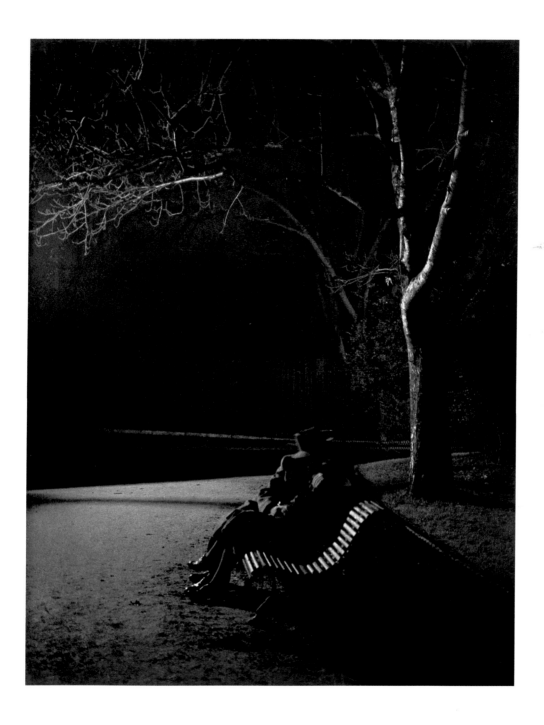

Two Lovers on a Public Bench and a Tramp
Liebespaar auf einer Bank und ein Clochard
Couple d'amoureux sur un banc et un clochard
Boulevard Saint-Jacques, Paris 14ᵉ, c. 1932

Bench in the Tuileries Gardens
Bank in den Tuilerien
Banc aux Tuileries
Paris, 1930–1932

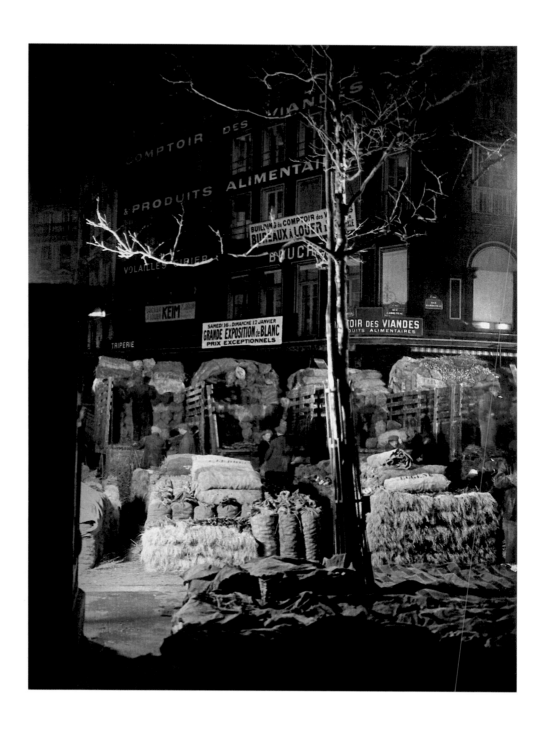

Unloading Vegetables at Les Halles
Abladen von Gemüse in Les Halles
Déchargement de légumes aux Halles
Paris 1er, c. 1931

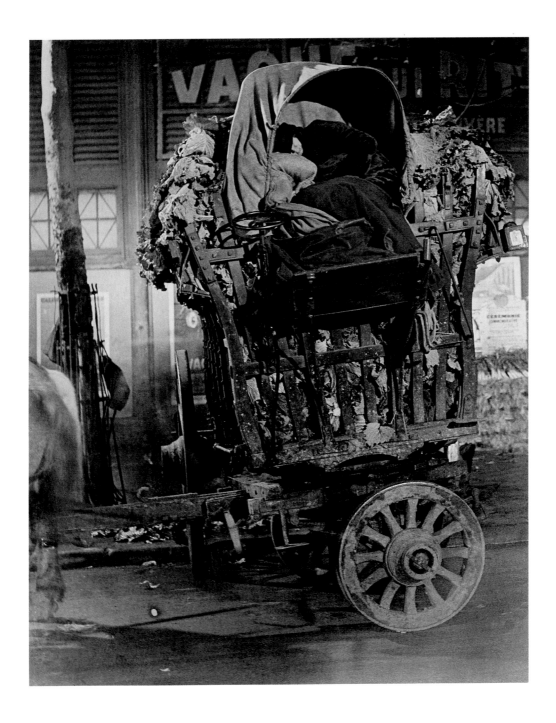

Sleeping Grocerywoman at Les Halles
Schlafende Gemüsefrau in Les Halles
Maraîchère endormie aux Halles
Paris 1er, c. 1930–1932

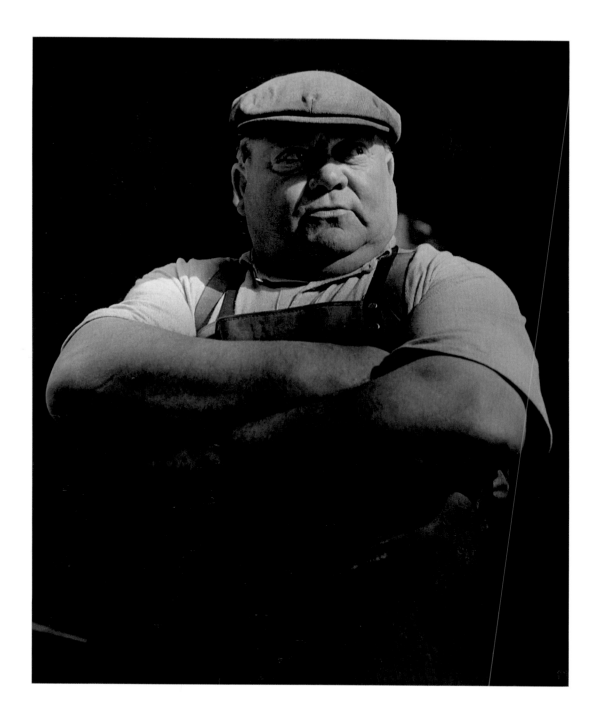

Strongman of Les Halles
Lastenträger von Les Halles
Fort des Halles
Paris 1ᵉʳ, 1939

The Strongmen of Les Halles
Die Lastenträger von Les Halles
Les forts des Halles
Paris 1ᵉʳ, 1935

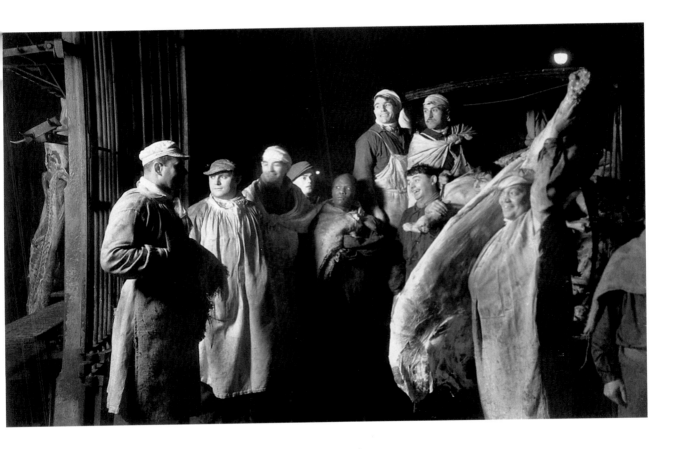

"*I need the subject to be as conscious as possible that he is taking part in an event … in an artistic act. I need his active collaboration …*"

„*Ich lege Wert darauf, dass mein Motiv sich dessen so bewusst wie möglich ist, dass es an einem Ereignis teil hat … an einem künstlerischen Augenblick. Ich brauche seine volle Mitarbeit …*"

«*Je tiens à ce que mon sujet ait aussi conscience que possible qu'il participe à un événement… à un moment artistique. J'ai besoin de sa pleine collaboration…*»[3]

Brassaï

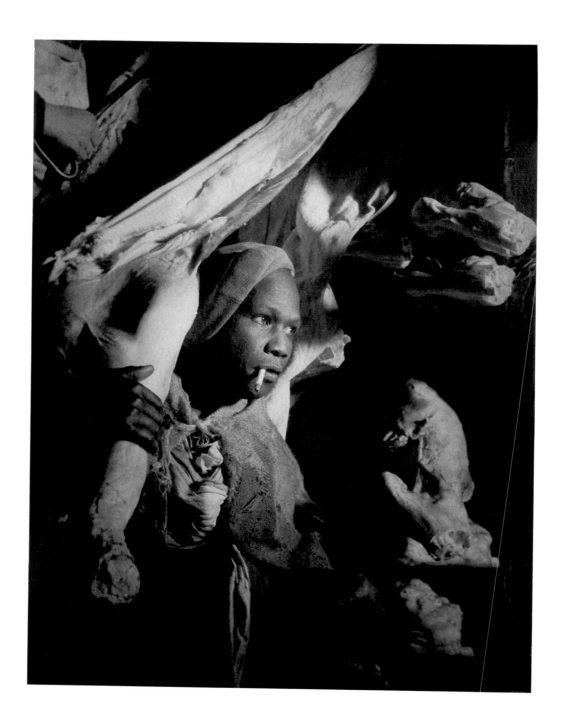

Meat Porter at Les Halles ("The King of Ethiopia")
„Der Negus" (Fleischträger in Les Halles)
« Le Négus » (porteur de viande aux Halles)
Paris 1er, 1935

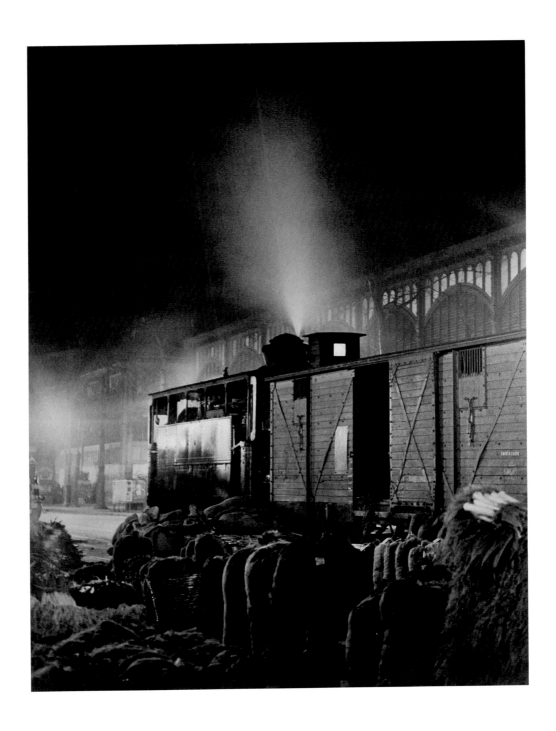

The Little Train of Les Halles
Der kleine Zug von Les Halles
Le petit train des Halles
Paris 1ᵉʳ, 1935

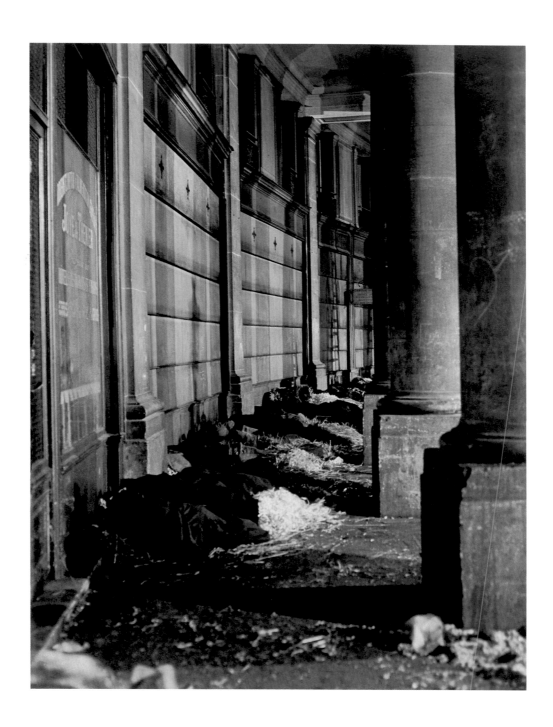

Tramps at the Bourse du Commerce
Clochards an der Bourse du Commerce
Clochards. Bourse du Commerce
Paris 1er, 1930–1932

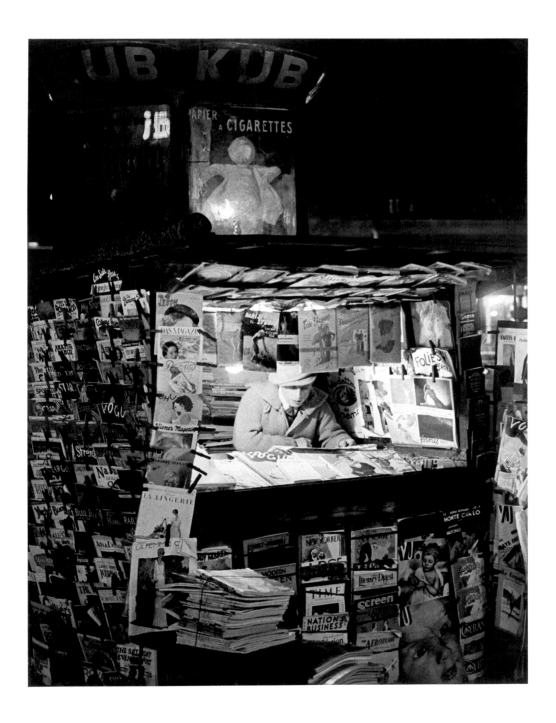

Newsstand
Kiosk
Kiosque
Paris, 1930–1932

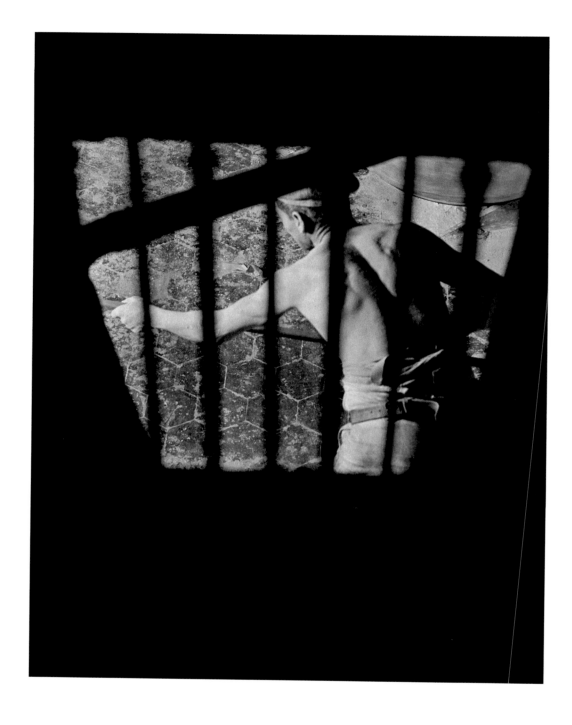

Baker
Bäcker
Boulanger
Paris, c. 1930–1932

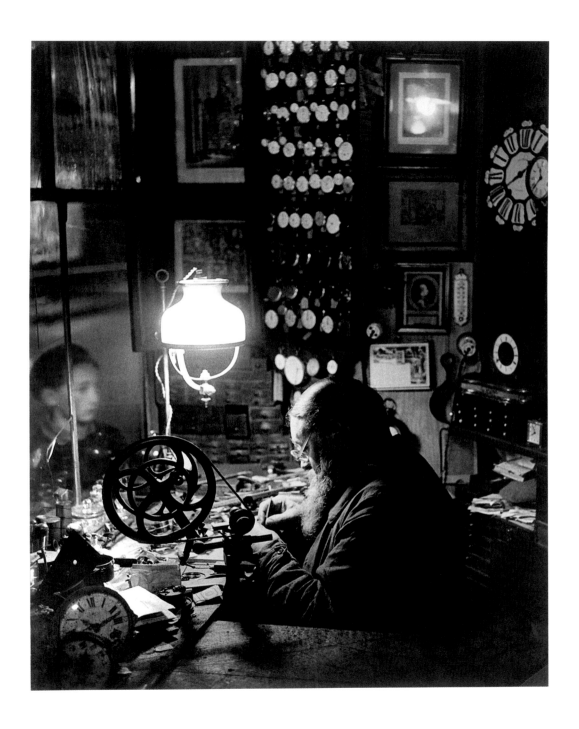

Watchmaker in the rue Dauphine
Der Uhrmacher in der Rue Dauphine
L'Horloger de la rue Dauphine
Paris 6ᵉ, c. 1932–1933

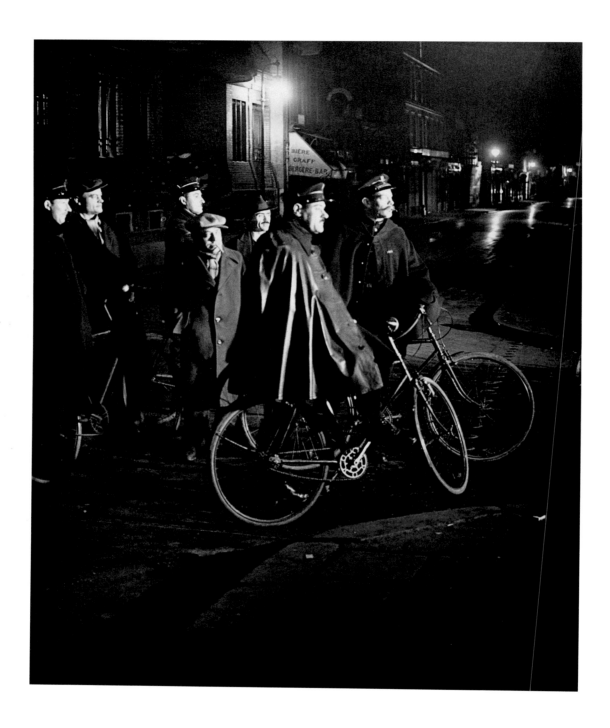

Police Raid in Montmartre
Polizisten bei einer Razzia am Montmartre
La police pendant une rafle à Montmartre
Paris 18ᵉ, 1932

Big Albert's Gang
Die Bande des „großen Albert"
La bande du Grand Albert
Quartier Italie, Paris 13ᵉ, c. 1931–1932

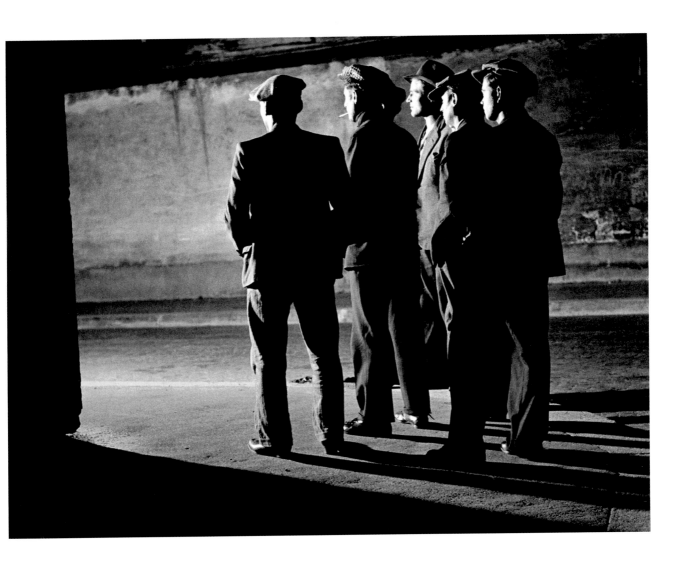

"I've always felt that the formal structure of a photo, its composition, was just as important as the subject itself. ... You have to eliminate every superfluous element, you have to guide your own gaze with an iron will."

„Ich habe immer die formale Struktur eines Fotos, seine Komposition, für ebenso wichtig gehalten wie das Motiv selbst. ... Alles Überflüssige muss entfernt werden, man muss das Auge wie ein Diktator lenken."

« J'ai toujours tenu la structure formelle d'une photo, sa composition, pour aussi importante que le sujet lui-même. ... Il faut éliminer tout ce qui est superflu, il faut diriger l'œil en dictateur. » [3]

Brassaï

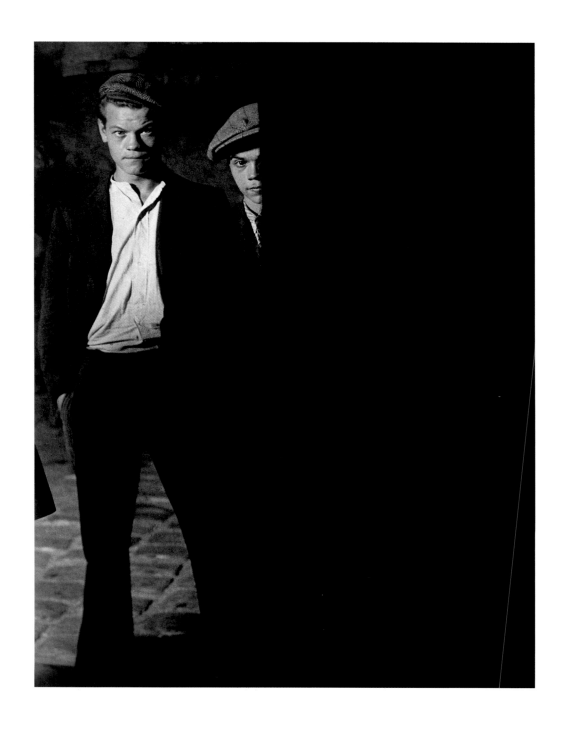

Two Thugs from Big Albert's Gang
Zwei Gauner aus der Bande des „großen Albert"
Deux voyous de la bande du Grand Albert
Paris, 1931–1932

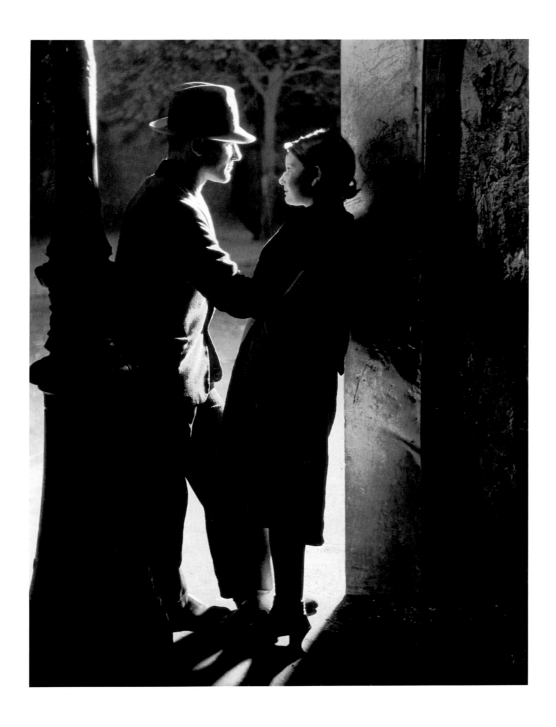

Lovers beneath a Streetlight
Liebespaar unter einer Straßenlaterne
Couple d'amoureux sous un réverbère
Paris, 1932

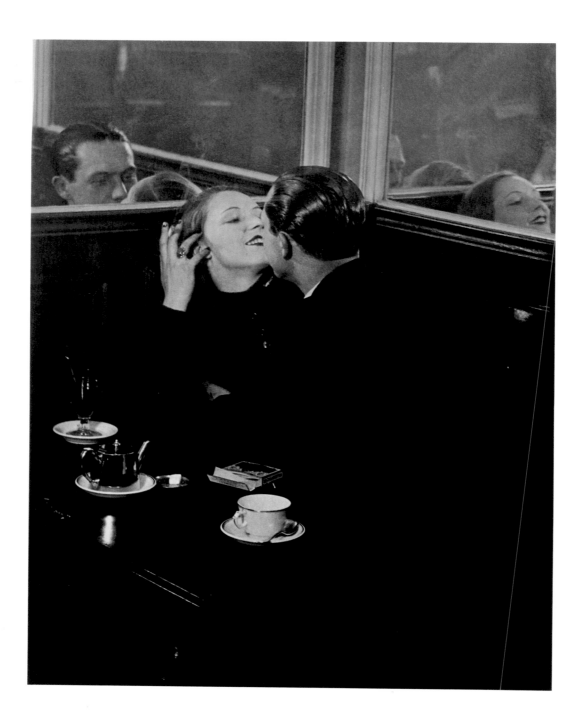

Lovers in a Small Café
Liebespaar in einem kleinen Café
Couple d'amoureux dans un petit café parisien
Quartier Italie, Paris 13ᵉ, c. 1932

Two Girls in a Bar on the Boulevard Rochechouart
Zwei Mädchen in einer Bar, Boulevard Rochechouard
Deux filles dans un bar, boulevard Rochechouard
Paris 18ᵉ, c. 1932

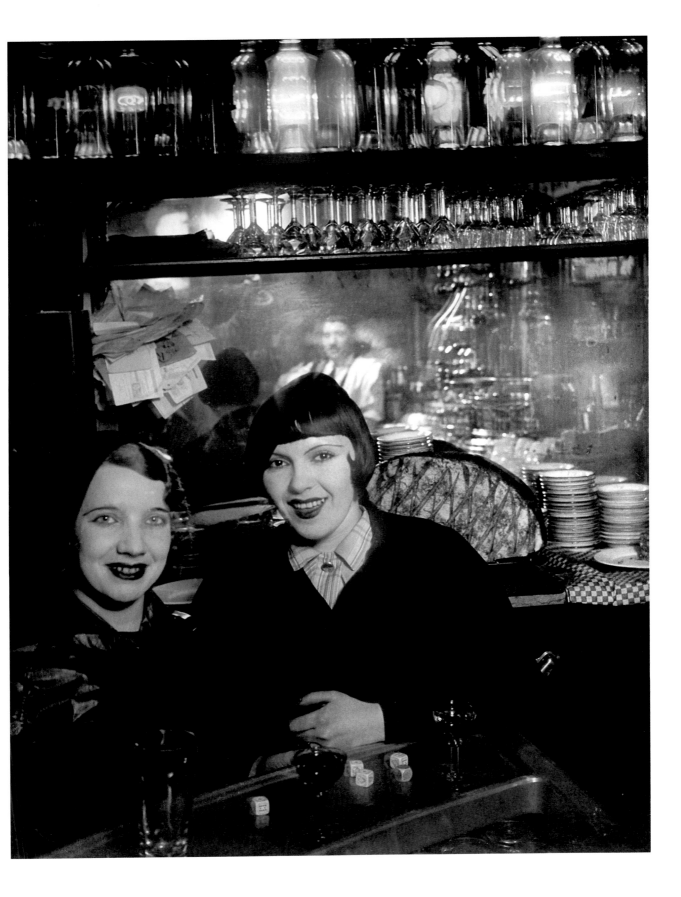

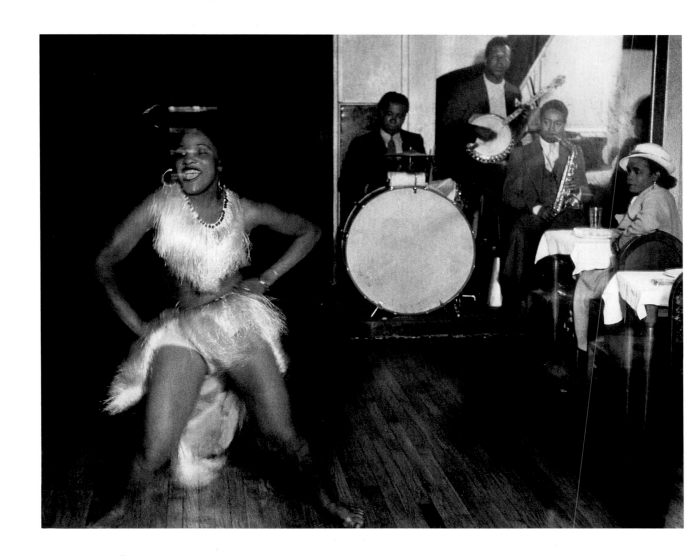

"Basically, my work has been one long reportage on human life."

„*Im Grunde habe ich eine große Reportage über das menschliche Leben gemacht.*"

« *Au fond, j'ai fait un grand reportage sur la vie humaine.* »

Brassaï

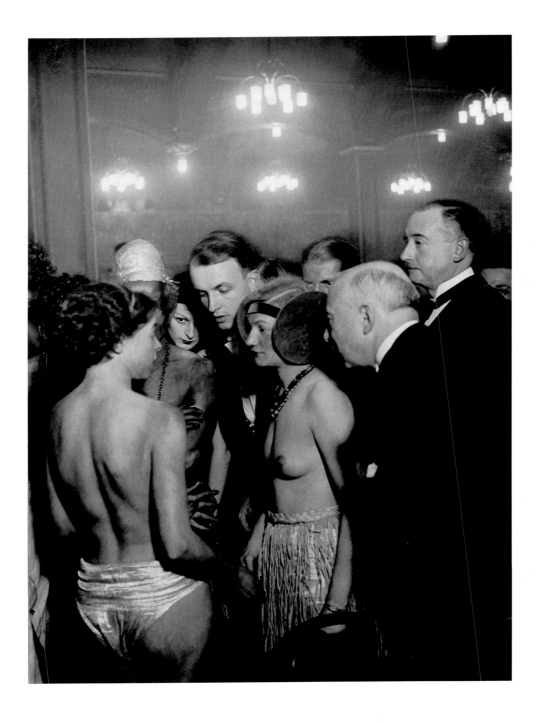

The Dancer Gisèle at the "Boule Blanche"
Die Tänzerin Gisèle im „Boule Blanche"
La danseuse Gisèle à la « Boule Blanche »
Montparnasse, Paris, c. 1932

The Bal de la Horde at the "Bullier"
Beim Bal de la Horde im „Bullier"
Au Bal de la Horde au « Bullier »
Montparnasse, Paris, c. 1932

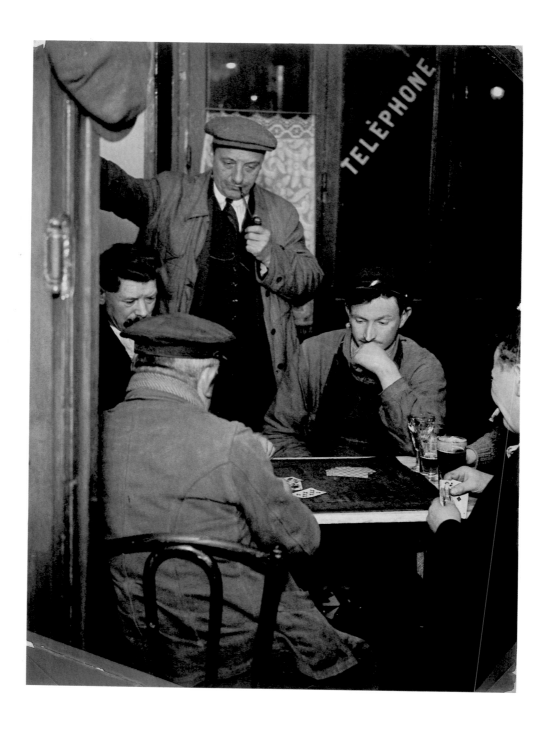

Belote Players
Belote-Spieler
Joueurs de belote
1933

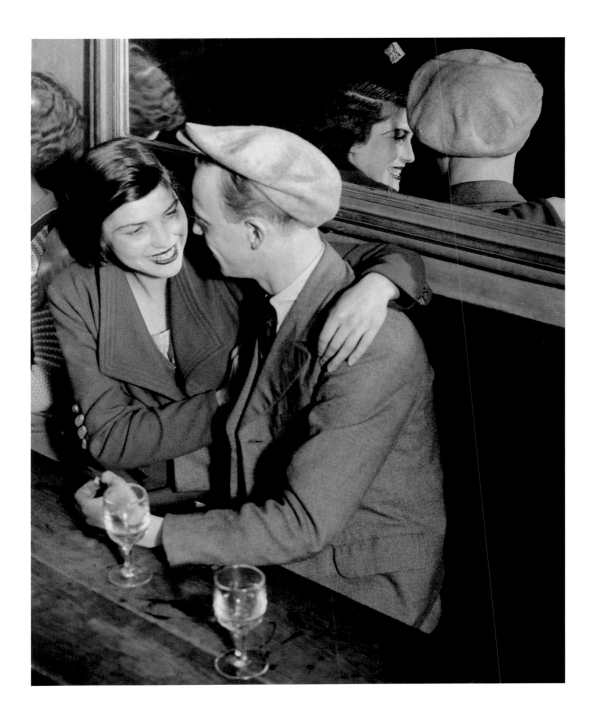

Couple at the "Four Seasons" Dance Hall
Paar beim Musette-Ball im „Quatre-Saisons"
Couple au bal musette des «Quatre-Saisons»
Rue de Lappe, Paris 11ᵉ, c. 1932

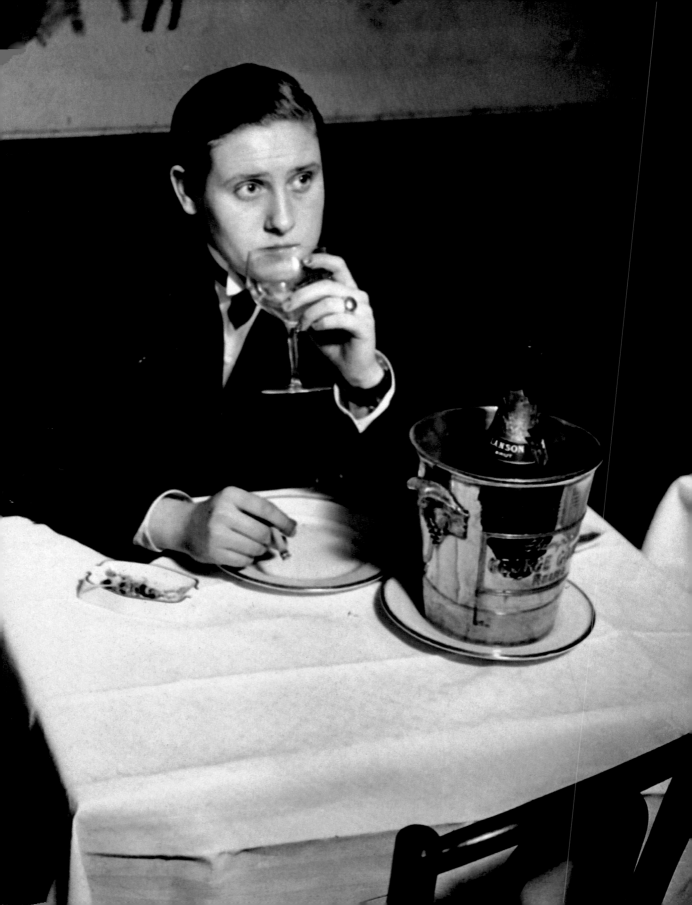

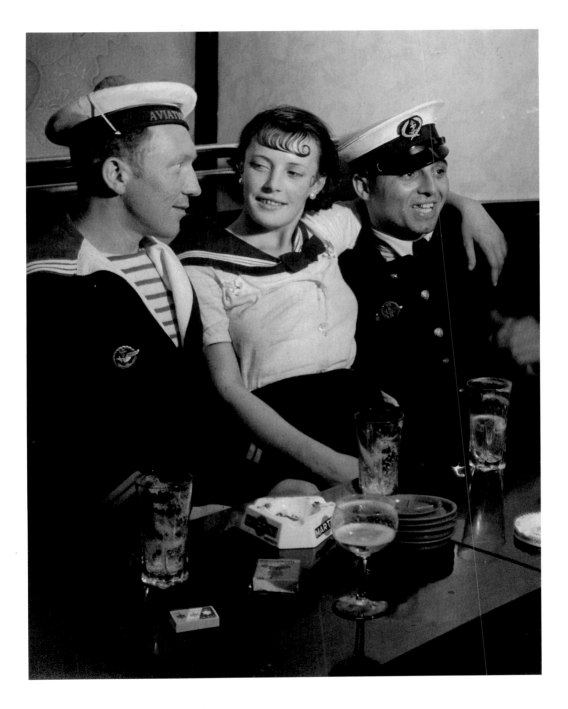

Lulu from Montparnasse drinking alone
at the "Monocle"
Lulu de Montparnasse allein im „Monocle"
Lulu de Montparnasse buvant seule au « Monocle »
Paris 14ᵉ, c. 1933

Conchita with Sailors
Conchita mit Matrosen
Conchita avec les marins
Place d'Italie, Paris 13ᵉ, c. 1933

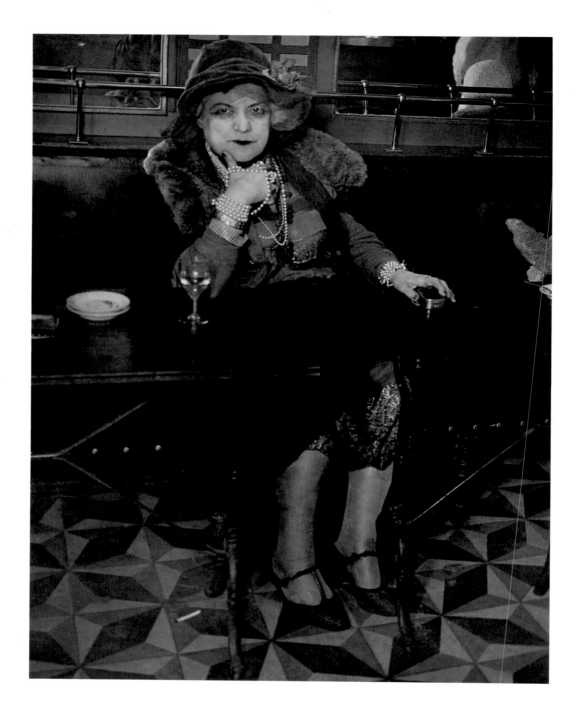

Môme Bijou at the "Bar de la Lune"
Môme Bijou in der „Bar de la Lune"
La Môme Bijou au «Bar de la Lune»
Montmartre, Paris 6ᵉ, 1932

Girl Playing Snooker
Mädchen am Billardtisch
Fille au billard russe
Boulevard Rochechouart, Paris 18ᵉ, c. 1932

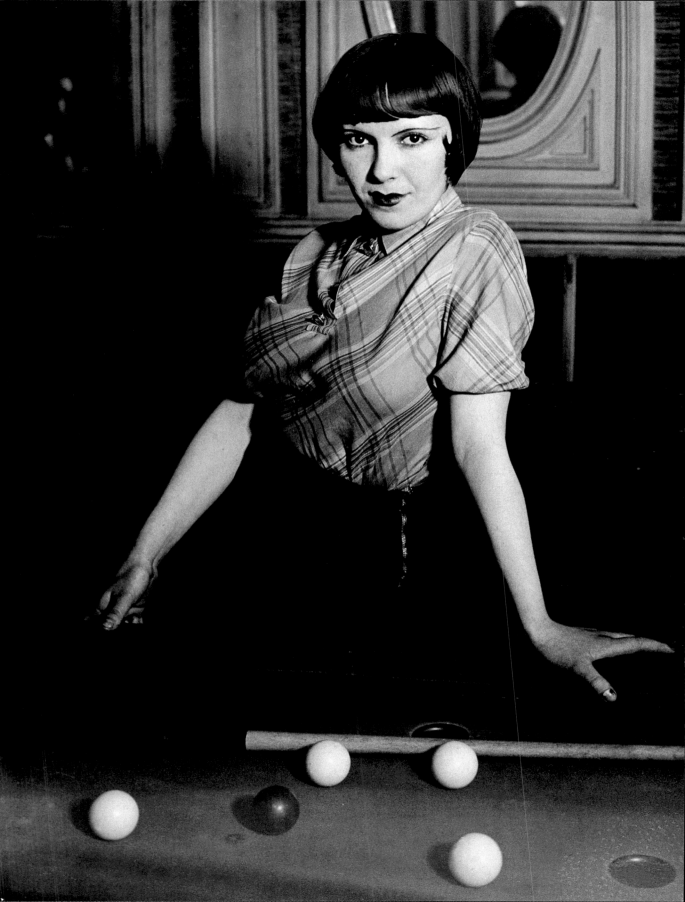

"Thanks to my endless walks through Paris, I was able to go on
and do a kind of special study of the creatures who peopled the
city at night. I was familiar with all the low life, and even with
the criminals of that time. I knew the prostitutes, the pimps, the
brothels . . . I even photographed an opium den."

„Meine unablässigen Wanderungen durch Paris haben mich dazu
gebracht, den Lebenswandel der Geschöpfe der Nacht in Paris genauer
unter die Lupe zu nehmen. Ich bin im Milieu ein und aus gegangen,
sogar bei den Gaunern und Ganoven. Die Mädchen, die Zuhälter, die
Bordelle . . . sogar eine Opiumhöhle habe ich fotografiert."

« Mes promenades continuelles dans Paris m'ont ensuite permis de
réaliser une espèce d'étude de mœurs de la faune parisienne nocturne.
J'ai fréquenté le milieu et même les voyous de l'époque. Les filles, les
souteneurs les bordels . . . j'ai même photographié une fumerie d'opium. »[3]

Brassaï

Secret Paris
Das geheime Paris
Paris secret

Streetwalker
Schöne der Nacht
Belle de nuit (de face)
Quartier Italie, Paris 13e, c. 1932

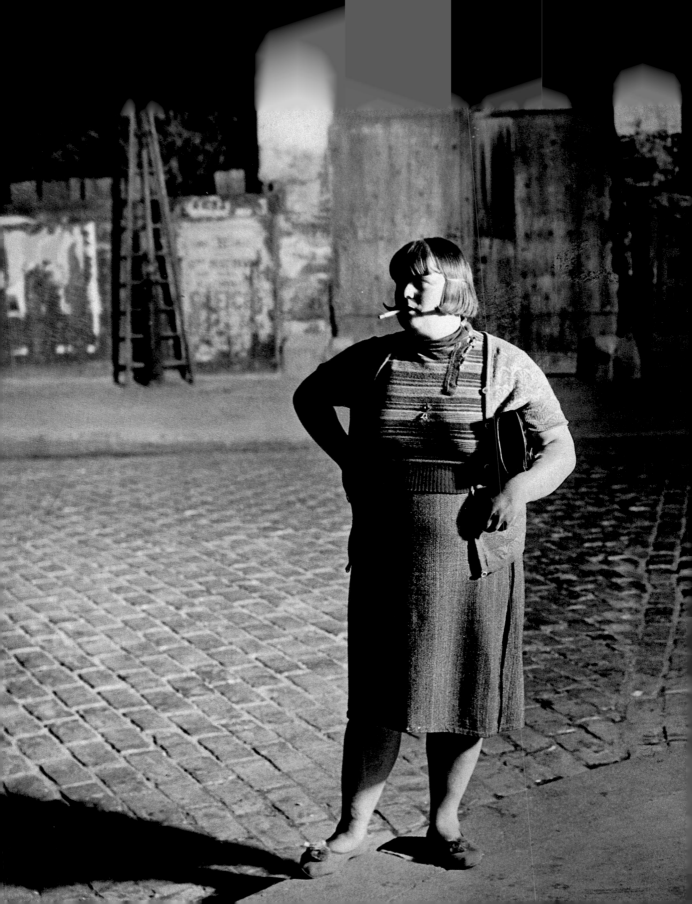

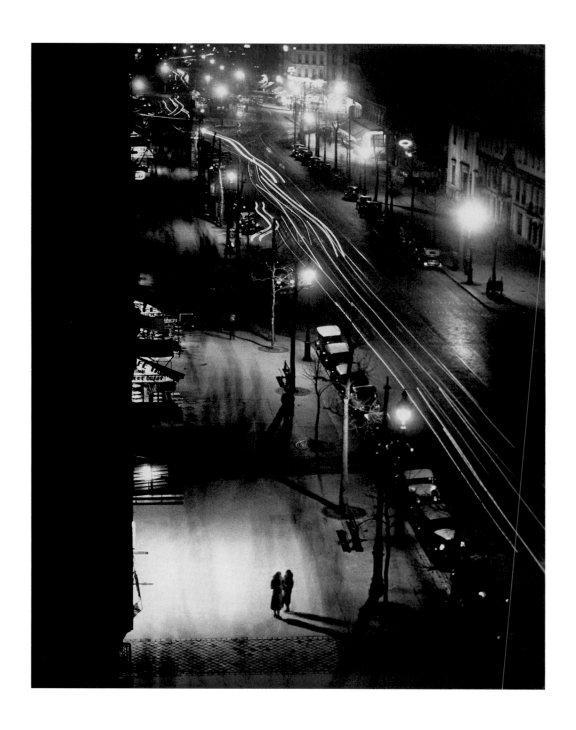

Two Prostitutes Soliciting
Zwei Mädchen auf dem Strich
Deux filles faisant le trottoir
Boulevard Montparnasse, Paris, 1932

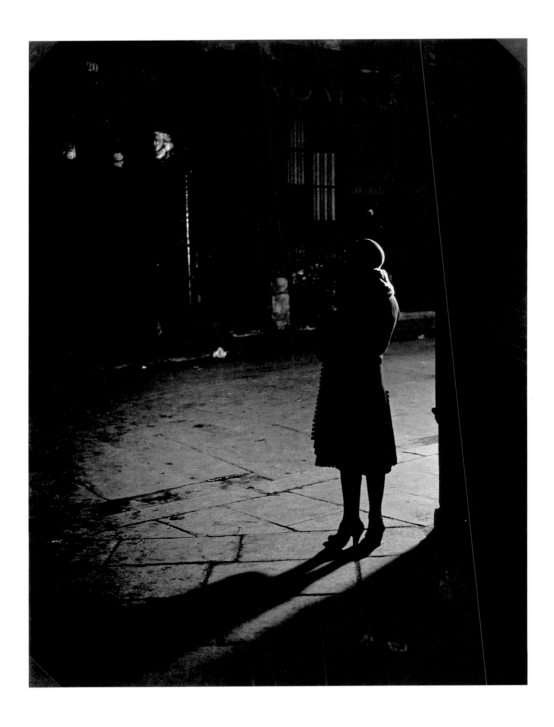

Rue Quincampoix
Paris 4e, 1932

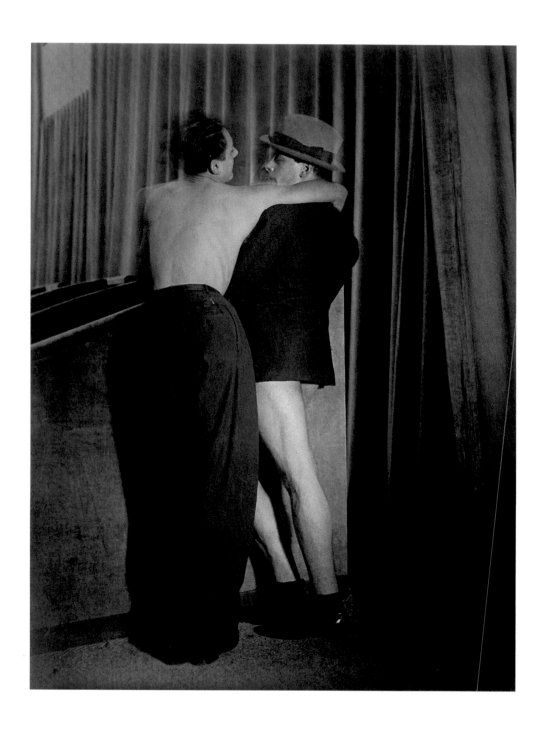

One Suit for Two: The Homosexuals' Ball at "Magic City"
Ein Anzug für zwei, auf dem Homosexuellenball im „Magic City"
Un costume pour deux, au bal des invertis du «Magic-City»
Paris, c. 1931

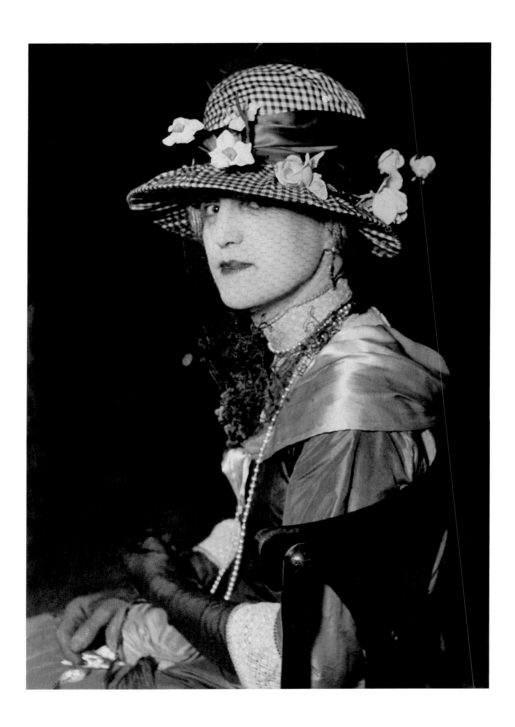

The Duchess of Zoë at the Homosexuals' Ball at "Magic City"
Die Herzogin von Zoë auf dem Homosexuellenball im „Magic-City"
La duchesse de Zoë au bal des invertis du «Magic-City»
Paris, 1932

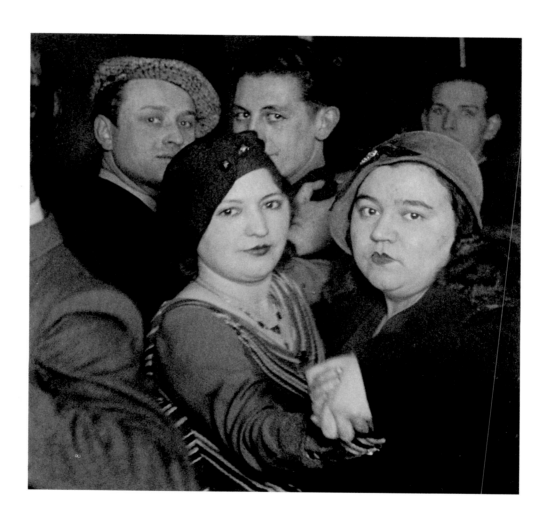

"Brassaï is a living eye … his gaze pierces straight to the heart of truth in everything. Like a falcon, or a shark, we see him quiver, then plunge at reality."

„Brassaï ist ein lebendiges Auge … sein Blick dringt direkt ins Herz der Dinge vor. Wie einen Falken oder einen Hai sehen wir ihn zittern, bevor er sich auf die Wirklichkeit stürzt."

« Brassaï est un œil vivant… ses yeux ont cette véracité qui étreint tout et qui fait du faucon et du requin la sentinelle frémissante de la réalité. »

Henry Miller

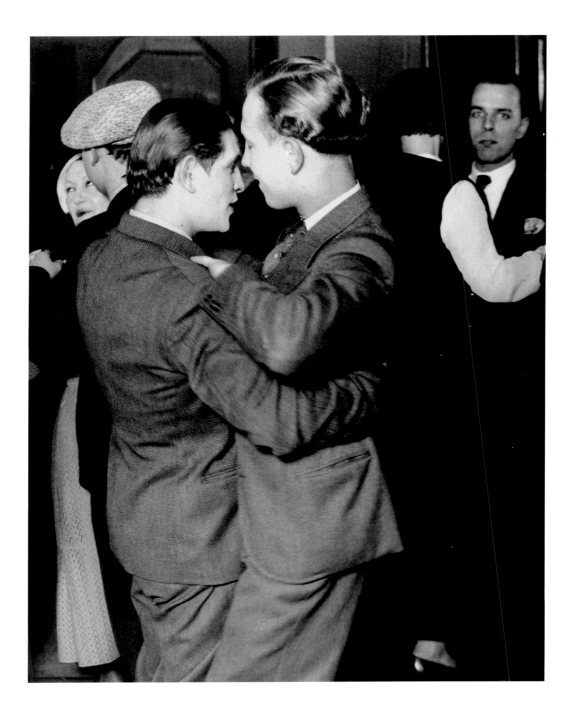

Homosexual Couples at the Montagne Sainte-Geneviève Dance
Homosexuelle Paare auf dem Ball der Montagne Sainte-Geneviève
Couples d'homosexuels au bal de la Montagne Sainte-Geneviève
Paris 5ᵉ, 1932

Young Couple at the Montagne Sainte-Geneviève Dance
Junges Paar auf dem Ball der Montagne Sainte-Geneviève
Jeune couple au bal de la Montagne Sainte-Geneviève
Paris 5ᵉ, c. 1931

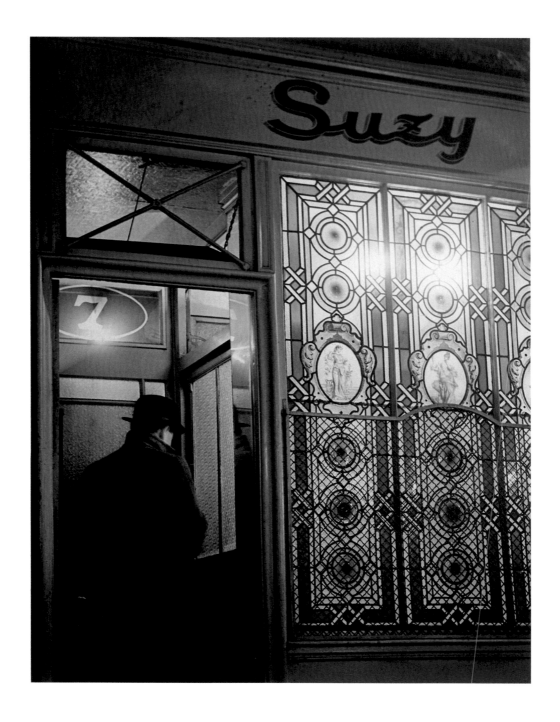

At Suzy's
Bei Suzy
Chez Suzy
Rue Grégoire-de-Tours, Paris 6ᵉ, c. 1932

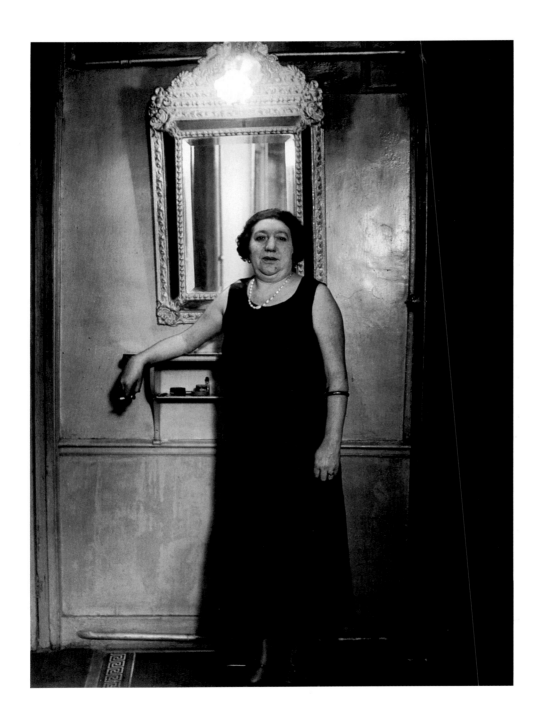

The Deputy Madame at Suzy's
Die zweite Dame vom „Chez Suzy"
La sous-maîtresse de «Chez Suzy»
Rue Grégoire-de-Tours, Paris 6ᵉ, c. 1932

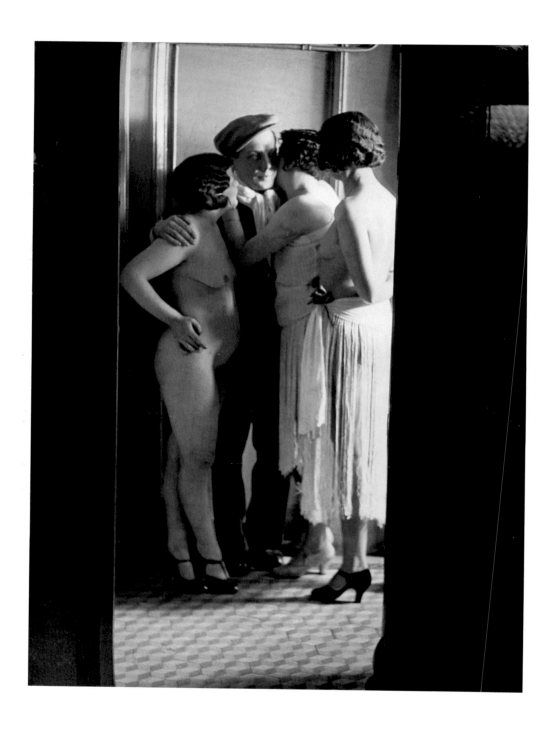

At Suzy's
Bei Suzy
Chez Suzy
Rue Grégoire-de-Tours, Paris 6ᵉ, c. 1932

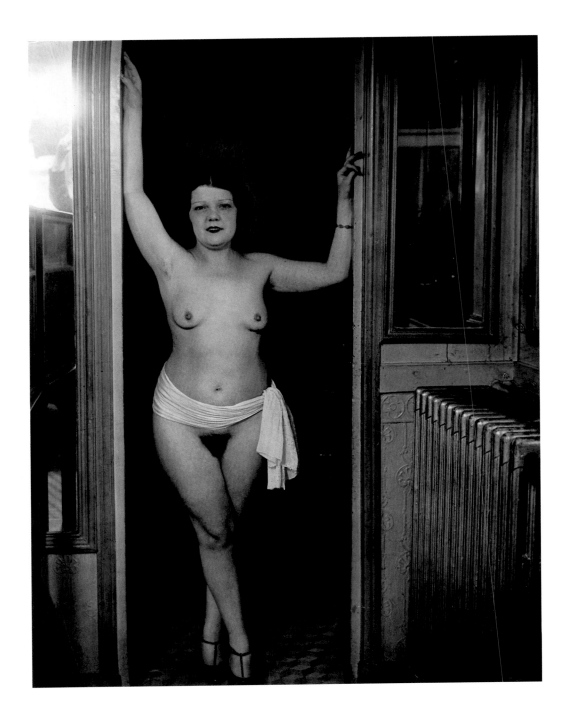

At Suzy's (woman with sash)
Bei Suzy (Frau mit Lendentuch)
Chez Suzy (femme au ruban)
Rue Grégoire-de-Tours, Paris 6ᵉ, c. 1932

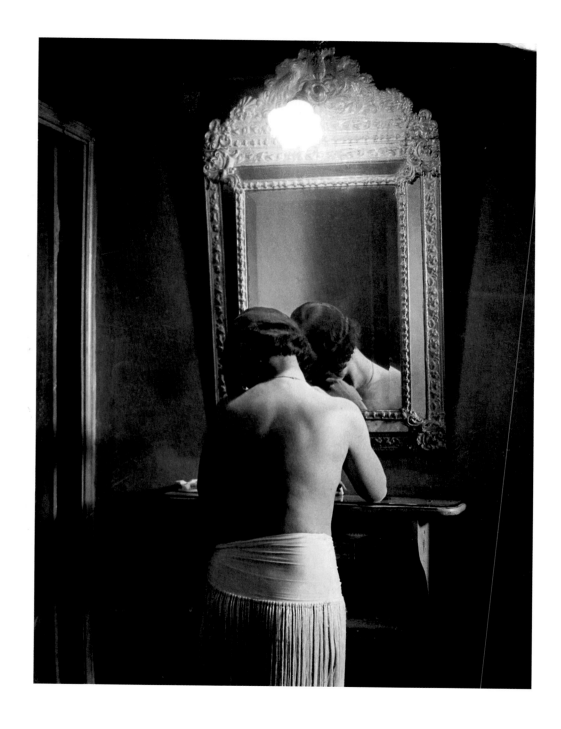

At Suzy's
Bei Suzy
Chez Suzy
Rue Grégoire-de-Tours, Paris 6ᵉ, c. 1931–1932

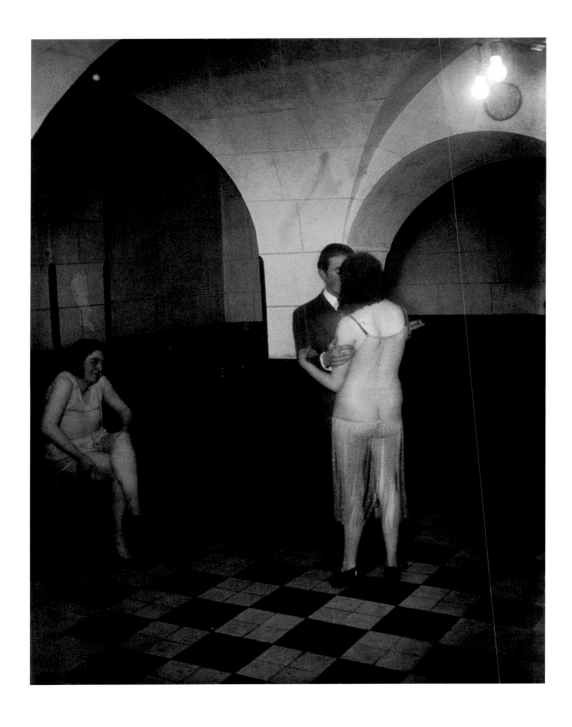

A Monastic Brothel
Klösterliches Bordell
Une maison close monacale
Rue Monsieur-le-Prince, Paris 6ᵉ, c. 1931

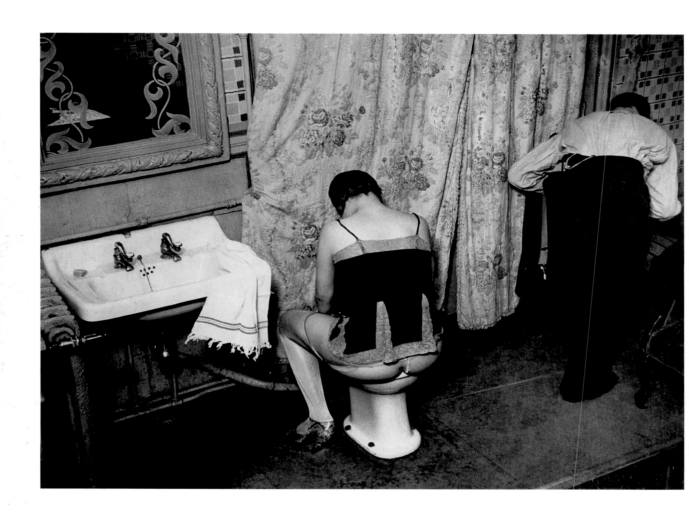

<div style="float:left">

Getting Dressed
Ankleiden in einem Stundenhotel
La toilette dans un hôtel de passe
Rue Quincampoix, Paris 4ᵉ, c. 1932

</div>

<div style="float:right">

Getting Dressed
Ankleiden in einem Stundenhotel
Toilette dans une maison de passe
Rue Quincampoix, Paris 4ᵉ, c. 1932

</div>

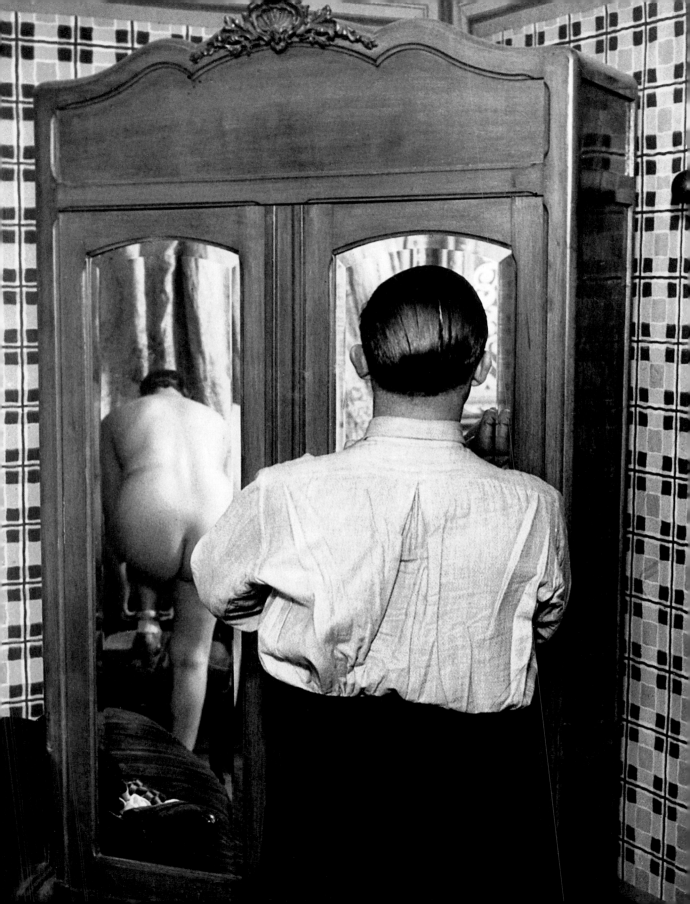

Day Visions
Bei Tageslicht
Visions de jour

"I don't invent anything. I imagine everything ... most of the
time, I have drawn my images from the daily life around me.
I think that it is by capturing reality in the humblest, most
sincere, most everyday way I can, that I can penetrate to the
extraordinary."

"Ich erfinde nichts. Ich stelle nur alles vor ... Fast immer habe ich meine
Bilder aus dem täglichen Leben ringsum geschöpft. Ich meine, dass das
die ehrlichste und demütigste Art ist, das Reale, das Alltäglichste zu
erfassen, und zum Fantastischen zu führen."

»Je n'invente rien. J'imagine tout ... la plupart du temps, j'ai puisé mes
images dans la vie journalière autour de moi. Je pense que c'est la saisie
la plus sincère et la plus humble du réel, du plus quotidien, qui mène au
fantastique.«1

Brassaï

Hotels used by Prostitutes in the rue Quincampoix
Die Rue Quincampoix und ihre Stundenhotels
La rue Quincampoix et ses hôtels de passe
Paris 4e, c. 1932

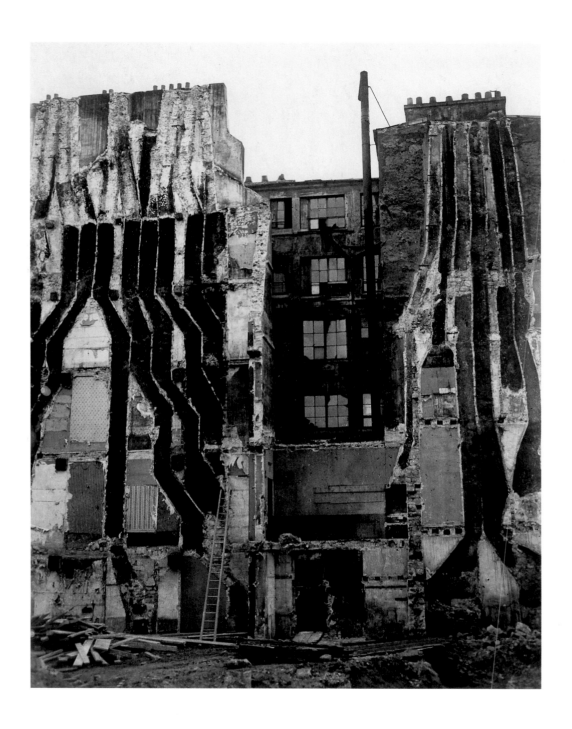

Ruined Walls
Zerstörte Häuserwände
Murs détruits
Rue Simon-le-Franc, Paris 4ᵉ, 1931

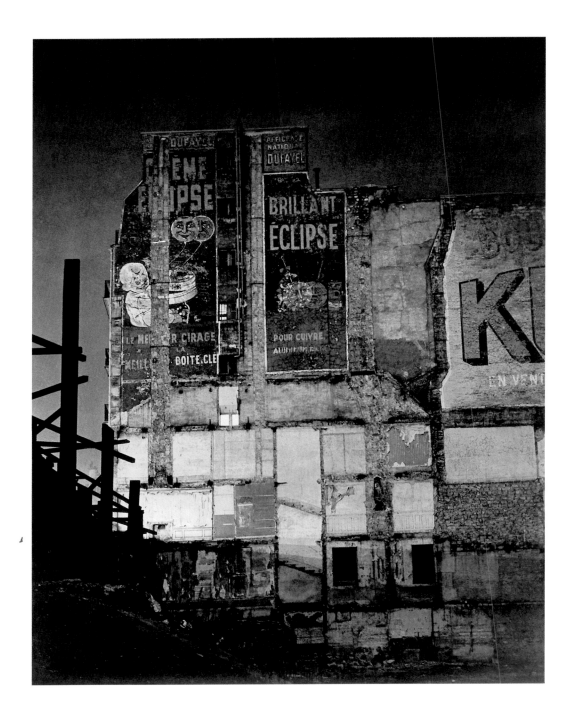

Walls of the former Bullier Dance Hall
Hauswand des ehemaligen Bal Bullier
Murs de l'Ancien Bal Bullier (« Crème éclypse – bébé »)
Avenue de l'Observatoire, Paris 14ᵉ, c. 1933–1934

The Obelisk on the Place de la Concorde during the War
Obelisk an der Place de la Concorde während des Krieges
L'obélisque de la Concorde pendant la guerre
Paris 8ᵉ, 1939–1940

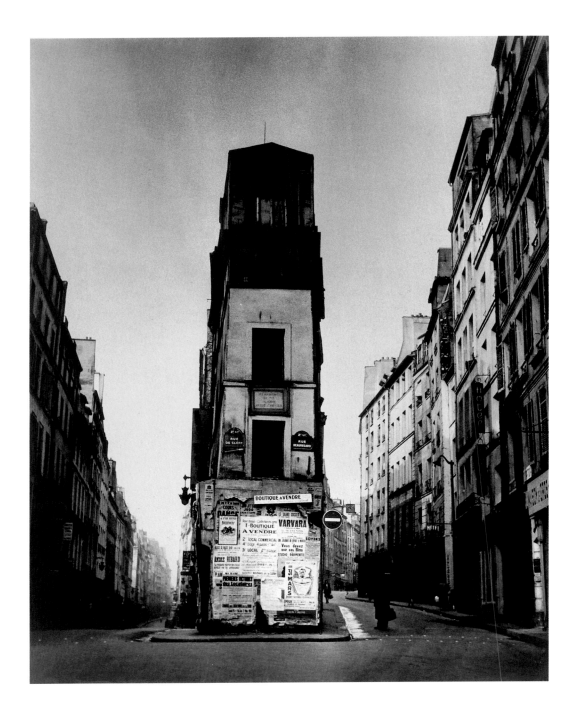

André Chénier's House, on the corner of rue de Cléry and rue Beauregard
Das Haus von André Chénier, Ecke Rue de Cléry/Rue Beauregard
Maison d'André Chénier, angle rue de Cléry – rue Beauregard
Paris 2ᵉ, c. 1939

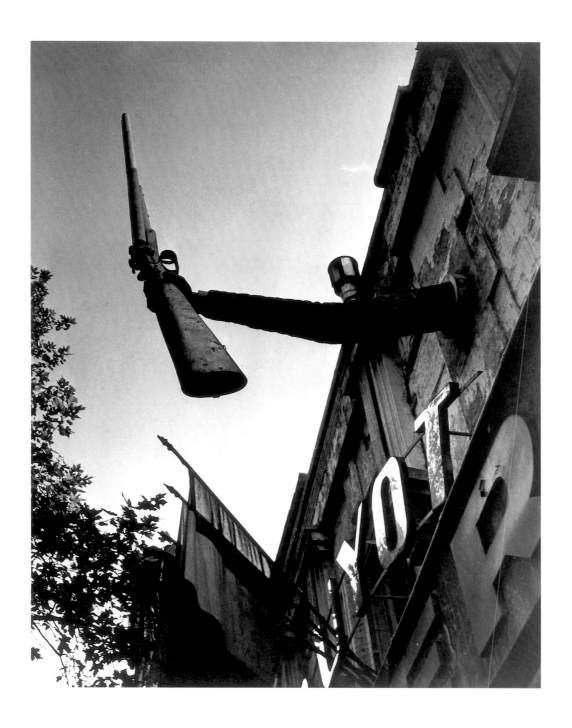

Sign
Zeichen
Enseigne
1931–1932

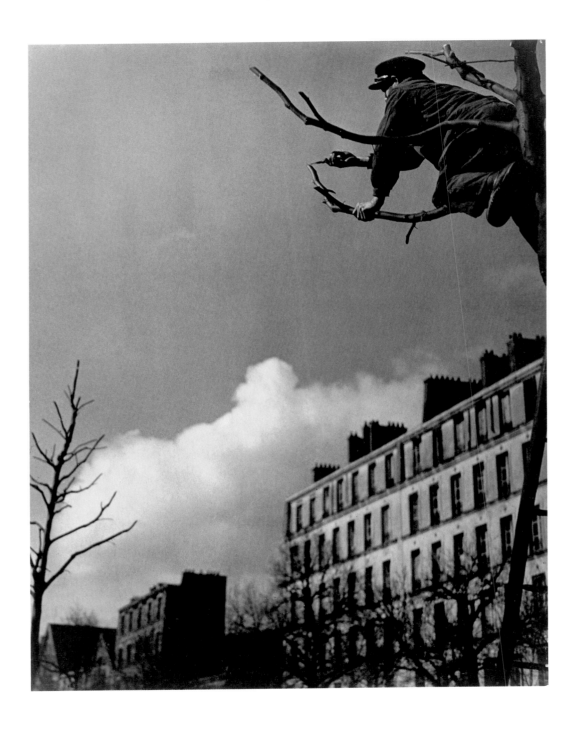

Pruning (manicure for trees)
Auslichter: Baumpflege
L'élagueur (toilette de l'arbre)
Paris, 1931

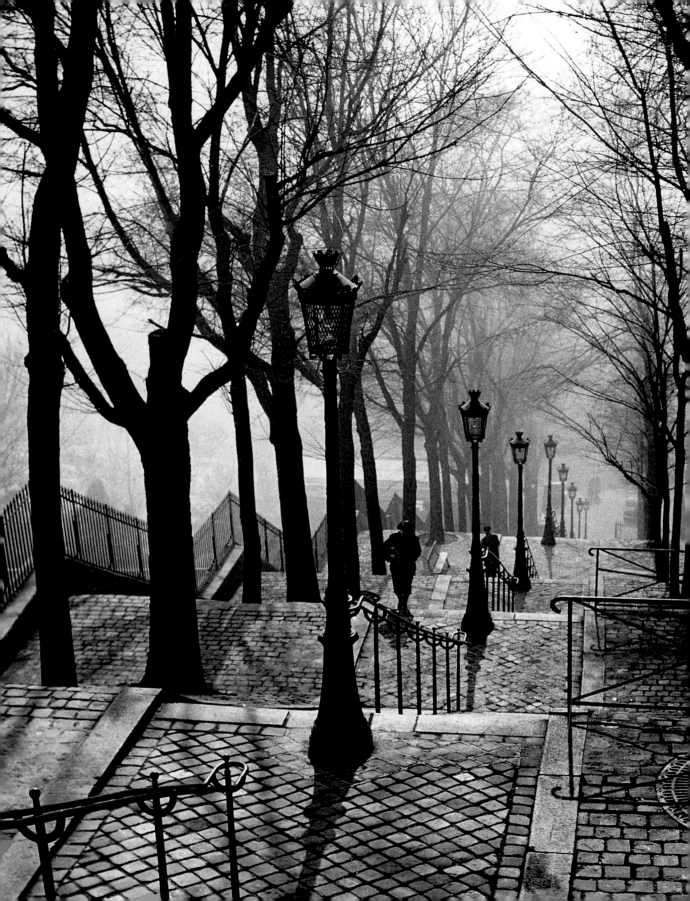

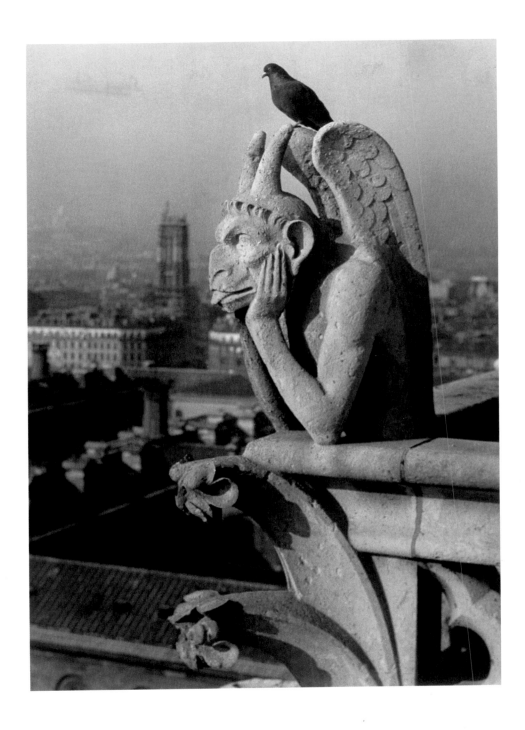

Stairs in Montmartre
Treppen an der Butte Montmartre
Escalier de la Butte Montmartre
Paris 18ᵉ, c. 1935–1937

Notre-Dame de Paris (devil and pigeon)
Notre-Dame de Paris (Teufel und Taube)
Notre-Dame de Paris (diable et pigeon)
Paris 1ᵉʳ, undated, o. J., s. d.

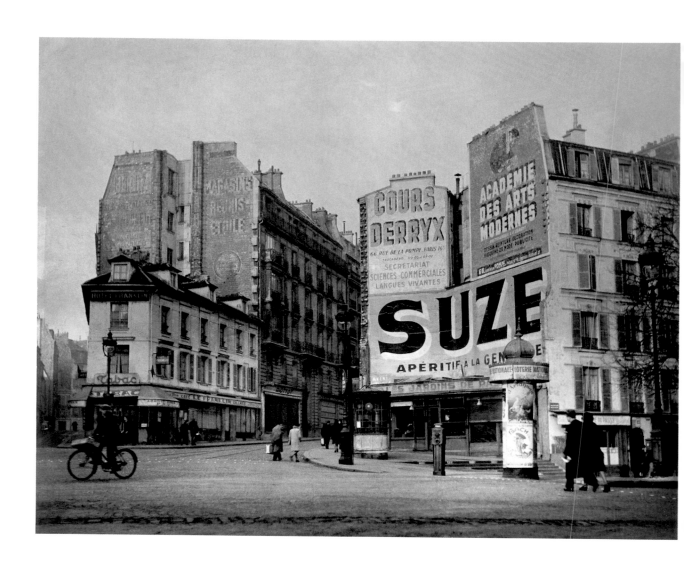

"My ambition has always been to show the everyday city as if we were discovering it for the first time."

„Mein Ehrgeiz hat immer darin bestanden, einen Aspekt der Stadt, wie sie uns täglich begegnet, so sichtbar zu machen, als entdeckten wir sie gerade zum ersten Mal."

« Mon ambition fut toujours de faire voir un aspect de la ville quotidienne comme si nous la découvrions pour la première fois. »

Brassaï

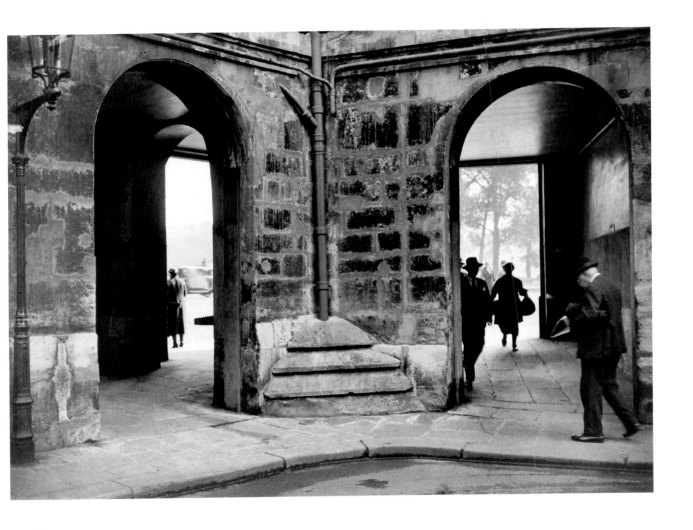

Quartier Passy
Paris 16ᵉ, 1940

The Institut de France, Passage Mazarine
Institut de France, Mazarine-Passage
L'Institut, passage Mazarine
Paris 6ᵉ, c. 1931

"I've always hated specialisation. That's why I've constantly changed the medium in which I express myself … That way I can breathe, I can see things anew …"

„Jede Art von Spezialisierung war mir immer ein Graus. Darum habe ich ständig mein Ausdrucksmedium gewechselt … Das hat mich erfrischt, meine Sichtweise erneuert …"

«J'ai toujours eu horreur de toute spécialisation. C'est pourquoi j'ai constamment changé mon médium d'expression… cela me donne de l'air, me rafraîchit la vision…»[3]

Brassaï

The Kiss
Der Kuss
Le Baiser
c. 1935–1937

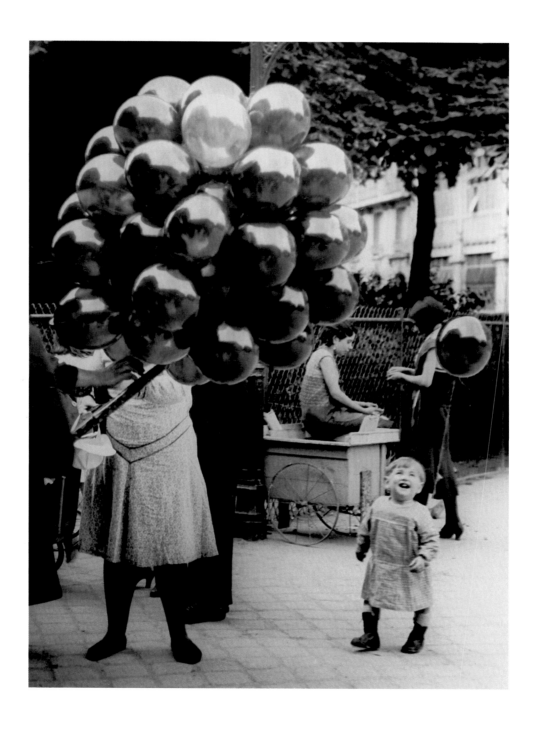

Balloon Seller
Die Ballonverkäuferin (Kinderlächeln)
La marchande de ballons (l'enfant souriant)
Paris, 1931

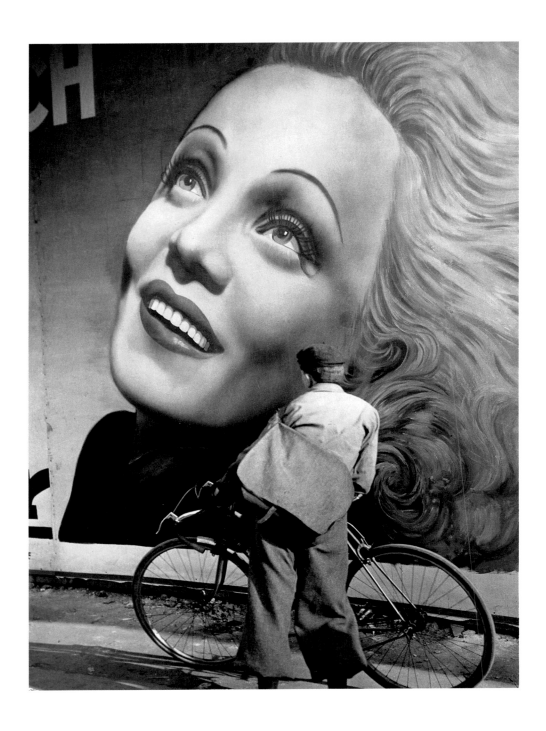

Marlène
Paris, 1937

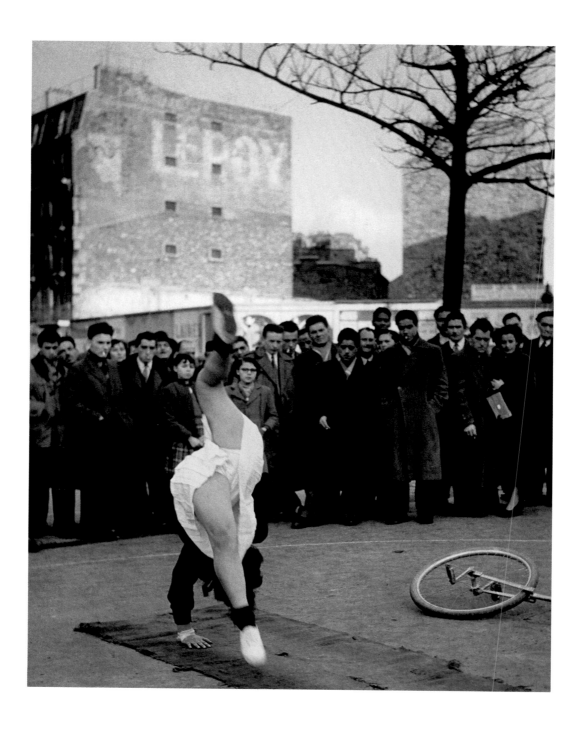

The Little Acrobat
Die kleine Gauklerin
La petite saltimbanque
Ménilmontant, Paris 20ᵉ, c. 1935

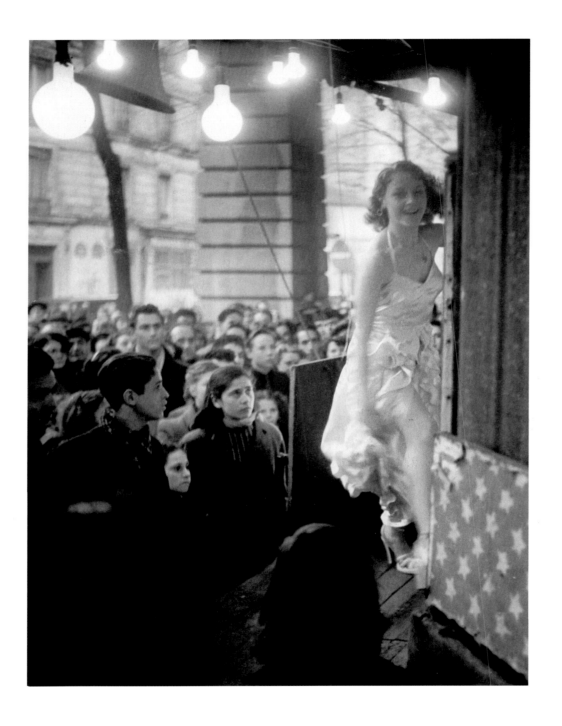

Wanda
Paris, 1950–1951

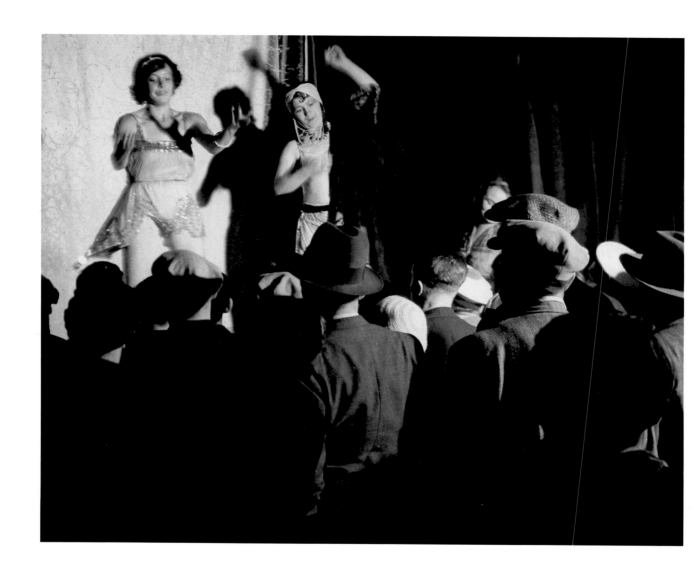

Conchita Dancing in the Tent of
"Her Majesty Woman"
Conchitas Tanz in der Bude „Ihre Majestät, die Frau"
La danse de Conchita dans la baraque
« Sa majesté la femme »
Boulevard Auguste Blanqui, Paris 14ᵉ, c. 1931

Three Women Wearing Masks for the Parade
Die drei maskierten Frauen, Jahrmarktsparade
Les trois femmes masquées pour la Parade
Boulevard Saint-Jacques, Paris 14ᵉ, c. 1931

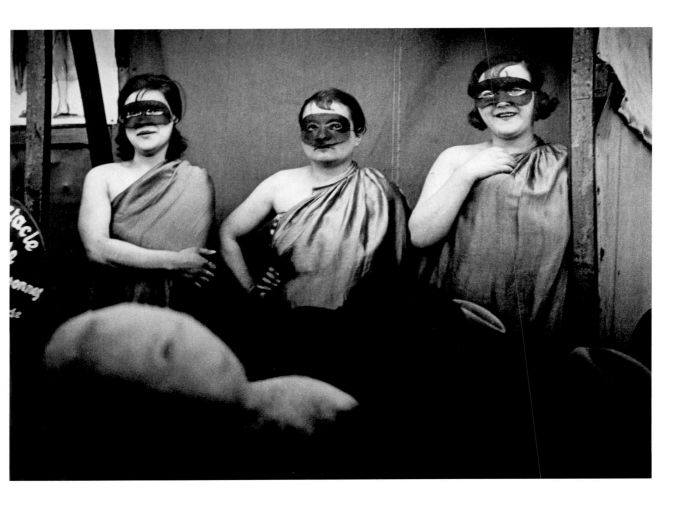

"*Even when dealing with what is fragmentary, defective, or vulgar, Brassaï manages to discover something new, something perfect … For him, seeing is an end in itself.*"

„*Selbst im Fragmentarischen, Mangelhaften, Vulgären entdeckt Brassaï etwas Neues und Perfektes … Sehen wird für ihn zum Selbstzweck.*"

«*Même dans le fragmentaire, le défectueux, le vulgaire, Brassaï décèle la nouveauté et la perfection… Voir pour lui, devient une fin en soi.*»

Henry Miller

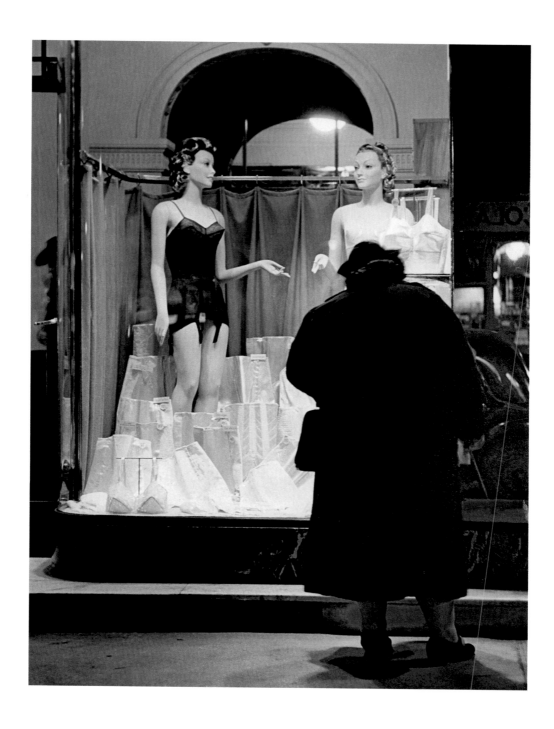

The Dream – Shop Window on the Boulevards
Der Traum – auf den großen Boulevards
Le rêve – Sur les grands boulevards
Paris, c. 1934

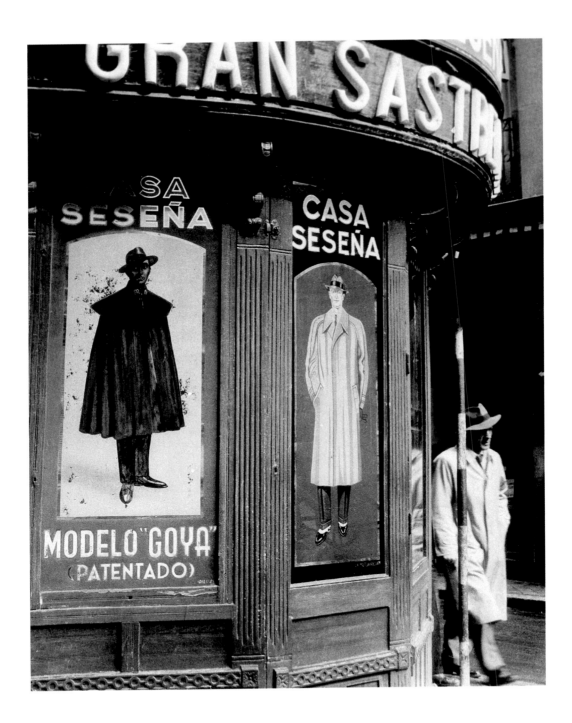

Tailor's Shopfront
Schaufenster einer Schneiderwerkstatt
Façade d'un tailleur
Madrid, 1950

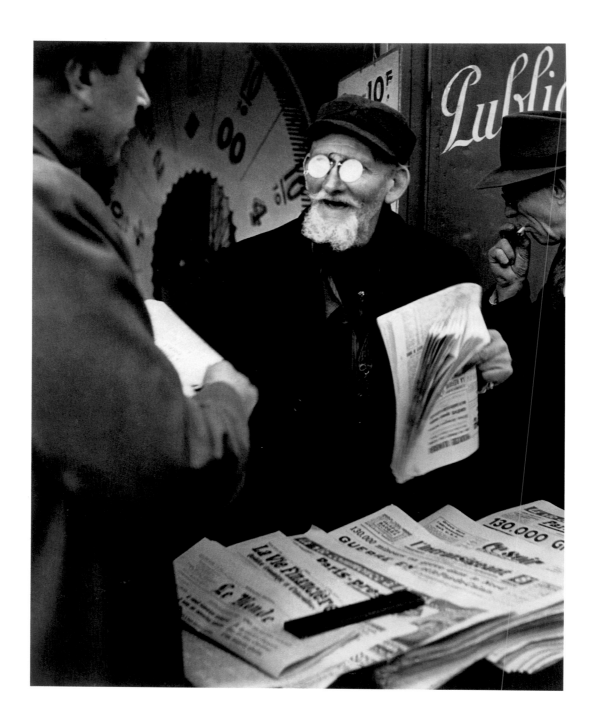

Newspaper Vendor
Zeitschriftenhändler
Marchand de journaux
Place Denfert-Rochereau, Paris 14ᵉ, 1948

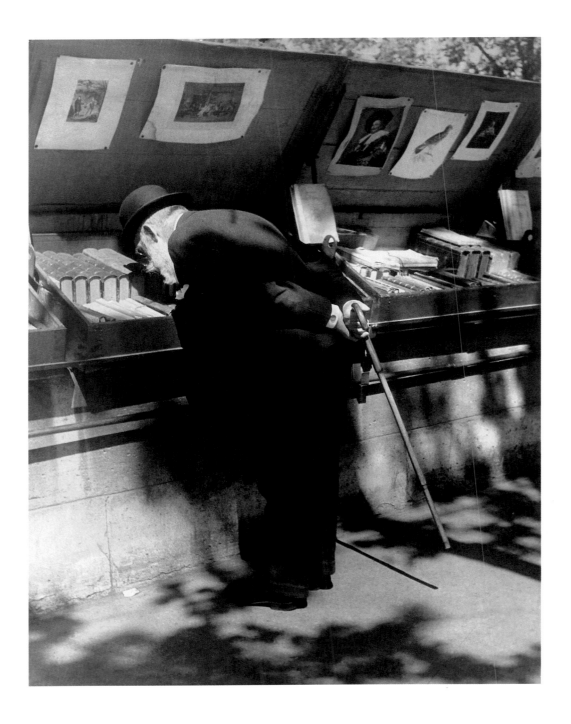

Professor Louis Dimier, Member of the Institute, on the bank of the Seine
Professor Louis Dimier, Mitglied des Instituts, am Seine-Kai
Le professeur Louis Dimier, membre de l'Institut sur les quais de la Seine
Paris, 1931–1932

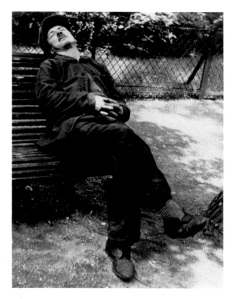
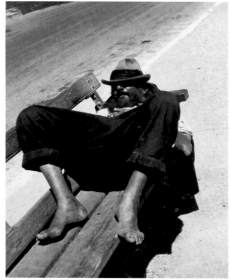
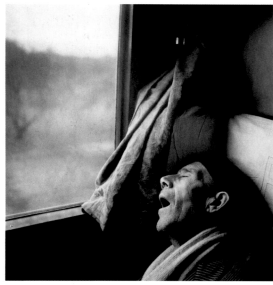
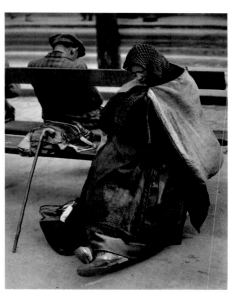

Man Sleeping on a Bench
Schlafender Mann auf einer Bank
Homme endormi sur un banc
Place Denfert-Rochereau, Paris 14ᵉ, 1933–1934

On the Rome–Naples Express
Im Express Rom–Neapel
Dans le Rome–Naples Express
1955

Tramp in Cannes
Clochard in Cannes
Clochard à Cannes
1932–1934

Tramps
Clochards
Clochards
Boulevard Rochechouard, Paris 18ᵉ, c. 1932–1935

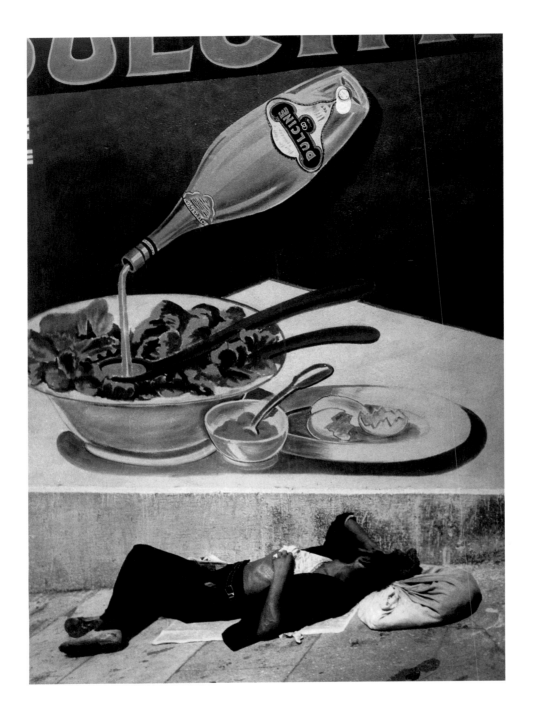

Tramp in Marseilles
Vagabund in Marseille
Vagabond à Marseille
1935

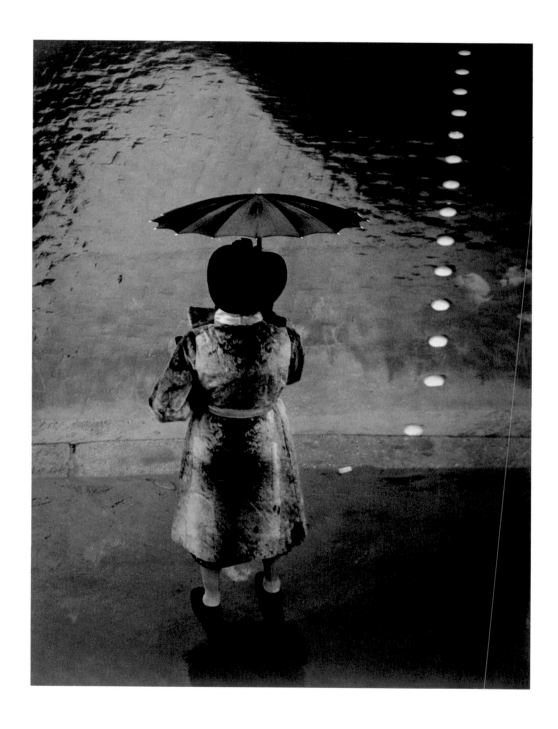

Rue de Rivoli
Paris 1ᵉʳ, 1935–1937

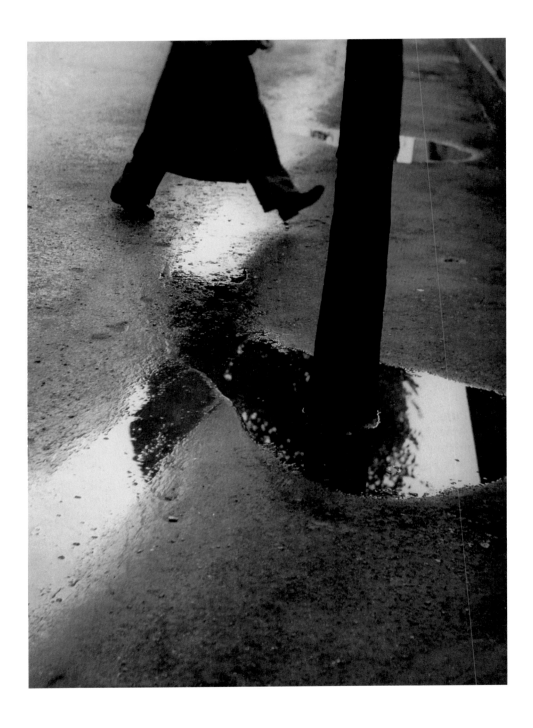

Legs Stepping over Puddles
Beine, über Pfützen steigend
Jambes enjambant flaques d'eau
undated, o. J., s. d.

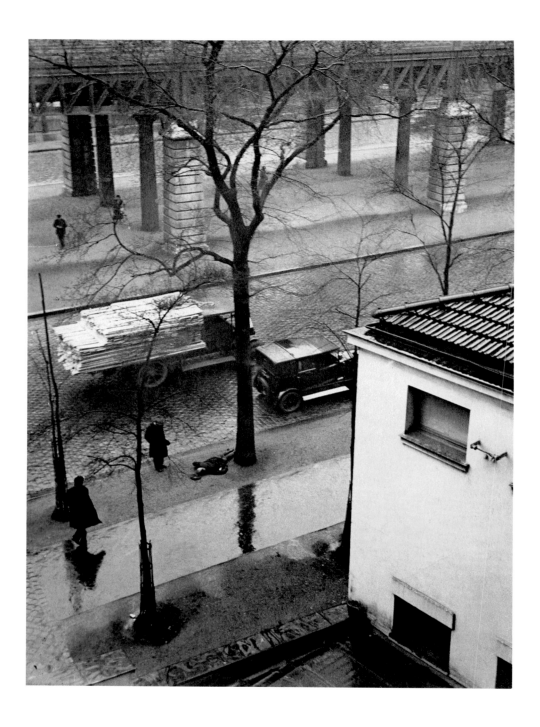

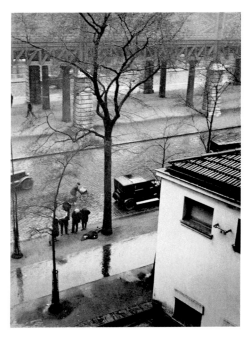
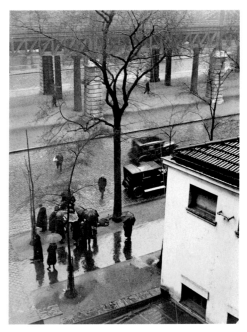
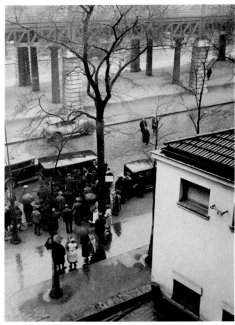
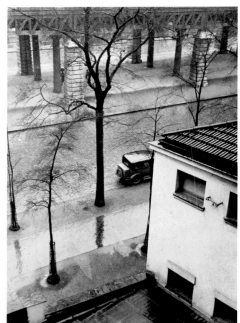

A Man Dies in the Street
Ein Mann stirbt auf der Straße
Un homme meurt dans la rue
Boulevard de la Glacière, Paris 13ᵉ, 1932

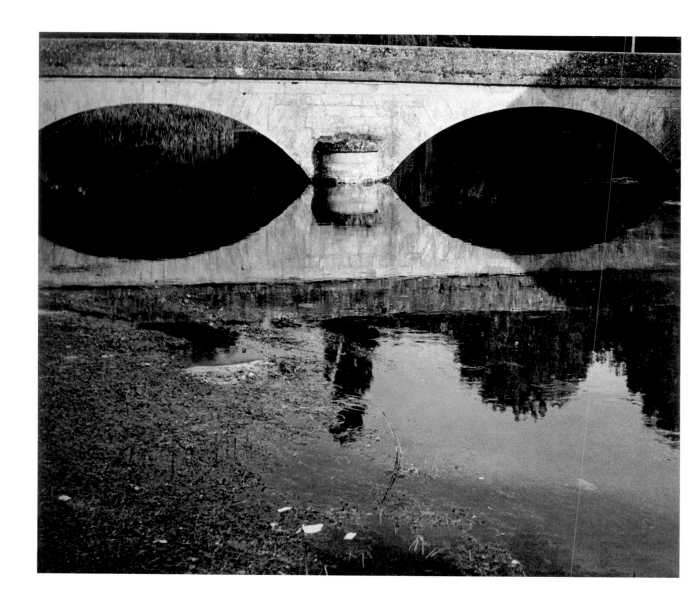

"If you take your inspiration from nature, you don't invent anything, because what you want to do is to interpret something. But still, everything passes through your imagination. What you produce at the end is very different from the reality you started with."

„Wer sich von der Natur anregen lässt, erfindet nichts, denn er will etwas interpretieren. Aber alles läuft durch seine Imagination hindurch, und das, was er am Ende schafft, unterscheidet sich sehr von der Realität."

« Quelqu'un qui s'inspire de la nature n'invente rien puisqu'il veut interpréter quelque chose. Mais tout passe par son imagination et ce qu'il a réalisé a, finalement, une grande différence avec la réalité. »[3]

Brassaï

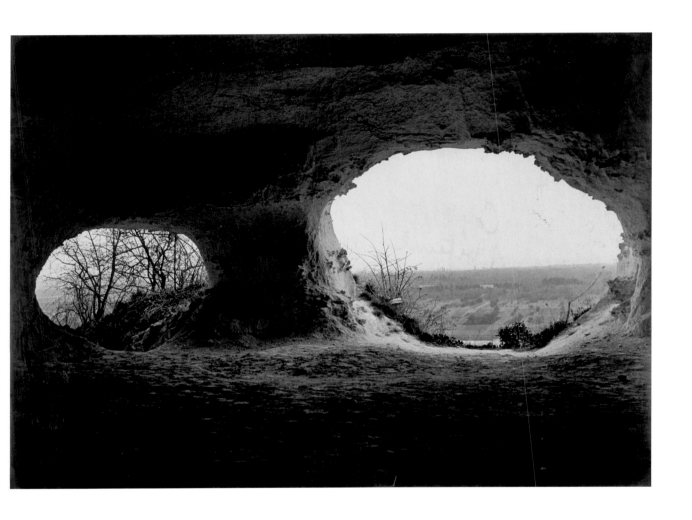

The Bridge of Eyes
Die „Augen-Brücke"
Pont « les yeux »
Brantôme, undated, o. J., s. d.

Cave Dweller
Höhlenbewohner
Troglodyte
c. 1935

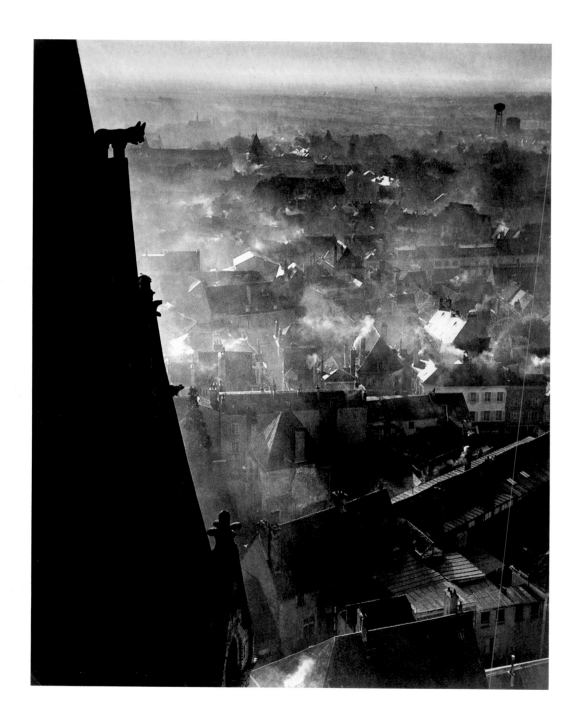

Chartres in Winter
Chartres im Winter
Chartres en hiver
1946

Isère Valley
Felder in den Bergen
Champs alpestres
French Alps, Französische Alpen, Alpes françaises, 1937

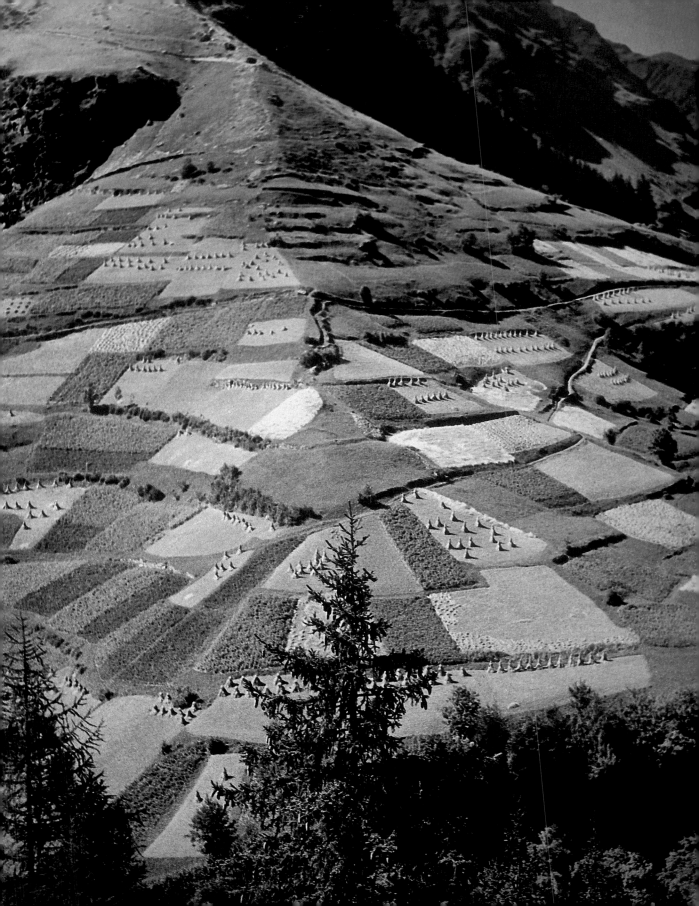

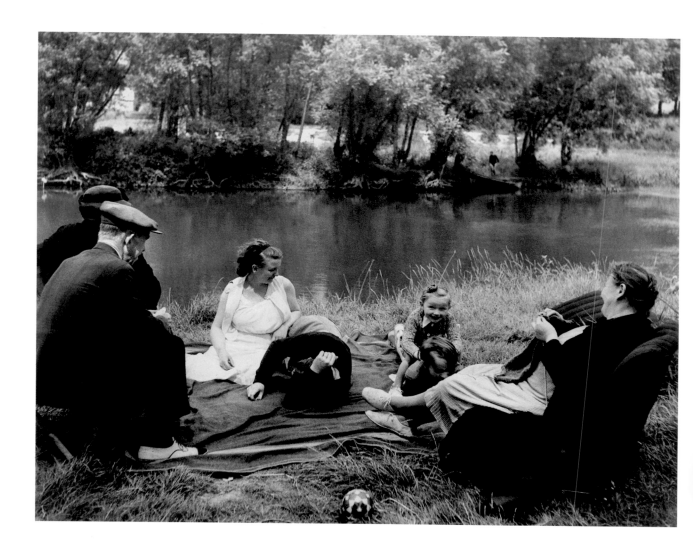

A Day Out in the Country (grandmother and grandchildren on the banks of the Marne)
Landpartie (Großmutter mit Enkeln am Marne-Ufer)
Partie de campagne (grand-mère et petits-enfants au bord de la Marne)
1939

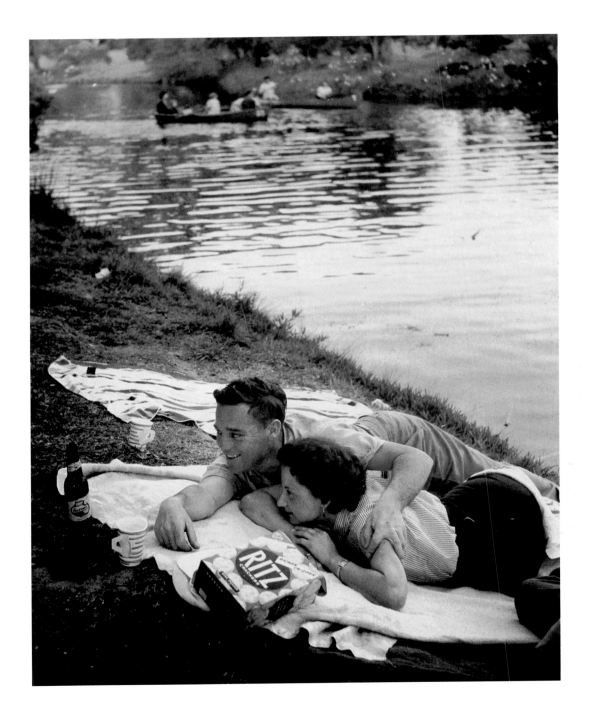

Couple Lying beside a Lake
Paar am Seeufer
Couple étendu au bord d'un lac
Louisiana, 1957

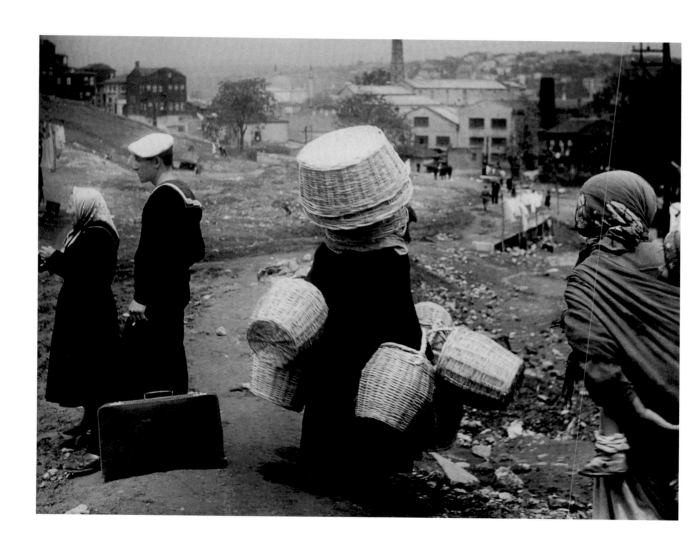

Basket Sellers in Istanbul
Korbhändler in Istanbul
Marchands de paniers à Istanbul
1953

Two Men Posing for a Travelling Photographer
in Istanbul
Zwei Männer, die in Istanbul vor einem
Wanderfotografen posieren
Deux hommes posant pour un photographe ambulant
à Istanbul
1953

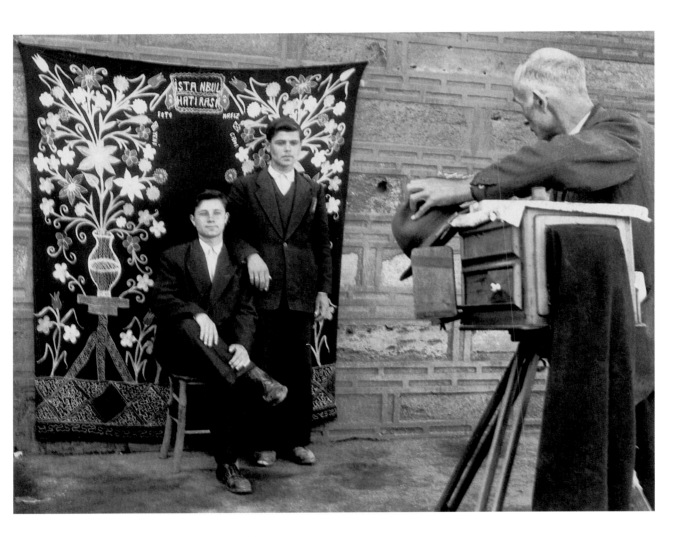

"In any case, I always took people by surprise, for they never knew at what exact moment I was going to take the shot … In addition, given the kind of equipment available at that time, I often needed artificial light: so I would have someone to help me who would be holding a magnesium flare. As a result, no one knew when I was going to press the shutter."

„Jedenfalls habe ich die Leute immer überrascht, weil sie nie wussten, in welchem Augenblick ich abdrücken würde … Außerdem brauchte ich angesichts des damals zur Verfügung stehenden Materials häufig künstliches Licht und ließ mir von einer anderen Person helfen, die das Magnesium hielt. Schon darum konnte man nicht wissen, in welchem Augenblick ich auf den Auslöser drücken würde."

« De toute façon je surprenais toujours les gens parce qu'ils ignoraient à quel moment j'enregistrais… De plus, vu le matériel de l'époque, j'avais souvent besoin de lumière artificielle et je me faisais aider d'une autre personne qui tenait le magnésium, ce qui fait que l'on ne pouvait pas savoir à quel moment j'allais déclencher. » [3]

Brassaï

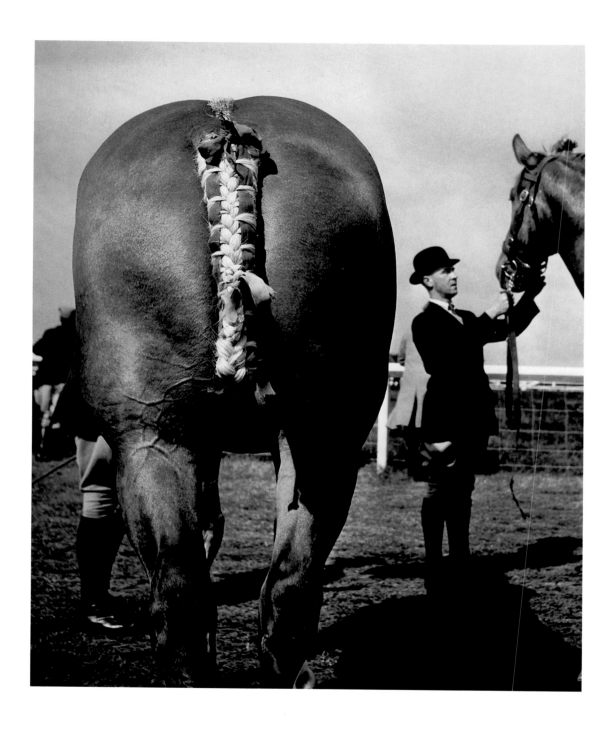

The Royal Horse Show
Newcastle, England, Angleterre, 1959

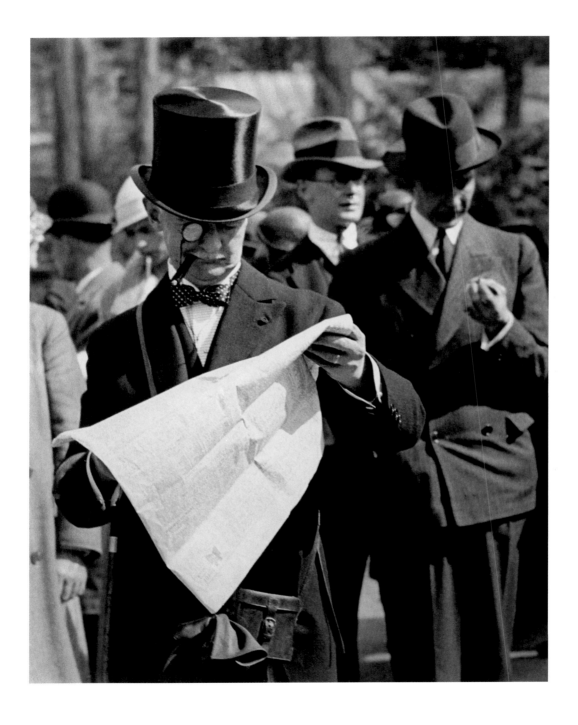

Longchamp Races (race-goer with monocle reading the newspaper)
Beim Pferderennen in Longchamp (Rennsport-Anhänger liest mit Monokel die Zeitung)
Les courses à Longchamp (turfiste au monocle lisant son journal)
1932

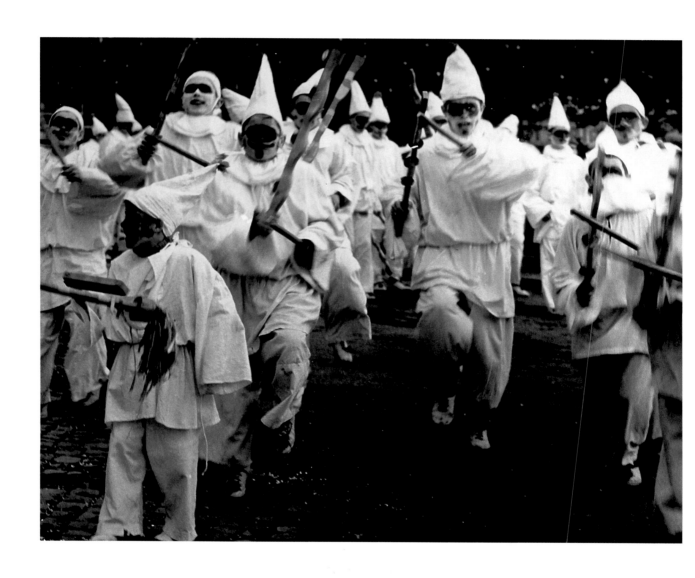

Frascati Carnival
Karneval in Frascati
Carnaval de Frascati
Italy, Italien, Italie 1954

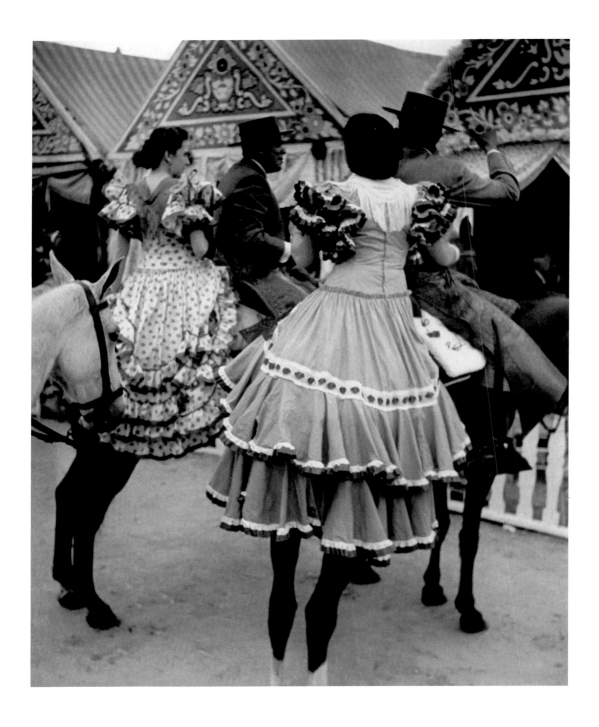

Fair in Seville
Feria in Sevilla
Féria à Séville
1951

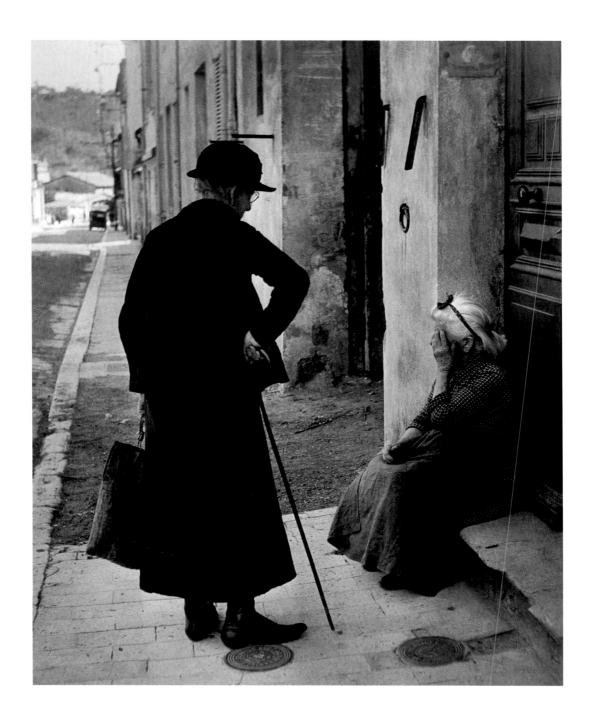

Street Scene in Vallauris
Straßenszene in Vallauris
Scène de rue à Vallauris
1946–1948

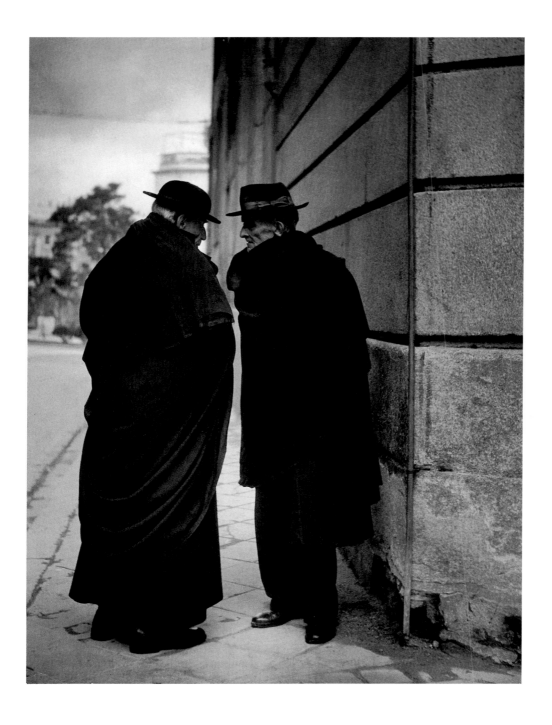

Conversation in Madrid
Begegnung in Madrid
Colloque à Madrid
c. 1950–1951

Artists of My Life
Begegnungen mit Künstlern
Artistes de ma vie

"As a photographer, I never restricted myself to a particular subject. I photographed whatever happened to catch my attention: faces, street scenes, landscapes, or any one of the thousands of chance events of everyday life. Art and artists were a part of my own day-to-day life in Paris."

„Als Fotograf habe ich mich nie auf ein bestimmtes Sujet beschränkt. Alles, was meine Aufmerksamkeit auf sich lenkte, nahm ich auf: Gesichter, Straßenszenen, Landschaften oder eine der tausend zufälligen Ereignisse des täglichen Lebens. Und zu meinem täglichen Leben in Paris gehörten Kunst und Künstler dazu."

«Dans la photographie même, je ne me suis jamais cantonné à un seul sujet, je photographiais tout ce qui m'intéressait : des visages, la rue, des paysages et les mille aspects de la vie quotidienne. L'art et les artistes font partie de ma vie. » 5

Brassaï

Picasso
Rue des Grands-Augustins, Paris 6e, 1939

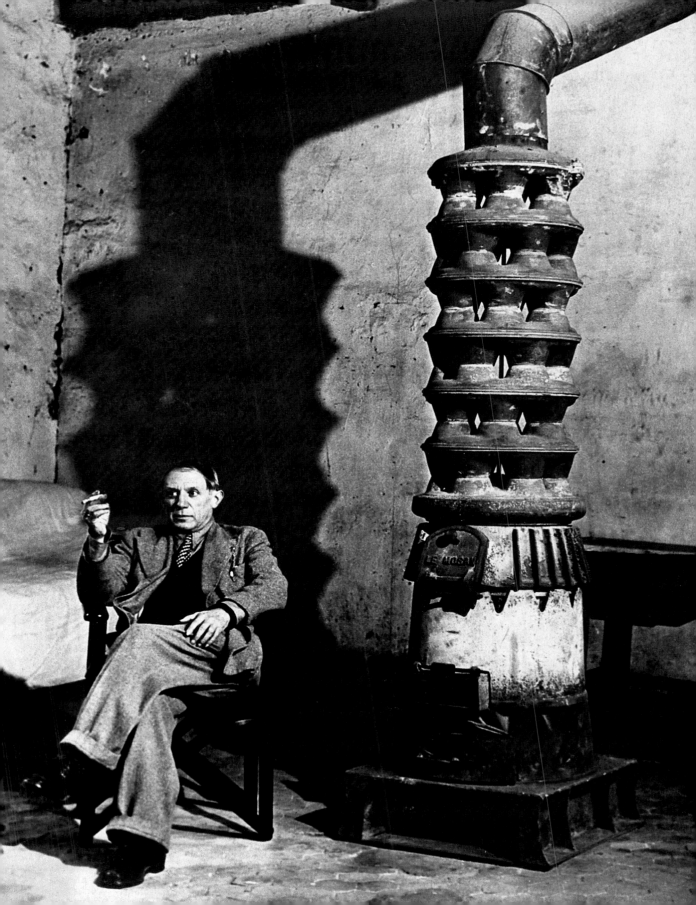

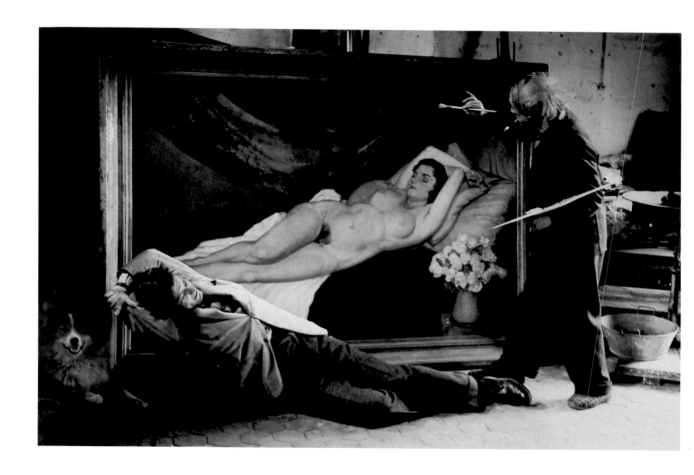

"I had climbed the winding staircase to Picasso's studio on the Rue des Grands-Augustins in Paris countless times to see, written in the painter's own hand, the huge ICI, or HERE, drawn on the wall to indicate the entrance."

„Unzählige Male war ich die Wendeltreppe zu Picassos Atelier in der Rue des Grands-Augustins hochgestiegen und hatte an der Wand das riesige, vom Künstler mit eigener Hand geschriebene ICI (HIER) gesehen, das den Eingang bezeichnete."

« Chez Picasso, rue des Grands-Augustins à Paris, en haut d'un escalier en colimaçon que j'ai grimpé tant de fois, à côté du bouton de sonnette un gigantesque ICI tracé à la main signalait l'entrée de son atelier. »[15]

Brassaï

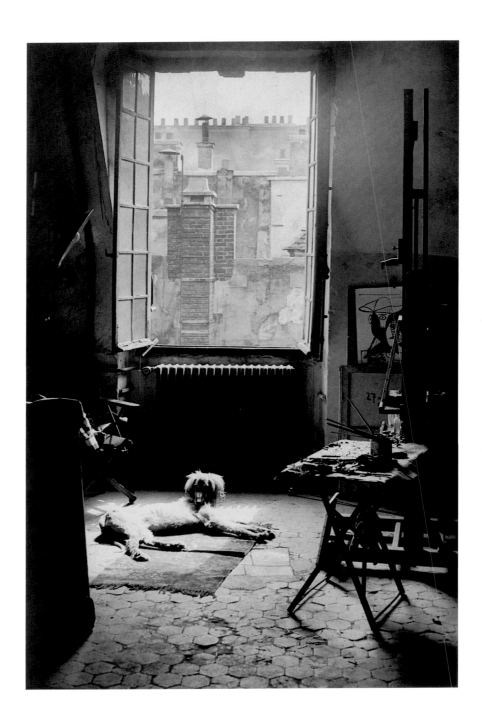

Jean Marais and Picasso Posing as Painter and Model
Jean Marais und Picasso posieren als Maler und Modell
Jean Marais et Picasso dans la pose du peintre et son modèle
1944

Picasso's Studio
Picassos Atelier
L'Atelier de Picasso
Rue des Grands-Augustins, Paris 6ᵉ, 9ᵗʰ May 1944

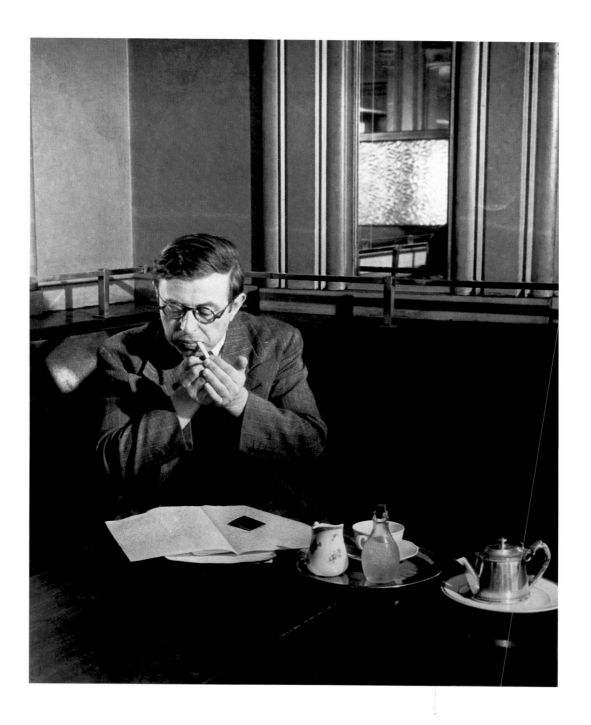

Jean-Paul Sartre at the "Café de Flore"
Jean-Paul Sartre im „Café de Flore"
Jean-Paul Sartre au « Café de Flore »
Paris 6ᵉ, 1944

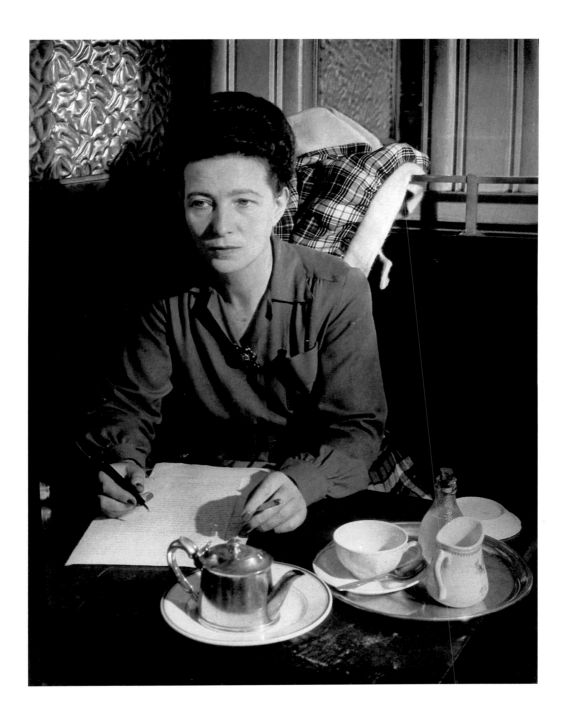

Simone de Beauvoir at the "Café de Flore"
Simone de Beauvoir im „Café de Flore"
Simone de Beauvoir au « Café de Flore »
Paris 6ᵉ, 1944

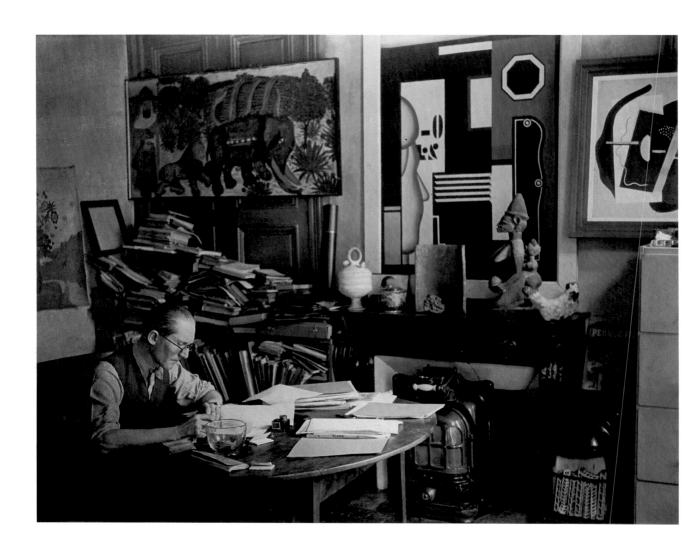

"Even the huge drawing table the architect used was so loaded with objects, books, and files that he was left with only a tiny cleared area where he could draw or write."

„Sogar der riesige Zeichentisch, den der Architekt benutzte, war mit Gegenständen, Büchern und Papieren so überladen, dass ihm nur ein winziger aufgeräumter Bereich zum Zeichnen oder Schreiben blieb."

«Même la grande table de l'architecte était tellement surchargée d'objets, de livres, de dossiers, qu'il ne lui restait qu'une toute petite place pour dessiner ou écrire.» [15]

Brassaï

155

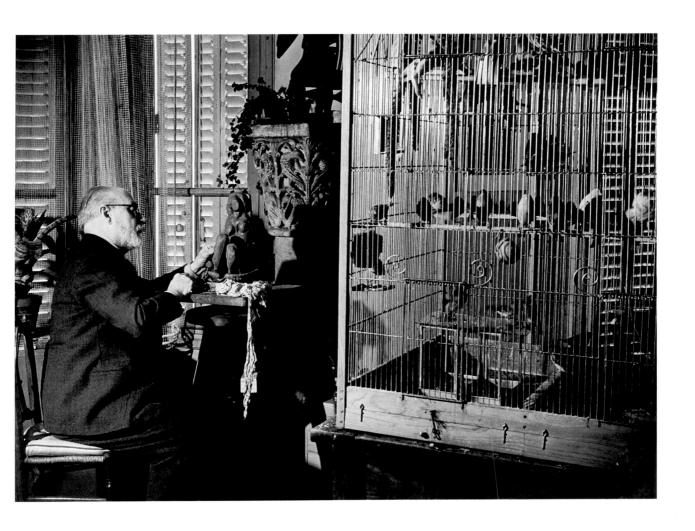

Le Corbusier at his Desk
Le Corbusier an seinem Arbeitstisch
Le Corbusier à sa table de travail
Rue Jacob, Paris 6ᵉ, 1931

Matisse Sculpting beside one of his Bird Cages
Matisse vor seinem Vogelkäfig an einer
Skulptur arbeitend
Matisse sculptant auprès d'une de ses cages à oiseaux
c. 1934

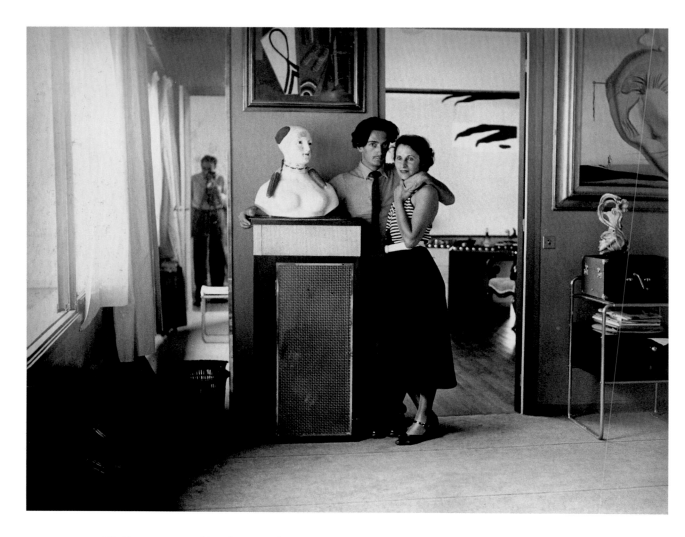

"Dalí was young and handsome, with an emaciated face and pale olive
complexion, and he sported a small moustache. His large moonstruck eyes
glittered with intelligence, with a strange fire, and his long gypsy's hair
was slick with brilliantine ..."

„Dalí war jung und gutaussehend; stolz trug er in seinem ausgezehrten Gesicht
mit der blassgrünen Farbe einen kleinen Schnurrbart. Seine großen, närrischen
Augen sprühten vor Intelligenz in einem merkwürdigen Feuer, und seine langen
Zigeunerhaare glänzten vor Brillantine ..."

« L'homme était jeune et beau : visage émacié d'une pâleur olivâtre orné de petites
moustaches ; grands yeux d'halluciné scintillant d'intelligence et d'un étrange feu ;
longs cheveux de gitan ruisselant de brillantine ... » [15]

Brassaï

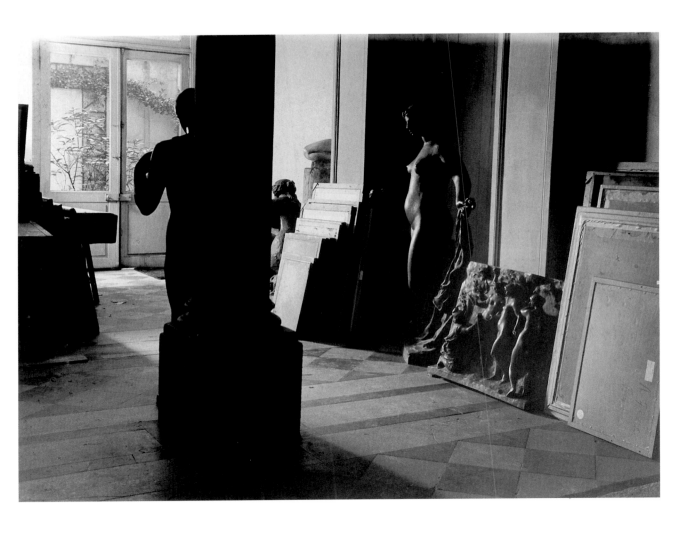

Dalí and Gala at the Villa Seurat
Dalí und Gala in der Villa Seurat
Dalí et Gala à la villa Seurat
Paris 14e, c. 1932

At Vollard's: Hallway with Maillol's "Venus with Necklace"
Vorraum des Hauses von Ambroise Vollard mit der
„Venus mit Halsschmuck" von Maillol
Chez Vollard, le hall avec la « Vénus au collier » de Maillol
Rue Martignac, Paris 7e, 1934

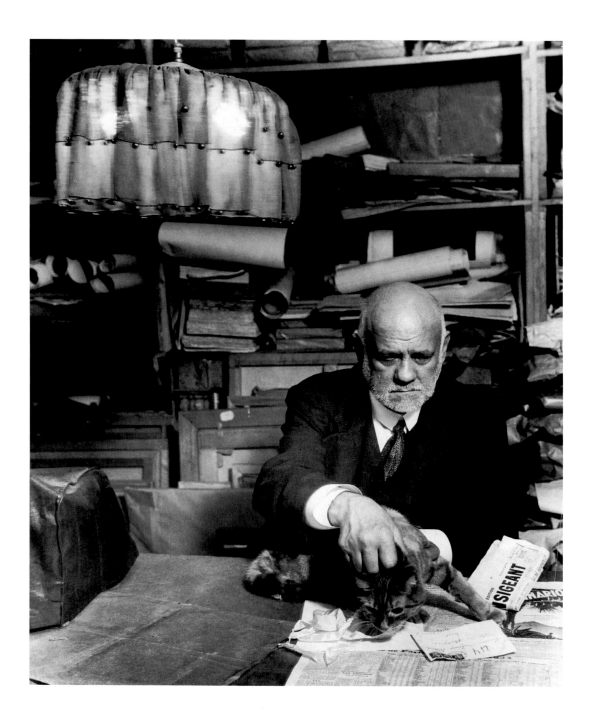

Vollard with Cat in his Office
Ambroise Vollard mit Katze in seinem Büro
Vollard au chat dans son bureau
1934

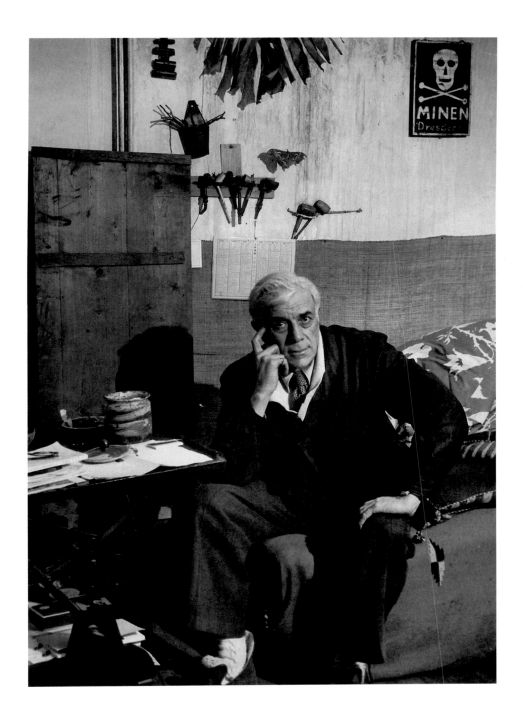

Georges Braque Sitting with Skull and Crossbones
Georges Braque vor einem Totenkopfplakat
Georges Braque, assis de face avec une affiche « tête de mort »
1946

Pigeondre (The Hands of Léon-Paul Fargue
and Louise de Vilmorin)
Turteltauben (Hände von Léon-Paul Fargue
und Louise de Vilmorin)
Pigeondre (Mains de Léon-Paul Fargue
et de Louise de Vilmorin)
1934

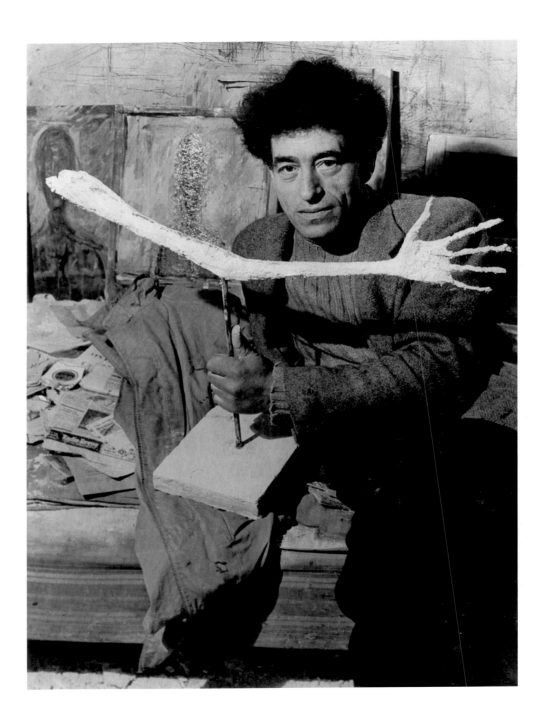

Alberto Giacometti
1947–1948

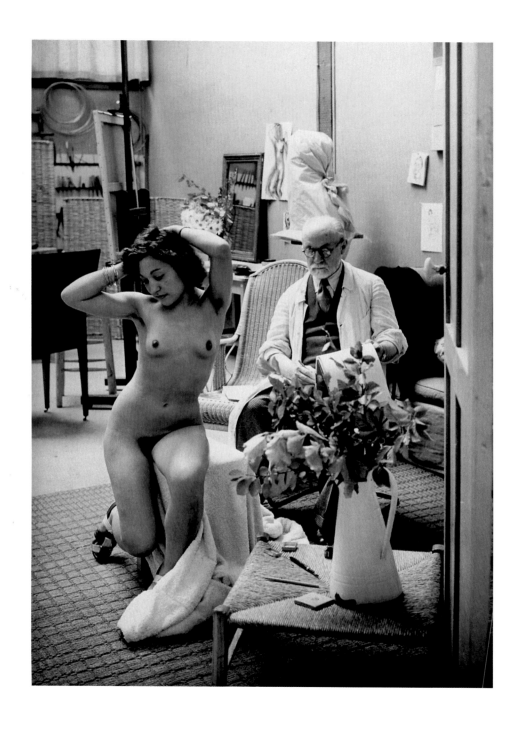

Matisse Drawing a Model in his Studio in the rue des Plantes
Matisse beim Aktzeichen in einem Atelier in der Rue des Plantes
Matisse dessinant un nu dans un atelier de la rue des Plantes
Paris 14ᵉ, 1939

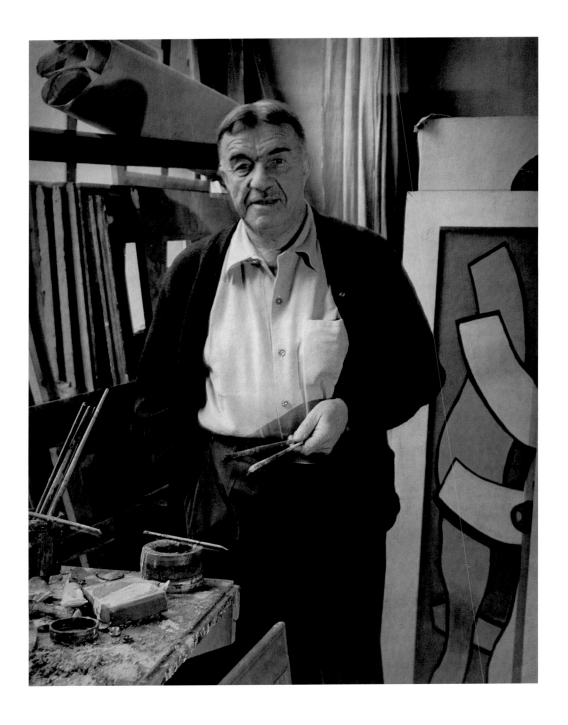

Fernand Léger in his Studio
Fernand Léger in seinem Atelier
Fernand Léger dans son atelier
Rue Notre-Dame-des-Champs, Paris 6e, 1937

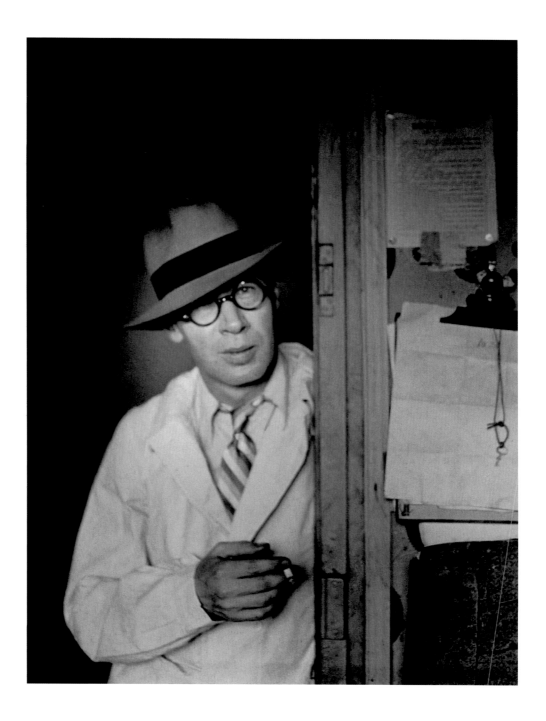

Henry Miller Standing in a Doorway wearing a Hat
Henry Miller mit Hut in der Tür stehend
Henry Miller au chapeau dans l'embrasure de la porte
Hôtel des Terrasses, Paris, c. 1931–1932

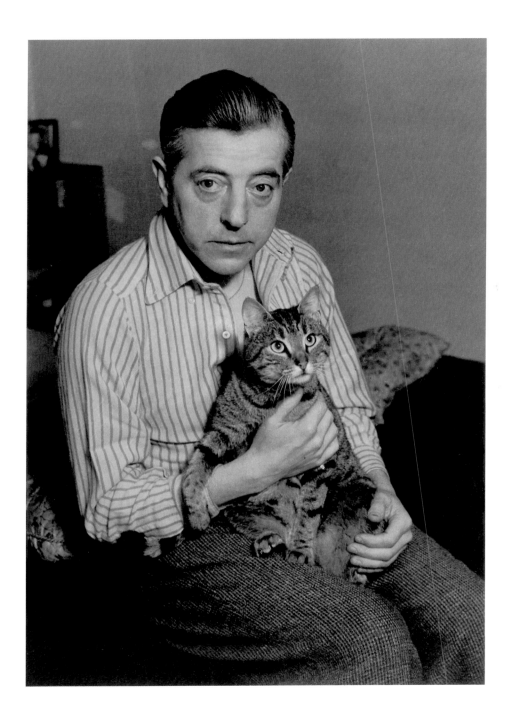

Jacques Prévert with Cat
Jacques Prévert mit Katze
Jacques Prévert au chat
1945

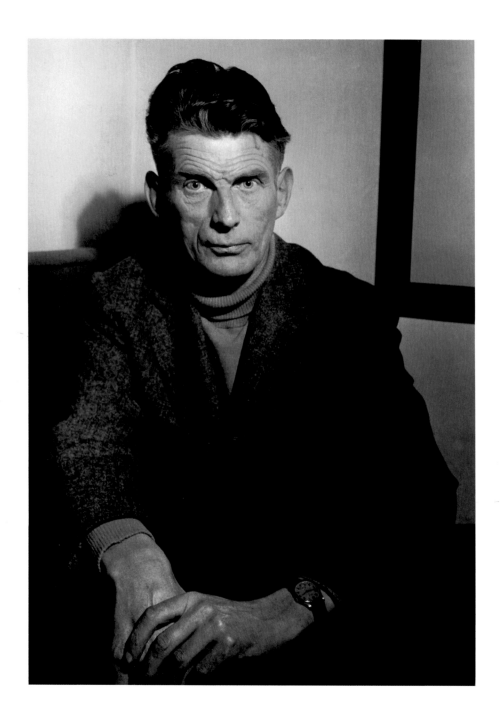

Samuel Beckett
1957

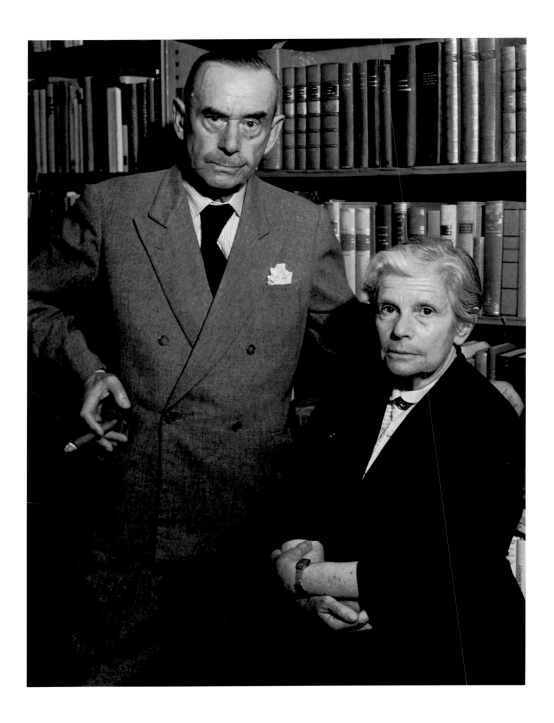

Thomas Mann and his Wife
Thomas Mann mit seiner Frau
Thomas Mann et sa femme
Kilchberg, Lake Zurich, Zürichsee, lac de Zurich, 2nd June 1955

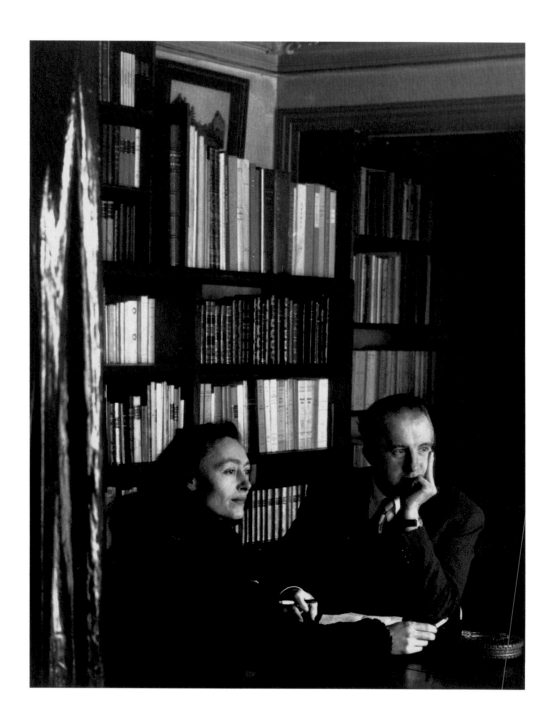

Paul and Nush Eluard at home
Paul und Nush Eluard in ihrem Heim
Paul et Nush Eluard chez eux
Rue de la Chapelle, Paris 18ᵉ, 1944

Olivier Messiaen in the Trinité Church
Olivier Messiaen in der Trinité-Kirche
Olivier Messiaen, église de la Trinité
Paris 9ᵉ, c. 1946

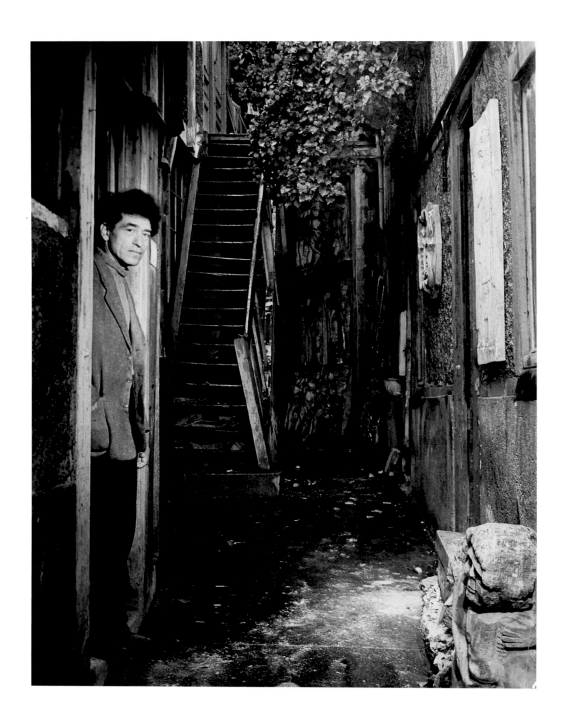

Giacometti at the Door of his Studio
Giacometti an der Tür seines Ateliers
Giacometti à la porte de son atelier
1947–1948

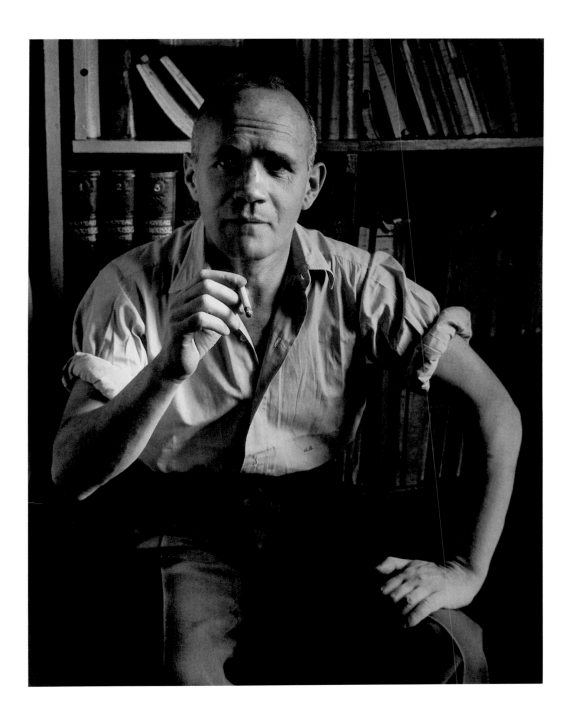

Jean Genet, Seated and Holding a Cigarette
Jean Genet, sitzend und eine Zigarette haltend
Jean Genet assis, tenant une cigarette
1948

Salvador Dalí at the Villa Seurat
Salvador Dalí, aufgenommen in der Villa Seurat
Salvador Dalí photographié à la villa Seurat
Paris 14ᵉ, c. 1932

Portrait of Maillol on his 75th Birthday
Maillol, porträtiert an seinem 75. Geburtstag
Portrait de Maillol pour ses 75 ans
Marly-le-Roi, 1936

Graffiti and Transmutations
Graffiti und Verwandlungen
Graffiti et Transmutations

Wall Propositions
Wandgestaltung
Propositions pour le mur
1950

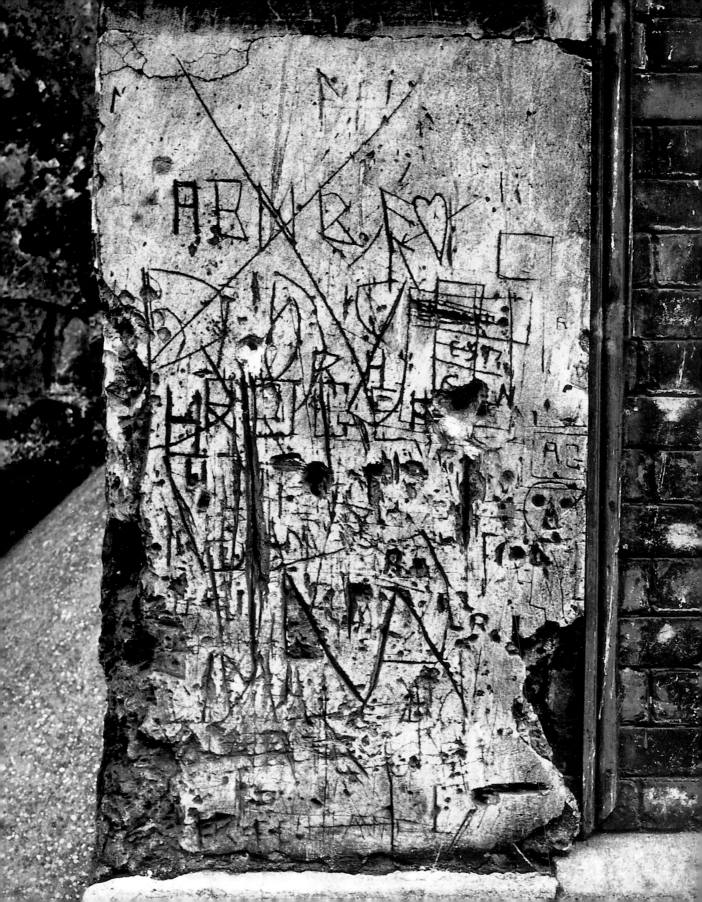

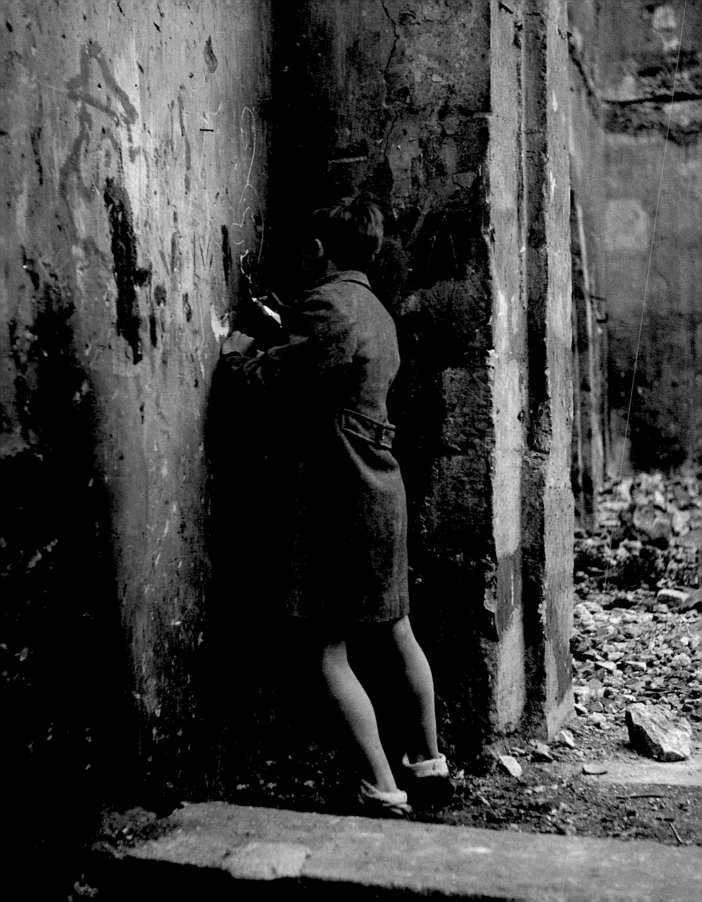

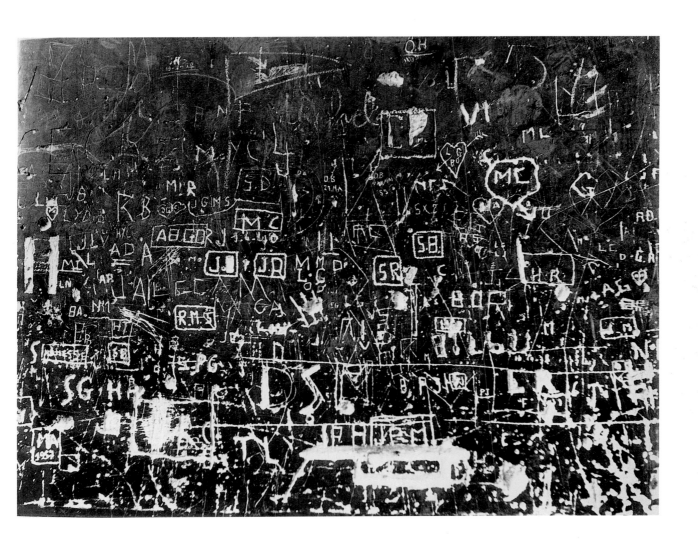

Child Snatching the Moment
Heimlicher Moment
Enfant à la sauvette
Marais, Paris, c. 1931–1934

Graffiti
Graffiti
Graffiti de Lutèce
Paris, 1950–1960

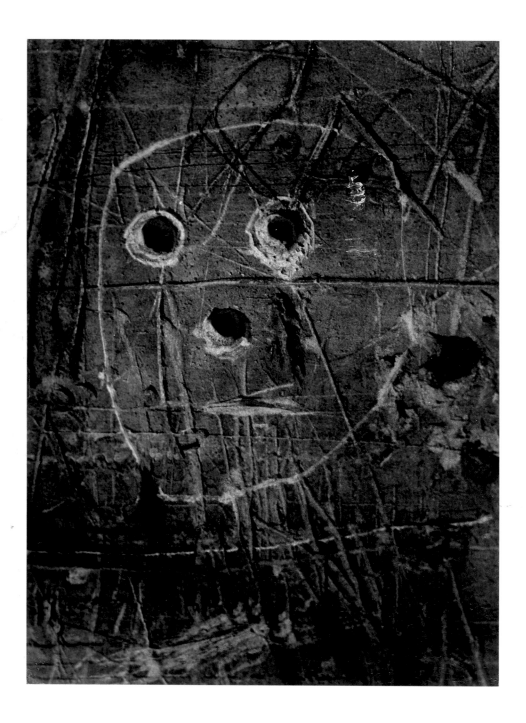

Masks and Faces
Masken und Gesichter
Masques et visages
Rue Mèdèah, Paris 1935

Masks and Faces
Masken und Gesichter
Masques et visages
Rue Mèdèah, Paris 1945

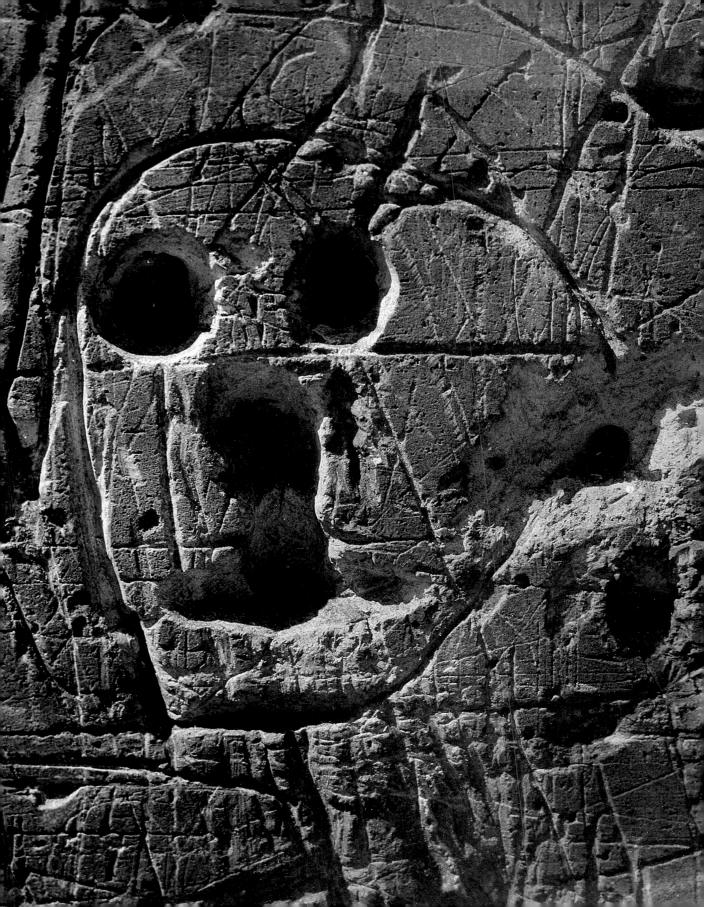

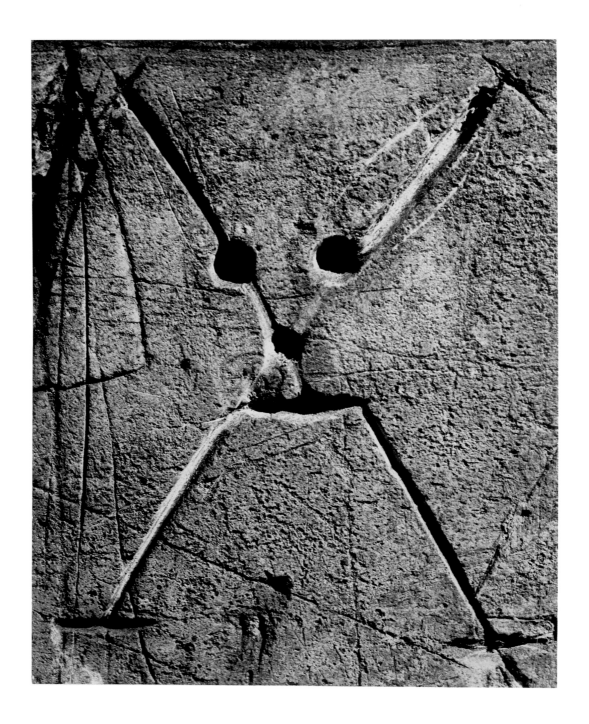

Death
Der Tod
La mort
1940

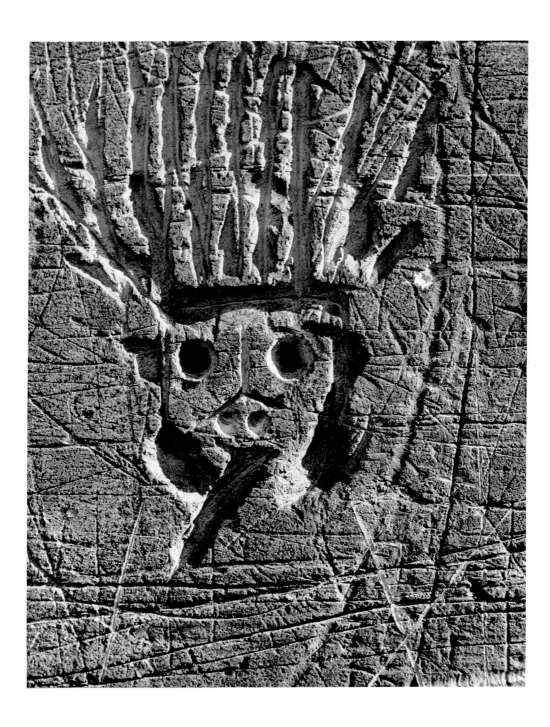

Primitive Images: The Sun King
Archaische Bilder: Sonnenkönig
Images primitives: Roi Soleil
Porte de Saint-Ouen, Paris 18ᵉ, 1945–1950

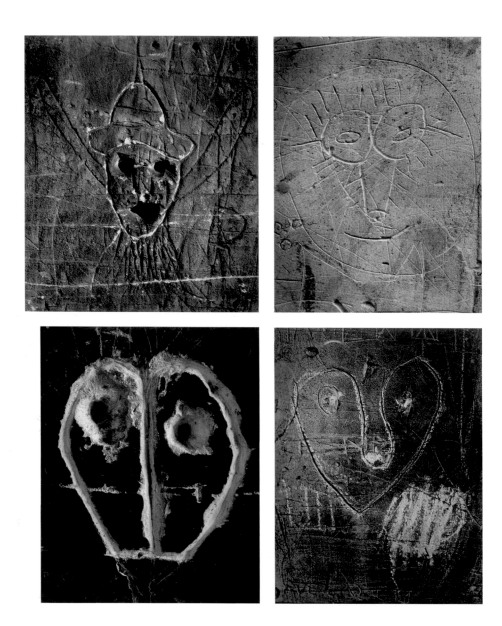

Graffiti, Series VIII: Magic
Graffiti, Serie VIII: Die Magie
Graffiti, série VIII : La Magie
1935

Graffiti, Series VIII: Magic
Graffiti, Serie VIII: Die Magie
Graffiti, série VIII : La Magie
1935

Graffiti, Series IV: Love
Graffiti, Serie IV: Die Liebe
Graffiti, série IV : L'Amour
1933

Graffiti, Series VIII: Magic
Graffiti, Serie VIII: Die Magie
Graffiti, série VIII : La Magie
1935

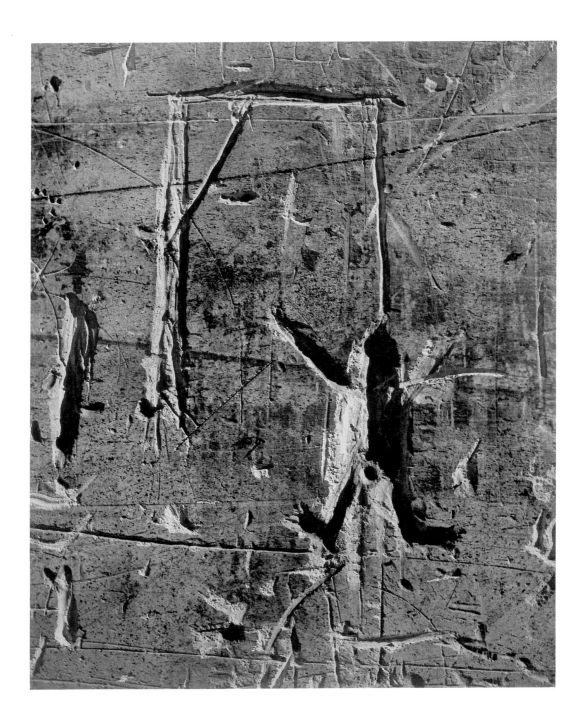

The Hanged Man, Series VIII: Magic
Der Erhängte, Serie VIII: Die Magie
Le Pendu, série VIII : La Magie
1932–1933

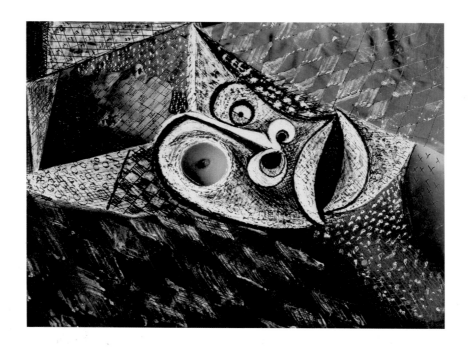

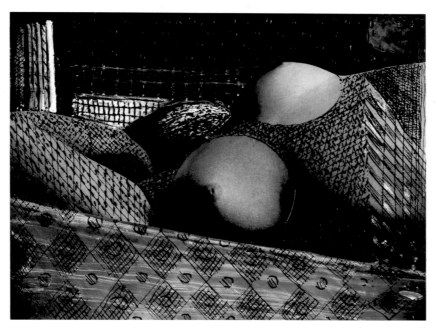

Transmutations: The Temptation of Saint Anthony
Verwandlungen: die Versuchung des Heiligen Antonius
Tentation de Saint Antoine – Série Transmutations
1934/1967

Transmutations: Girl Dreaming
Verwandlungen: träumendes junges Mädchen
Jeune fille rêvant – Série Transmutations
1934/1967

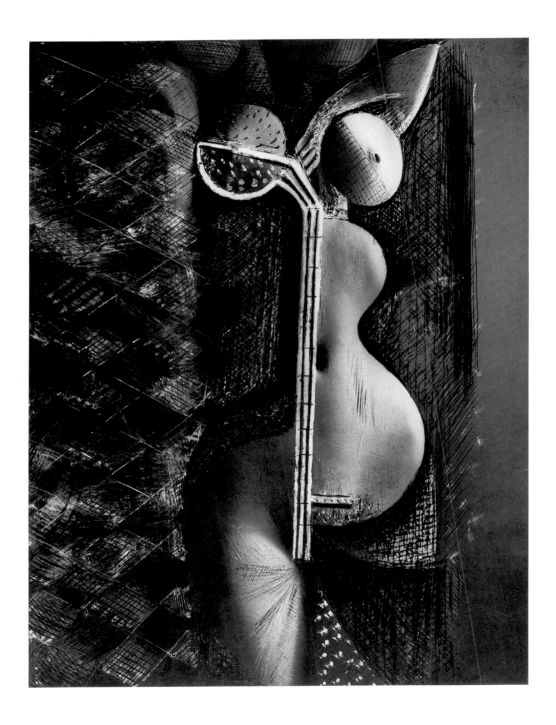

Offering
Opfergabe
Offrande
1934/1967

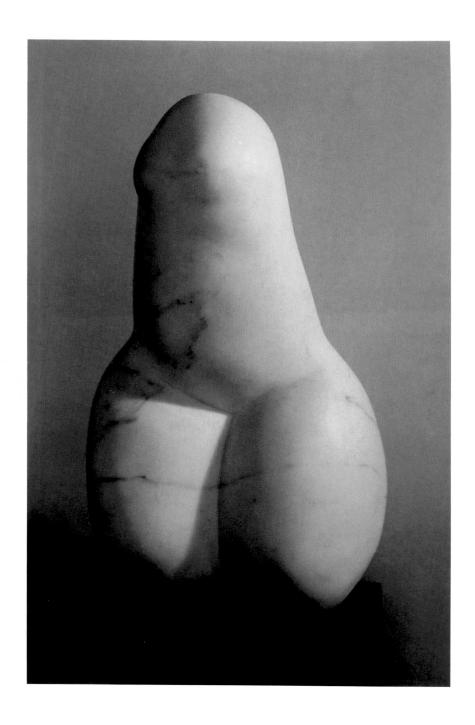

"Phallic": sculpture by Brassaï (Carrara marble)
„Phallisch": Skulptur von Brassaï (Carrara-Marmor)
« Phalique », sculpture de Brassaï (marbre de Carrare)
1961

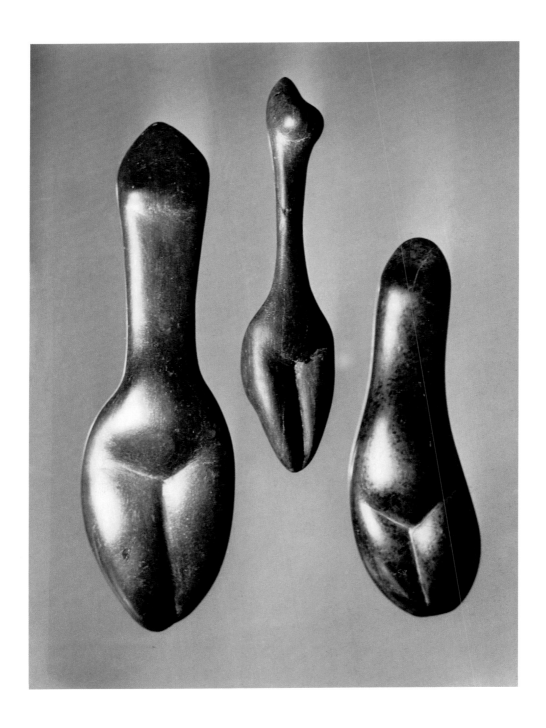

Nubile Woman – Mandoline Woman – Almond Woman
Heiratsfähige Frau, Mandolinenfrau und Mandelfrau
Femme nubile – Femme mandoline – Femme amande
1961

Biography
Biografie
Biographie

1899 Born Gyula Halasz on 9 September at Brasso in Transylvania, Hungary (now Romania). His father is a university lecturer in French literature, who had studied at the Sorbonne.

1903–1904 First visit to Paris.

1905 On his return, he resumes his studies, first in Brasso, then in Budapest.

1917–1918 Serves in the Austro-Hungarian army.

1921–1922 Takes classes at the Akademische Hochschule in Berlin-Charlottenburg.

1924 Arrives in Paris where he finds work both as a painter and as a journalist.

1925 Meets Henri Michaux, with whom he becomes friends.

1926 Meets André Kertész. Fascinated by Paris night life, he takes up photography. His walks around the city provide the material for the book *Paris de nuit*, published in 1932. Through his friend the art critic Maurice Raynal, who writes for *L'Intransigeant*, Brassaï meets E. Tériade.

1932 Tériade introduces him to Picasso. Brassaï photographs Picasso's sculptures and his studio in the rue de La Boétie for the first issue of the review *Minotaure*, published by A. Skira, with E. Tériade as artistic director. Through his work for *Minotaure*, he meets the Surrealists (André Breton, Paul Eluard, Robert Desnos, Benjamin Péret, Tristan Tzara…). Adopts the name Brassaï (literally, "from Brasso").

1930–1963 Brassaï publishes his photographs in *Minotaure, Verve, Picture Post, Lilliput, Coronet, Labyrinthe, Réalités, Plaisirs de France* and *Harper's Bazaar*. For *Harper's*, he undertakes a series of portraits of artists (including Picasso, Bonnard, Giacometti, Braque and Le Corbusier) and writers (among them, René Char, Jacques Prévert, Colette, Lawrence Durrell, Henry Miller and Jean Genet).

1899 Gyula Halasz (genannt Brassaï) wird am 9. September im ungarischen Brasso in Transsilvanien (heute Rumänien) geboren. Sein Vater, Universitätsprofessor für französische Literatur, hat an der Sorbonne studiert.

1903–1904 Brassaïs erster Parisaufenthalt.

1905 Nach seiner Rückkehr beginnt er die Schulausbildung in Brasso, die er später in Budapest fortsetzt.

1917–1918 Er dient in der österreichisch-ungarischen Armee.

1921–1922 Besucht Kurse an der Akademischen Hochschule in Berlin-Charlottenburg.

1924 Brassaï geht nach Paris, wo er als Maler und Journalist arbeitet.

1925 Begegnung mit Henri Michaux, mit dem er sich anfreundet.

1926 Brassaï lernt André Kertész kennen. Fasziniert vom Pariser Nachtleben, wird er Fotograf. Ergebnis seiner Wanderungen ist *Paris de nuit*, das 1932 erscheint. Sein Freund Maurice Raynal, Kunstkritiker beim *L'Intransigeant*, macht Brassaï mit E. Tériade bekannt.

1932 Über Tériade macht Brassaï die Bekanntschaft Picassos, dessen bildhauerisches Werk wie auch dessen Atelier in der Rue de La Boétie er für die erste Ausgabe des *Minotaure* fotografiert. Durch diese von A. Skira herausgegebene Zeitschrift, deren künstlerische Leitung E. Tériade innehat, lernt er Surrealisten wie André Breton, Paul Eluard, Robert Desnos, Benjamin Péret und Tristan Tzara kennen. Er nennt sich nun Brassaï (wörtlich: aus Brasso).

1930–1963 Brassaï arbeitet für *Minotaure, Verve, Picture Post, Lilliput, Coronet, Labyrinthe, Réalités, Plaisirs de France* und *Harper's Bazaar*. Für Letztere fotografiert er zahlreiche Künstler (Picasso, Bonnard, Giacometti, Braque, Le Corbusier) und Schriftsteller (René Char, Jacques Prévert, Colette, Lawrence Durrell, Henry Miller, Jean Genet…).

1899 Gyula Halasz (dit Brassaï) naît le 9 septembre à Brasso en (Transsylvanie) Hongrie (maintenant Roumanie). Son père, professeur de littérature française à l'université avait fait ses études à la Sorbonne.

1903–1904 Premier séjour de Brassaï à Paris.

1905 À son retour, il étudie à Brasso puis à Budapest.

1917–1918 Il sert dans l'armée austro-hongroise.

1921–1922 Il suit les cours de l'Akademische Hochschule à Berlin-Charlottenburg.

1924 Brassaï arrive à Paris où il va d'abord travailler comme peintre et journaliste.

1925 Rencontre Henri Michaux, avec lequel il se lie d'amitié.

1926 Rencontre André Kertész. Fasciné par la vie nocturne de Paris, il devient photographe. De ses promenades naîtra *Paris de nuit*, publié en 1932. Par l'intermédiaire de son ami Maurice Raynal, critique d'art à *l'Intransigeant*, Brassaï rencontre E. Tériade.

1932 Tériade lui présente Picasso dont il photographie l'œuvre sculpté et l'atelier de la rue de La Boétie pour le premier numéro de *Minotaure*. C'est par l'intermédiaire de cette revue éditée par A. Skira sous la direction artistique de E. Tériade qu'il rencontre les surréalistes (André Breton, Paul Eluard, Robert Desnos, Benjamin Péret, Tristan Tzara…). Il adopte le nom Brassaï (littéralement: « de Brasso »).

1930–1963 Brassaï travaille pour *Minotaure, Verve, Picture Post, Lilliput, Coronet, Labyrinthe, Réalités, Plaisirs de France,* et *Harper's Bazaar*. C'est pour cette dernière revue qu'il photographie de nombreux artistes (Picasso, Bonnard, Giacometti, Braque, Le Corbusier) et des écrivains (René Char, Jacques Prévert, Colette, Lawrence Durrell, Henry Miller, Jean Genet…).

1933 First solo exhibition of photos, *Paris de nuit* (*Paris after Dark*), first in Paris (Arts et Métiers Graphiques), then London (Batsford Gallery).

1934 Awarded the Emerson Medal (London) for his book *Paris de nuit*. Meets Matisse while photographing him for *Verve*.

1940 Brassaï refuses to request a photographer's permit from the Germans, even though they encourage him to do so. As a result he can neither continue to work nor publish his images.

1943 Writes *Bistro-Tabac*. In late September, Brassaï starts work on a new series of photographs of sculptures by Picasso, which will keep him busy until 1946. These images are

1933 Erste Einzelausstellung von *Paris de nuit* in Paris in der Galerie Arts et Métiers graphiques, dann in London in der Batsford Gallery.

1934 Erhält die Emerson-Medaille (London) für sein Buch *Paris de nuit*. Lernt anlässlich einer Reportage für *Verve* Matisse kennen.

1940 Von den Deutschen aufgefordert, eine Fotografiererlaubnis einzuholen, weigert sich Brassaï, dem Folge zu leisten. Darum kann er seine Fotografien nicht mehr veröffentlichen und seinen Beruf nicht mehr ausüben.

1943 Brassaï schreibt *Bistro-Tabac*. Ende September beginnt er die Skulpturen Picassos zu fotografieren, die mit einem Text von Daniel-Henry Kahnweiler 1949 in dem Buch *Les sculp-*

1933 Première exposition personnelle de *Paris de nuit* à Paris, Arts et Métiers graphiques, puis à Londres (Batsford Gallery).

1934 Reçoit la médaille Emerson (Londres) pour son livre *Paris de nuit*. Fait la connaissance de Matisse lors d'un reportage pour *Verve*.

1940 Bien qu'il soit sollicité par les Allemands, Brassaï refuse de demander une autorisation de photographier, ce qui l'empêche de publier ses photographies, et d'exercer son métier.

1943 Écrit *Bistrot-Tabac*. Fin septembre, il commence les photographies des sculptures de Picasso publiées avec un texte de Daniel-Henry Kahnweiler en 1949 dans le livre *Les sculptures de Picasso*. Ce travail l'occupera jusqu'à la fin de 1946.

later published in book form in 1949, accompanied by a text by Daniel-Henry Kahnweiler (*Les sculptures de Picasso*).

1944 Brassaï starts to draw again.

1945 Meets Gilberte-Mercédès Boyer: they marry in 1948. Brassaï creates the stage sets, based on photographs, for *Rendez-vous* by Jacques Prévert, Joseph Kosma and Roland Petit, which premieres at the Théâtre Sarah-Bernhardt in June. The curtain is designed by Picasso.

1947 Photographic set design for *En passant*, a play by Raymond Queneau, at the Théâtre Agnès Capri.

1949 Photographic set design for *D'amour et d'eau fraîche*, a play by Elsa Triolet, at the Théâtre des Champs-Élysées. He writes a Surrealist poem, *Histoire de Marie*, which appears with a preface by Henry Miller.

1950 Photographic set design for *Phèdre*, a ballet by Jean Cocteau and Georges Auric, at the Paris Opéra.

1956 His film, *Tant qu'il y aura des bêtes*, shot in the Vincennes Zoo, wins the prize for most original work at the Cannes Film Festival.

1957 Golden Medal at the Photography Biennale in Venice. Travels to the United States. First colour photographs.

1960 The album *Graffiti* is published in Germany.

1964 Publishes *Conversations avec Picasso* in Paris.

1966 Shares the American Society of Magazine Photographers' Prize with his friend Ansel Adams.

1974 Awarded the Villa d'Arles medal, appointed Chevalier des Arts et Lettres.

1976 Appointed Chevalier de la Légion d'Honneur.

1978 Awarded France's first Grand Prix National de la Photographie.

1984 Dies on 7 July.

tures de Picasso veröffentlicht werden. Mit dieser Arbeit ist er bis Ende 1946 beschäftigt.

1944 Brassaï beginnt wieder zu zeichnen.

1945 Begegnung mit Gilberte-Mercédès Boyer, die er 1948 heiratet. Brassaï fertigt das fotografische Bühnenbild für *Rendez-vous* von Jacques Prévert, Joseph Kosma und Roland Petit, ein Stück, das im Juni im Théâtre Sarah-Bernhardt uraufgeführt wird. Den Vorhang schuf Picasso.

1947 Fotografisches Bühnenbild für das Stück *En passant* von Raymond Queneau, das im Théâtre Agnès Capri herauskommt.

1949 Fotografisches Bühnenbild für das Stück *D'amour et d'eau fraîche* von Elsa Triolet im Théâtre des Champs-Élysées. Er schreibt ein surrealistisches Poem, *Histoire de Marie*, zu dem Henry Miller das Vorwort verfasst.

1950 Fotografisches Bühnenbild für das Ballett *Phèdre* von Jean Cocteau und Georges Auric, das in der Opéra de Paris zur Aufführung kommt.

1956 Brassaï dreht einen Film im Zoo von Vincennes, *Tant qu'il y aura des bêtes*. Er erhält den Preis für den originellsten Beitrag beim Filmfestival in Cannes.

1957 Erhält die Goldmedaille auf der Biennale der Fotografie in Venedig. Reise in die Vereinigten Staaten. Erste Farbfotografien.

1960 Der Bildband *Graffiti* erscheint in Deutschland.

1964 Veröffentlicht *Conversations avec Picasso* in Paris.

1966 Erhält gemeinsam mit Ansel Adams den Preis der American Society of Magazine Photographers.

1974 Erhält die Medaille der Stadt Arles, wird zum Chevalier des Arts et Lettres ernannt.

1976 Ritter der Ehrenlegion.

1978 Erster Preis beim Grand Prix National de la Photographie.

1984 Brassaï stirbt am 7. Juli.

1944 Il recommence le dessin.

1945 Rencontre Gilberte-Mercédès Boyer qu'il épousera en 1948. Brassaï réalise les décors photographiques de *Rendez-vous* de Jacques Prévert, Joseph Kosma et Roland Petit, créé au théâtre Sarah-Bernhardt en juin. Le rideau était de Picasso.

1947 Décor photographique de *En passant* pièce de Raymond Queneau, au théâtre Agnès Capri.

1949 Décor photographique pour *D'amour et d'eau fraîche* pièce d'Elsa Triolet, au théâtre des Champs-Élysées. Il écrit un poème surréaliste *Histoire de marie*, préfacé par Henry Miller.

1950 Décor photographique pour *Phèdre*, ballet de Jean Cocteau et Georges Auric, à l'Opéra de Paris.

1956 Tourne un film au zoo de Vincennes: *Tant qu'il y aura des bêtes*, prix de l'originalité au festival de Cannes.

1957 Obtient la médaille d'or à la Biennale de photographie de Venise. Voyage aux États-Unis. Premières photographies en couleur.

1960 Parution de l'album *Graffiti* en Allemagne.

1964 Publie *Conversations avec Picasso* à Paris.

1966 Reçoit avec Ansel Adams le prix de l'American Society of Magazine Photographers.

1974 Reçoit la médaille de la ville d'Arles, est fait Chevalier des Arts et Lettres.

1976 Chevalier de la Légion d'Honneur.

1978 Premier Grand Prix National de la Photographie.

1984 Brassaï meurt le 7 juillet.

Exhibitions / Bibliography
Ausstellungen / Bibliografie
Expositions / Bibliographie

Solo Exhibitions
Einzelausstellungen
Expositions individuelles

1933 *Paris de nuit*, Arts et Métiers Graphiques, Paris, then Batsford Gallery, London.

1946 Palais des Beaux-Arts, Brussels.

1952 *Cent Photographies de Brassaï*, Musée des Beaux-Arts, Nancy.

1954 *Brassaï*, The Art Institute of Chicago, Chicago, Illinois.

1955 *Brassaï*, International Museum of Photography, George Eastman House, Rochester, New York; Walker Art Center, Minneapolis, Minnesota.

1957 *Graffiti*, The Museum of Modern Art, New York (travelling exhibition).

1958 *The Language of the Wall: Parisian Graffiti Photographed by Brassaï*, Institute of Contemporary Arts, London.

1959 *Eye of Paris*, Limelight Gallery, New York.

1960 *Graffiti*, Milan Triennale.

1962 *Graffiti*, Galerie Daniel Cordier, Paris.

1963 *Brassaï: Rétrospective*, Bibliothèque Nationale, Paris.

1964 *Picasso-Brassaï*, Galerie Madoura, Cannes (with sculptures by Picasso).

1966 *Retrospective*, Kölnischer Kunstverein, Cologne.

1968 *Retrospective*, The Museum of Modern Art, New York.

1970 *L'Art mural par Brassaï*, Galerie Rencontres, Paris, colour photographs.

1972–73 *Brassaï: sculptures, tapisseries, dessins*, Paris, Lyon, Galerie Verrière.

1974 *Brassaï: Hommage*, Musée Réattu, Arles.

1975 *Brassaï: The Eye of Paris*, Baltimore Museum of Art, Baltimore, Maryland.

1976 *Secret Paris of the 30s*, Marlborough Gallery, New York.

1977 *Das geheime Paris*, Galerie Lévy, Hamburg. *Le Paris secret des années 30*, Marlborough Gallery, Zurich.

1978 *Le Paris secret*, Musée des Beaux-Arts, Arnhem, Holland; Banque Lambert, Brussels.

1979 *130 Photographs*, The Photographer's Gallery, London.

Artists and Studios, Marlborough Gallery, New York.

Le Paris secret, Camera Obscura Gallery, Stockholm.

1984 *Brassaï*, Yurakucho Gallery, Tokyo.

1987 *Picasso vu par Brassaï*, Musée Picasso, Paris.

1988 *Brassaï, Paris le jour, Paris la nuit*, Musée Carnavalet, Paris.

1993 *Brassaï*, Centre National de la Photographie, Paris.

Brassaï, del Surrealismo al informalismo, Fundació Antoni Tàpies, Barcelona, then Centre National de la Photographie, Paris.

1998 *Brassaï and company*, The Art Institute of Chicago, Chicago, Illinois.

Brassaï, the eye of Paris, The Museum of Fine Arts, Houston.

2000 *Brassaï*, Centre Georges Pompidou, Paris.

Group Exhibitions
Gemeinschaftsausstellungen
Expositions collectives

1932 *Modern European Photographers*, Julien Levy Gallery, New York (using the name Halasz).

1937 *Photography 1839–1937*, The Museum of Modern Art, New York. Daguerre centenary exhibition, Karoles Palace, Budapest (Silver Medal).

1939 *Maîtres Photographes Contemporains*, Palais des Beaux-Arts, Brussels.

1951 *5 French Photographers*, The Museum of Modern Art, New York.

1953 *Post-war European Photography*, The Museum of Modern Art, New York.

1955 *Family of Man*, The Museum of Modern Art, New York.

1963 *Great Photographers*, Photokina, Cologne.

1976 *Photographs from the Julien Levy Collection, starting with Atget*, Art Institute of Chicago, Chicago, Illinois.

1981 *Les Réalismes*, Centre Georges Pompidou, Paris.

1985 *L'Amour fou, Photography and Surrealism*, Corcoran Gallery of Art, Washington, DC.

1986 *Explosante fixe*, Musée National d'Art moderne, Centre Georges Pompidou, Paris.

1987 *Regards sur Minotaure*, Musée Roth, Geneva.

1988 *Une exposition de photographie française à New York*, Centre Georges Pompidou, Paris.

1989 *The New Vision: Photography Between the World Wars*, Metropolitan Museum of Art, New York.

Books by Brassaï
Bücher von Brassaï
Livres de Brassaï

Paris de nuit, text by Paul Morand, Paris, Arts et Métiers Graphiques, 1932. English edition, *Paris after Dark: Brassaï*, London, Batsford, 1933. German edition, *Nächtliches Paris*, München, Schirmer und Mosel, 1979

Du mur des cavernes au mur d'usine (From cave wall to factory wall), text by Brassaï, in *Minotaure*, n° 3–4, 1933

Trente dessins (Thirty drawings), poem by Jacques Prévert, Paris, Éditions Pierre Tisné, 1946

Les Sculptures de Picasso, text by Daniel-Henry Kahnweiler, Paris, Les Éditions du Chêne, 1949. English edition, *The Sculptures of Picasso*, London, Focal Press, 1949

Histoire de Marie (Marie's Story), introduction by Henry Miller, Paris, Édition du Point du Jour, 1949

Camera in Paris, London, The Focal Press, 1949

Brassaï, texts by Henry Miller and Brassaï, Paris, Éditions Neuf, 1952

Séville en fête, texts by Henri de Montherlant and Dominique Aubier, Paris, Delpire, 1954. English edition, *Fiesta in Seville*, London, Thames and Hudson, 1956. German edition, *Festliches Spanien*, Feldafing, Buchheim-Verlag, 1954

Paris, text by John Russel, London, Viking Press, 1960

Graffiti, text by Brassaï, Stuttgart, Belser Verlag, 1960; Paris, Éditions du Temps, 1961. Reedited version, preface by Gilberte Brassaï, various texts by Brassaï, Paris, Flammarion, 1993

Conversations avec Picasso, text by Brassaï, Paris, Gallimard, 1964. English edition, *Picasso and Company*, London, Thames and Hudson, 1967. German edition, *Gespräche mit Picasso*, Hamburg, Rowohlt, 1966

Transmutations, portfolio of 12 engravings, Paris, Éditions Les Contards, 1967

Brassaï, text by Lawrence Durrell, New York, The Museum of Modern Art, 1968

Lewis Carroll et la photographie (Lewis Carroll and photography), text by Brassaï, in: *Lewis Carroll, lettres et photos* (Lewis Carroll: letters and photos), L'Herne, 1972

Portfolio of 10 photos, introduction by A. D. Coleman, New York, 1973

Henry Miller, grandeur nature, text by Brassaï, Paris, Gallimard, 1975. English edition, *Henry Miller, The Paris Years*, New York, Arcade Publ., 1995. German edition, *Henry Miller, Natürliche Größe*, Frankfurt a. M., S. Fischer, 1977

Le Paris secret des années 30, text by Brassaï, Paris, Gallimard, 1976. English edition, *The Secret Paris of the 30s*, London, Thames and Hudson, 1976. German edition, *Das geheime Paris: Bilder der dreißiger Jahre*, Frankfurt a. M., S. Fischer, 1976

Paroles en l'air (Idle words), Paris, Jean-Claude Simoëns, 1977

Henry Miller, rocher heureux, text by Brassaï, Paris, Gallimard, 1978. English edition, *Henry Miller, Happy Rock*. Chicago, University of Chicago Press, 2001

Elöhívás: Levelek, Bucharest, Kriterion, 1980. French edition, *Lettres à mes parents: 1920–1940)*, Gallimard, Paris, 2000. English edition, *Letters to My Parents*, texts by Gilberte Brassaï, Anne Wilkes Tucker, Chicago, University of Chicago Press, 1997

Les Artistes de ma vie, text by Brassaï, Paris, Éditions Denoël, 1982. English edition, *The Artists of My Life*, London, Thames and Hudson, 1982

Marcel Proust sous l'emprise de la photographie, Paris, Gallimard, 1997. English edition, *Proust in the Power of Photography*, Chicago, University of Chicago Press, 2001. German edition, *Proust und die Liebe zur Photographie*, Franfurt a. M., Suhrkamp, 2001

Brassaï, Editions Centre Pompidou, Paris 2000

Notes
Anmerkungen
Notes

1) Foreword by Henry Miller, *Brassaï*, Paris 1942.

2) Brassaï, *Conversations avec Picasso*, Paris 1964.

3) Conversation with the autor, published in *Photo-Revue*, February 1974.

4) Quoted in: France Bequette, "Rencontre avec Brassaï", in *Culture et Communication* no. 80, May 1980.

5) Archives G. Brassaï, quoted in: *Brassaï*, Paris 2000, p. 157.

6) Conversation with the author, published in *Photo-Revue*, February 1974.

7) Emile Henriot, *Le temps*, Editorial, January 1933

8) Conversation with the author, published in *Photo-Revue*, February 1974.

9) Brassaï, *Conversations avec Picasso*, Paris 1964.

10) Conversation with the author, published in *Photo-Revue*, February 1974.

11) op. cit.

12) op. cit.

13) Brassaï, *Marcel Proust sous l'emprise de la photographie*, Paris 1997, p. 30.

14) Foreword by Henry Miller, *Brassaï*, Paris 1942.

15) Brassaï, *Les artistes de ma vie*, 1982.

Photo Credits

Photos: Agence photographique de la RMN, Paris

t = top, b = bottom, r = right, l = left

© Photo CNAC/MNAM Dist. RMN/Jacques Faujour: Front Cover, pp. 5, 22 (2), 23, 25, 26tl, 26bl, 26br, 29 (2), 30b, 31, 33, 38, 39, 50, 61, 66, 67, 75, 76, 78, 98, 100, 117, 118, 119, 124, 127, 128br, 129, 130, 131, 132, 133 (4), 134, 135, 137, 146, 181, 186, 187

© Photo CNAC/MNAM Dist. RMN/Georges Meguerditchian: p. 147

© Photo CNAC/MNAM Dist. RMN/Bertrand Prévost: pp. 184 (2), 185

© Photo CNAC/MNAM Dist. RMN/Adam Rzepka: pp. 37, 40, 44, 45, 46, 47, 48, 52, 57, 58, 59, 60, 63, 65, 69, 70, 71, 72, 82, 91, 96, 178, 179, 180, 182 (4), 183

© Photo RMN – Michèle Bellot: pp. 2, 21, 24, 26tr, 27, 28, 30t, 36, 62, 74, 77, 79, 80, 81, 83, 84, 85, 86, 87, 89, 90, 93, 94, 95, 97, 99, 101, 102, 105, 107, 120, 121, 122, 123, 125, 128bl, 139, 140, 141, 142, 144, 145, 152–167, 169, 170, 171, 176, 189

© Photo RMN – Gérard Blot: pp. 34, 35, 41, 42, 43, 49, 51, 53, 55, 56, 64, 68, 73, 103, 149, 168, 173, 175, 176

© Photo RMN – Hervé Lewandowski: pp.106, 108, 109, 110, 111, 112, 113, 114, 115, 126, 128tl, 128tr, 136, 138, 143, 172, Back Cover

© Photo RMN – Franck Raux: pp. 150, 151

© Photo RMN – Reversement: p. 92

Images Courtesy of:

Centre Pompidou-MNAM-CCI, Paris: Front Cover, pp. 5, 22 (2), 23, 25, 26tl, 26bl, 26br, 29 (2), 30b, 31, 33, 37, 38, 39, 40, 44, 45, 46, 47, 48, 50, 52, 57, 58, 59, 60, 61, 63, 65, 66, 67, 69, 70, 71, 72, 75, 76, 78, 82, 91, 96, 98, 100, 117, 118, 119, 124, 127, 128br, 129, 130, 131, 132, 133 (4), 134, 135, 137, 146, 147, 178, 179, 180, 181, 182 (4), 183, 184 (2), 185, 186, 187

Musée Picasso, Paris: pp. 150, 151

Private Collection: pp. 2, 21, 24, 26tr, 27, 28, 30t, 34, 35, 36, 41, 42, 43, 49, 51, 53, 55, 56, 62, 64, 68, 73, 74, 77, 79, 80, 81, 83, 84, 85, 86, 87, 89, 90, 92, 93, 94, 95, 97, 99, 101, 102, 103, 105, 106, 107, 108, 109, 110, 111, 112, 113, 114, 115, 120, 121, 122, 123, 125, 126, 128tl, 128tr, 128bl, 136, 138, 139, 140, 141, 142, 143, 144, 145, 149, 152–173, 175, 176, 177, 189, Back Cover

Imprint

To stay informed about upcoming TASCHEN titles, please request our magazine at www.taschen.com or write to TASCHEN, Hohenzollernring 53, D–50672 Cologne, Germany, Fax: +49-221-254919.
We will be happy to send you a free copy of our magazine which is filled with information about all of our books.

Frontcover | Umschlagvorderseite | Couverture : *Lovers in a Small Café | Liebespaar in einem kleinen Café | Couple d'amoureux dans un petit café parisien*, Quartier Italie, Paris 13e, c. 1932

Backcover | Umschlagrückseite | Dos de couverture : *Stairs in Montmartre | Treppen an der Butte Montmartre | Escalier de la Butte Montmartre*, Paris 18e, c. 1935–1937.

Page | Seite 2: *Self-Portrait | Selbstbildnis | Autoportrait* Hôtel des Terrasses, Paris, 1931

Page | Seite 189: *Brassaï with Camera | Brassaï mit der Kamera | Brassaï avec la caméra* Villa Adrienne, Paris 14e, May 1955 (photo by Gilberte Brassaï)

© 2004 TASCHEN GmbH
Hohenzollernring 53, D–50672 Köln
www.taschen.com

© 2004 ESTATE BRASSAÏ – R.M.N.
for all photographs
www.photo.rmn.fr

Editor/Layout: Jean-Claude Gautrand
Editorial Coordination: Thierry Nebois, Cologne
English Translation: Peter Snowdon, Brussels
German Translation: Bettina Blumenberg, Munich
Typeface Design: Sense/Net, Andy Disl, Cologne
Production: Stefan Klatte, Cologne

Printed in Italy
ISBN 3-8228-3137-9